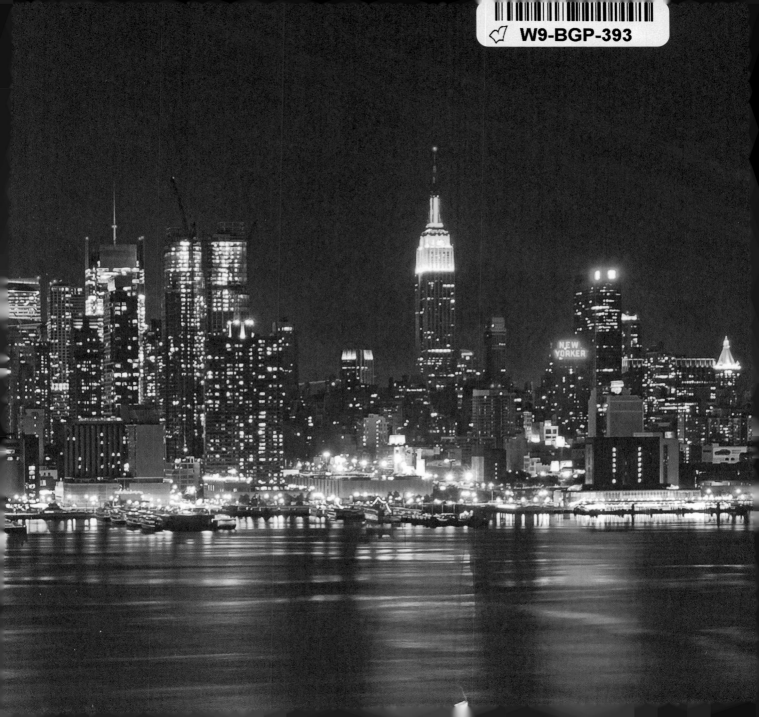

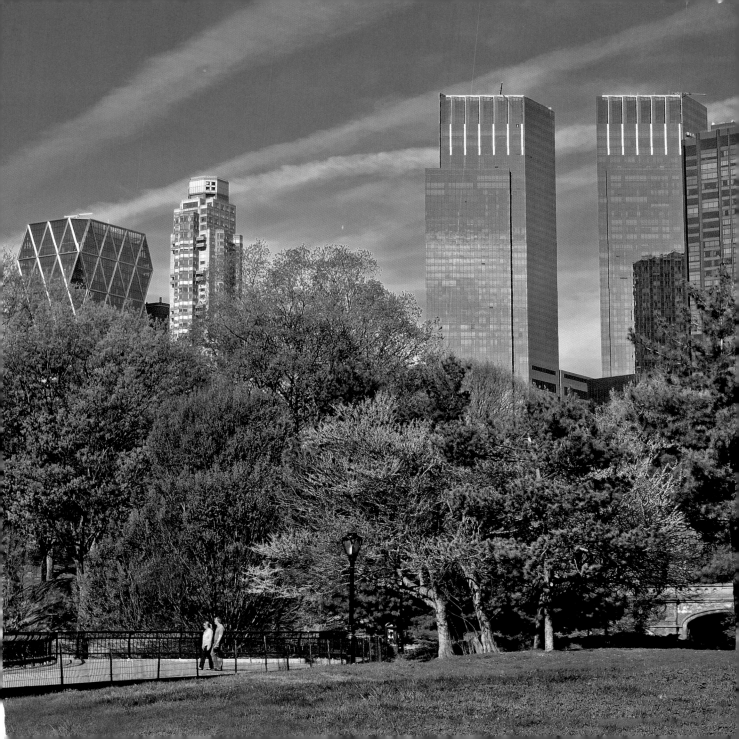

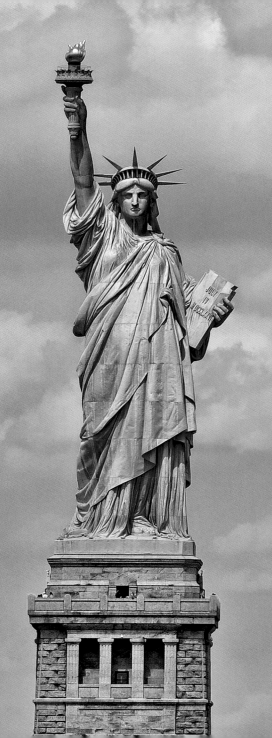

THE SEASONS OF
NEW YORK

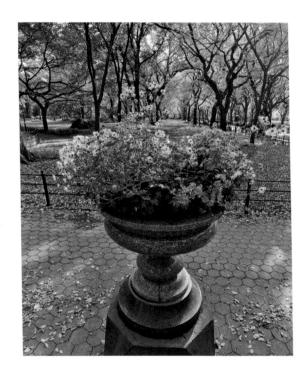

CHARLES J. ZIGA

UNIVERSE

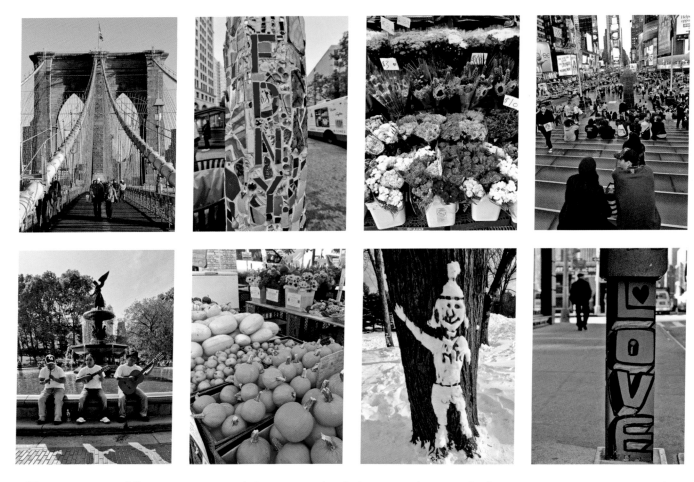

Spring, summer, fall, or winter, New York City is magical and vibrant. Simply eyeing the famous tourist attractions is enough to excite even the most seasoned traveler, but to truly experience this splendid city I encourage you to linger: picnic in Central Park's Sheep Meadow in the springtime, feel the electric pulse on the ruby-red steps in Times Square at dusk; hang out and watch the eclectic diversity of young people who populate Washington Square Park; soak up the city's heat on a summer evening in Bryant Park; walk the Brooklyn Bridge on a crisp autumn afternoon; tour the New York Public Library and its magnificent main reading room; stroll the High Line and view the panorama of Chelsea and Midtown; watch the commuters as they perform their daily ritual dance sidestepping through Grand Central Terminal; build a snowman in Central Park on a winter's day; marvel like a child at Rockefeller Center's holiday display; ride the Staten Island Ferry at twilight and view the Statue of Liberty, Ellis Island, and the city from afar; and visit the 9/11 memorial and behold the city's very soul. The best of New York is free and will leave you with lasting memories. —Charles Ziga

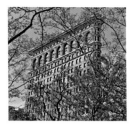 SPRING 6

 SUMMER 64

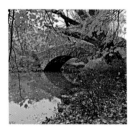 FALL 124

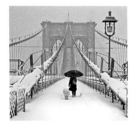 WINTER 166

1 Central Park near Driprock Arch looking
 southwest toward Columbus Circle
2 Statue of Liberty from Staten Island Ferry
3 Fall flowers at The Mall, Central Park

4 Brooklyn Bridge, FDNY lamppost,
 flowers at deli, ruby-red stairs, musicians
 at Bethesda Fountain, fall produce at farmer's
 market, snow art in Central Park, love graffiti

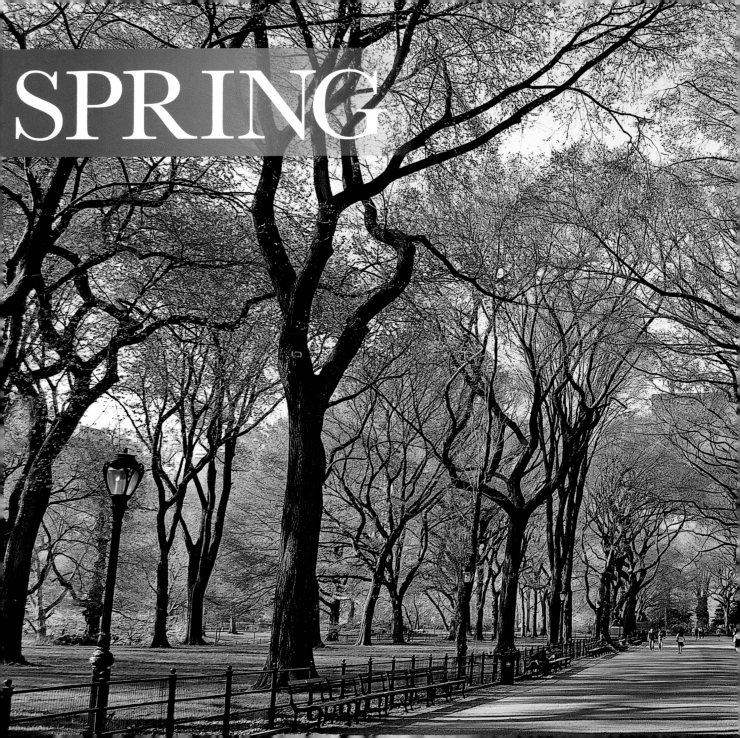

SPRING

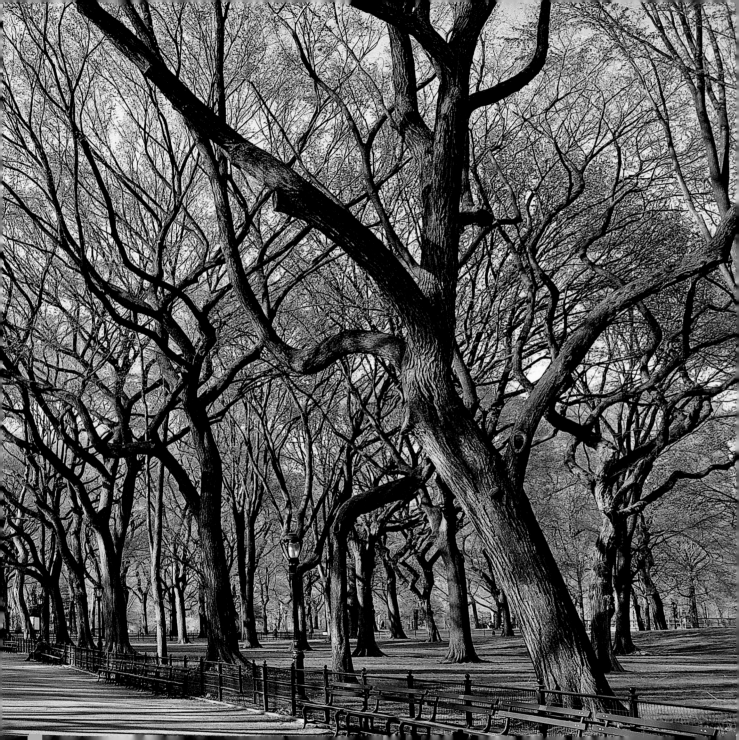

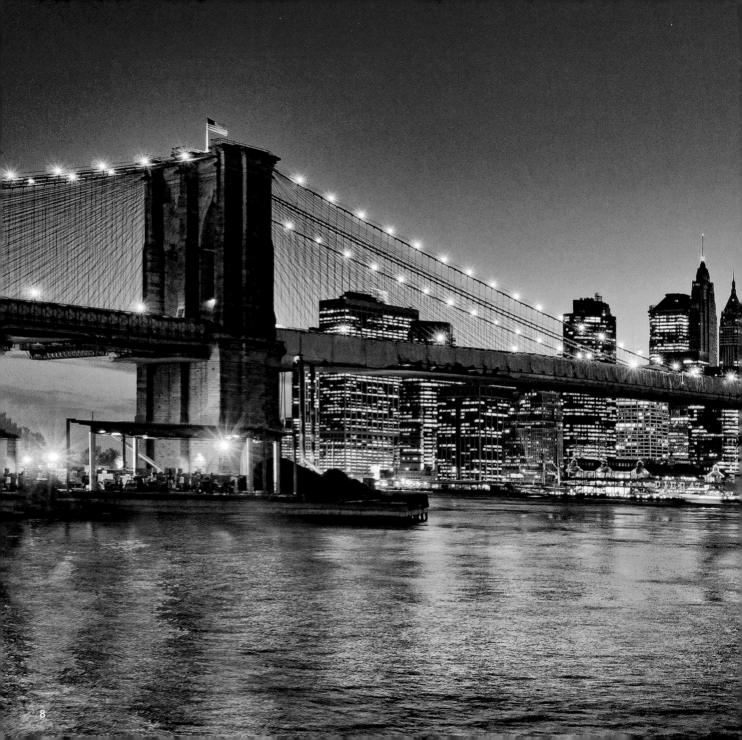

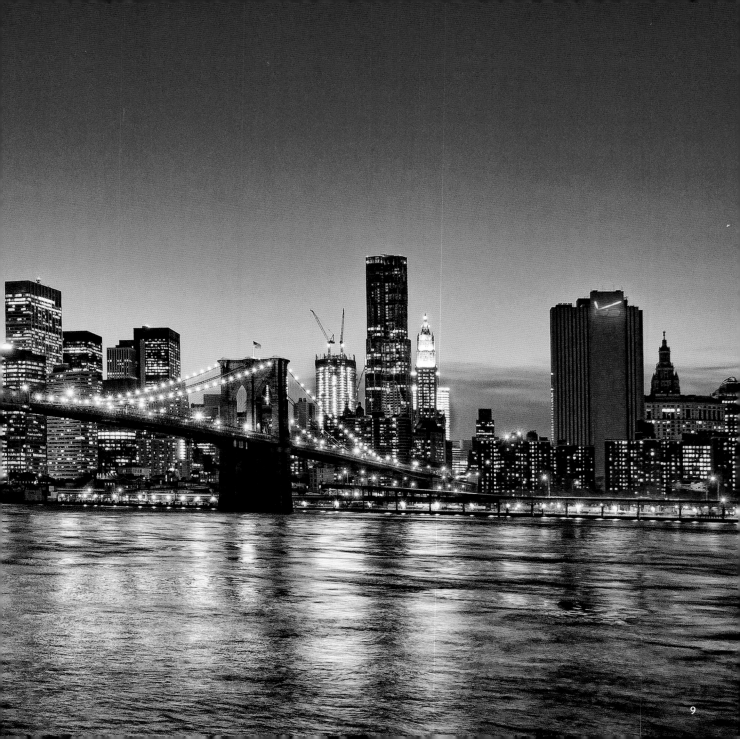

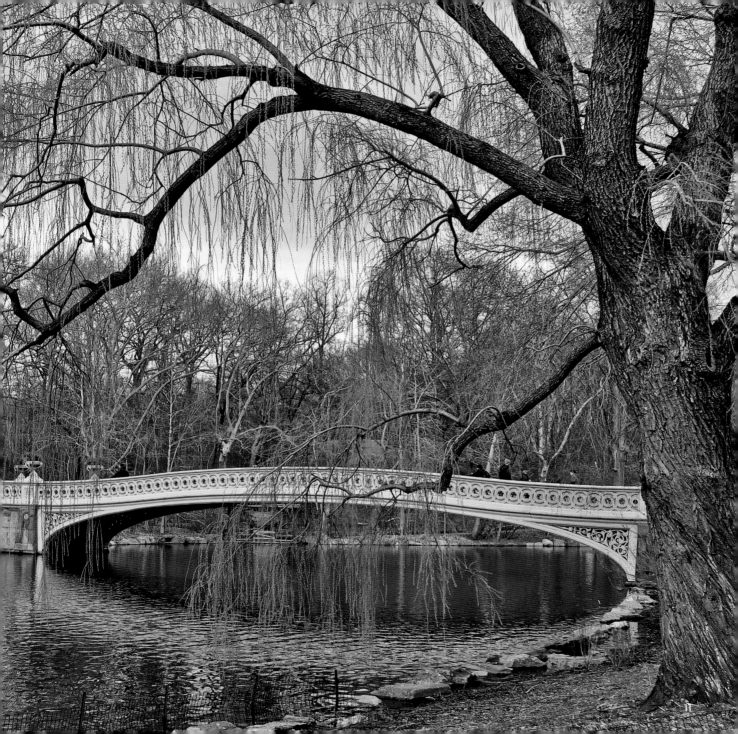

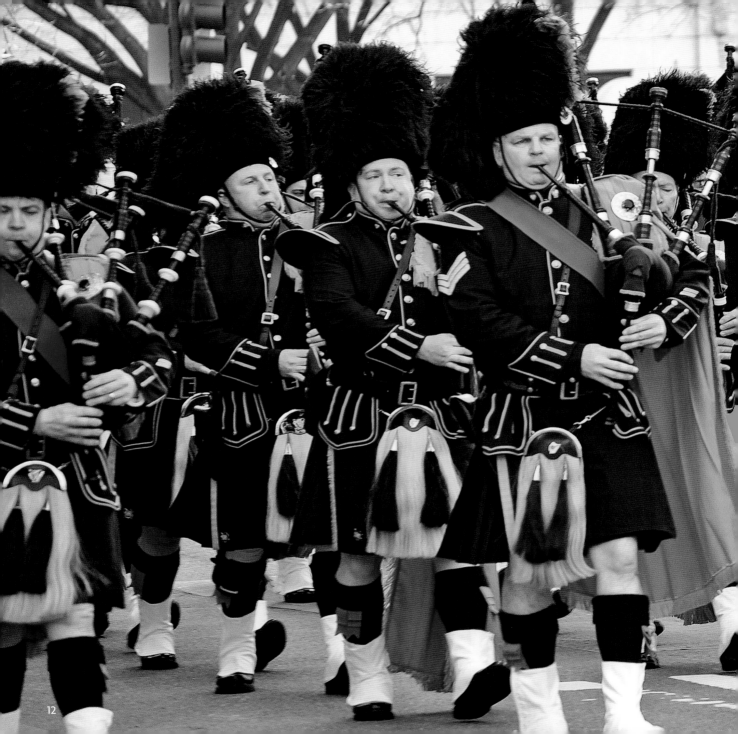

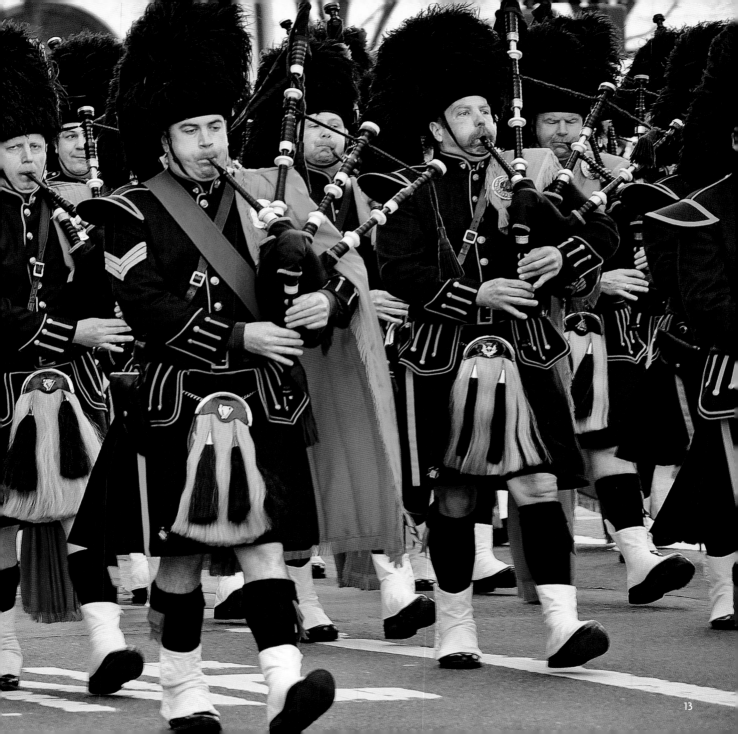

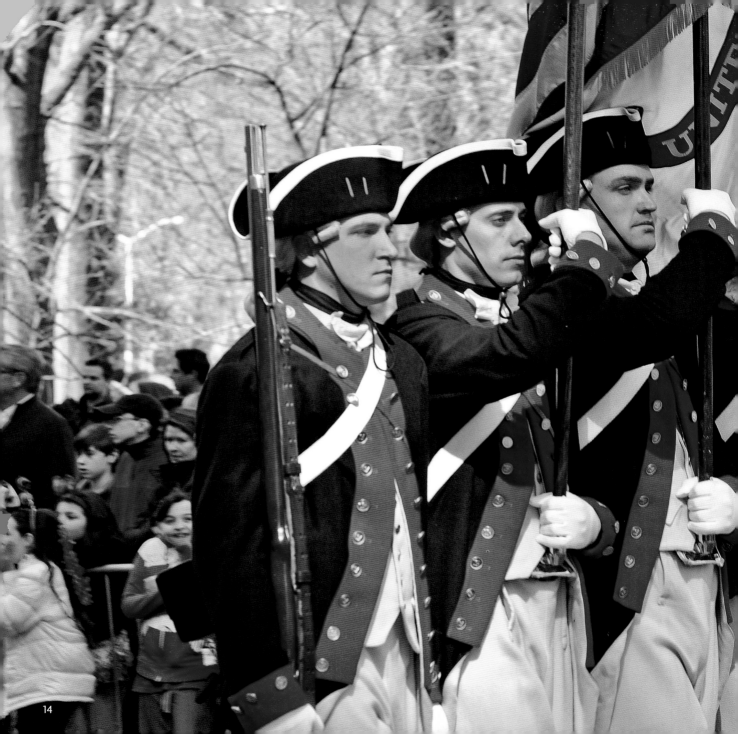

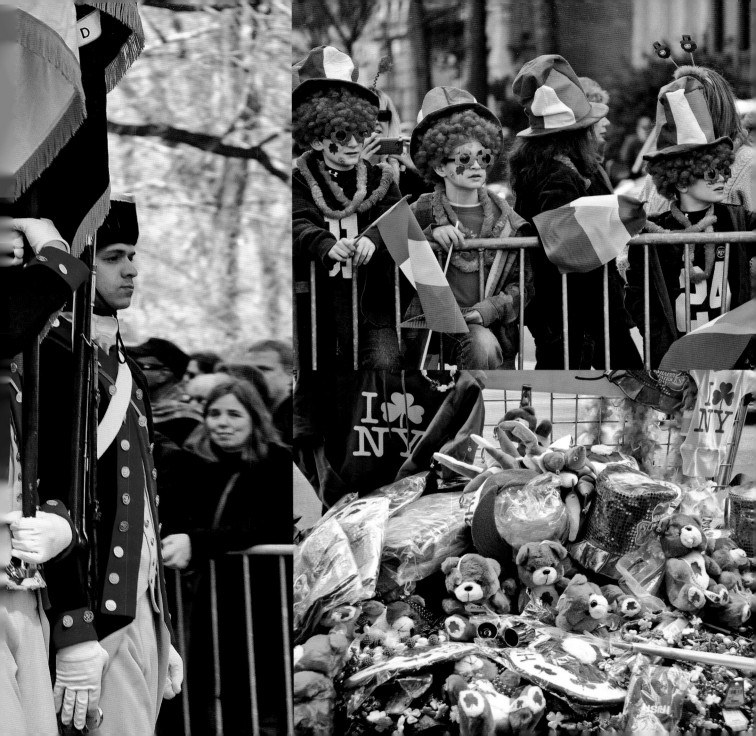

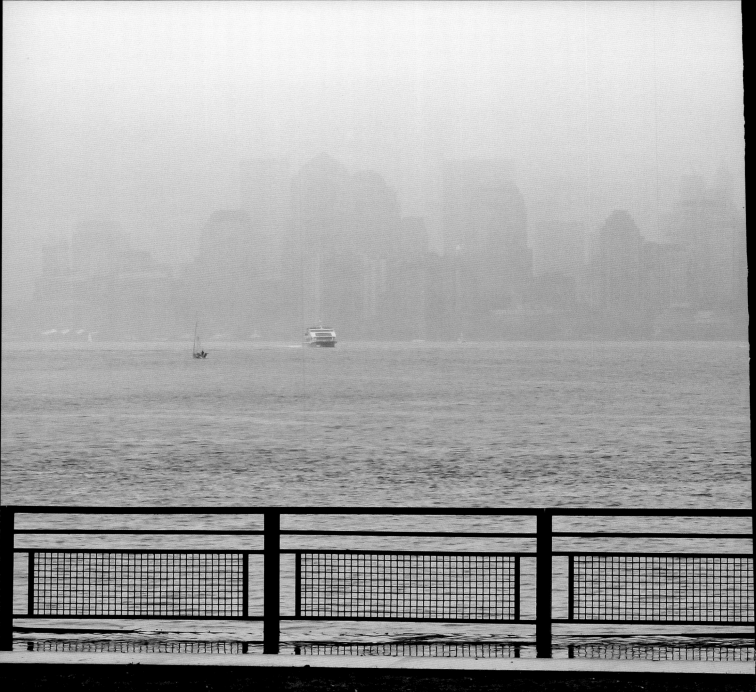

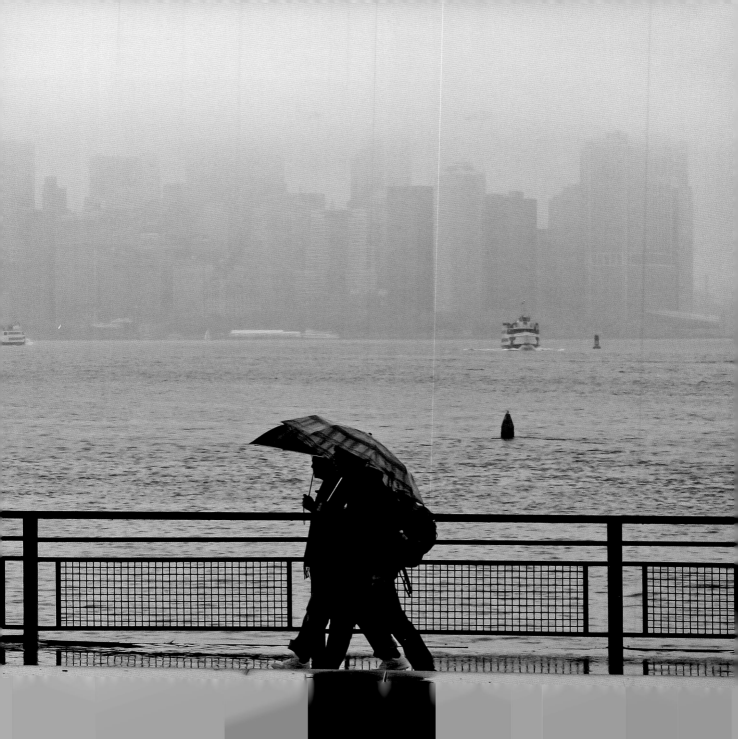

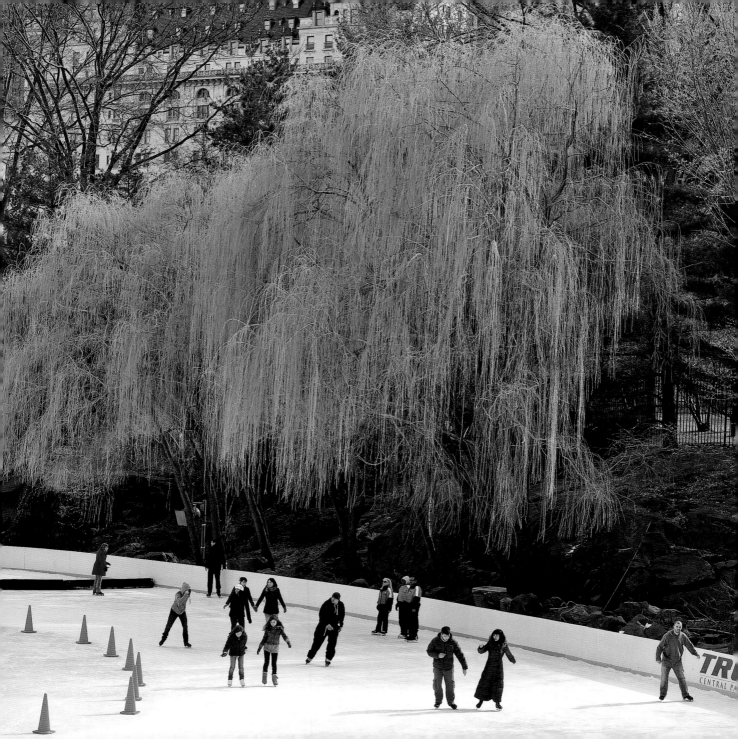

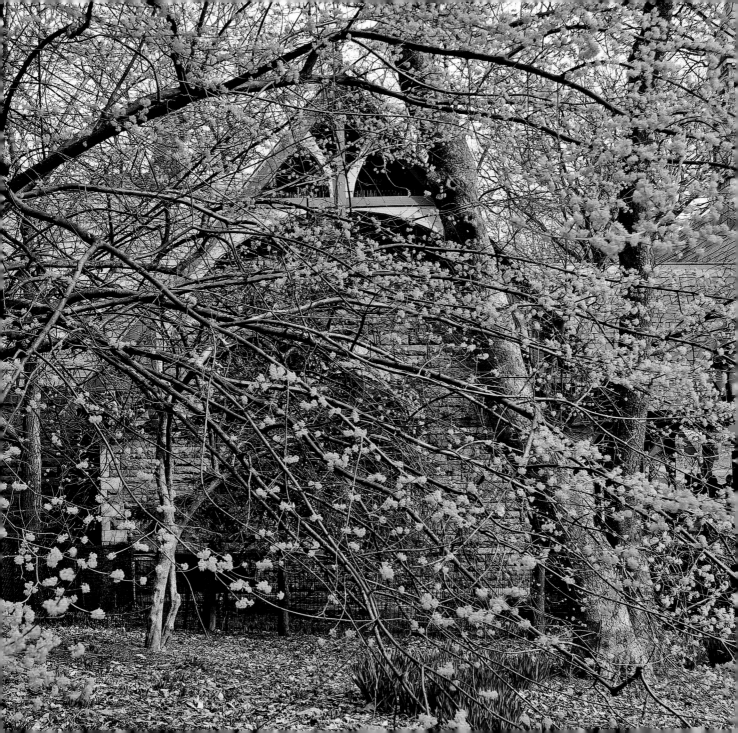

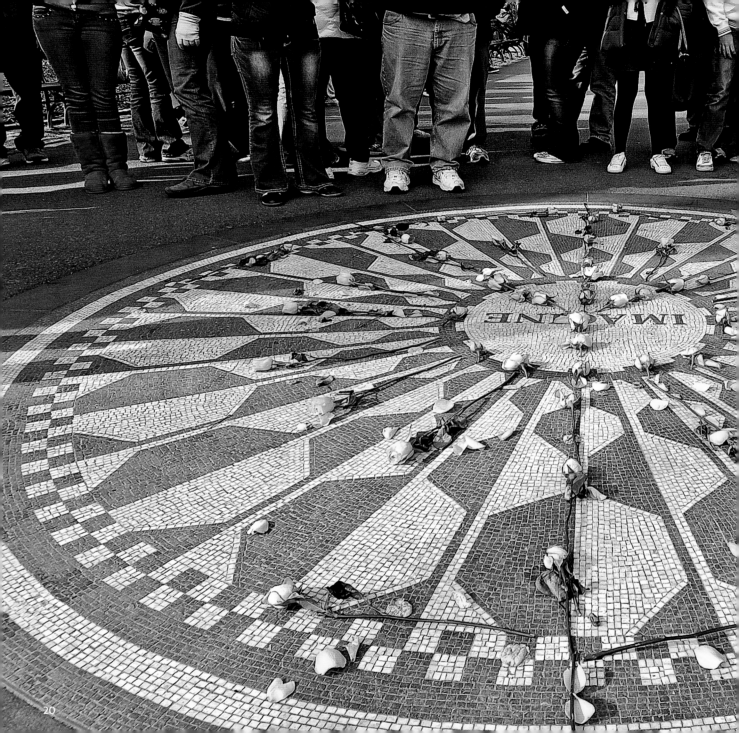

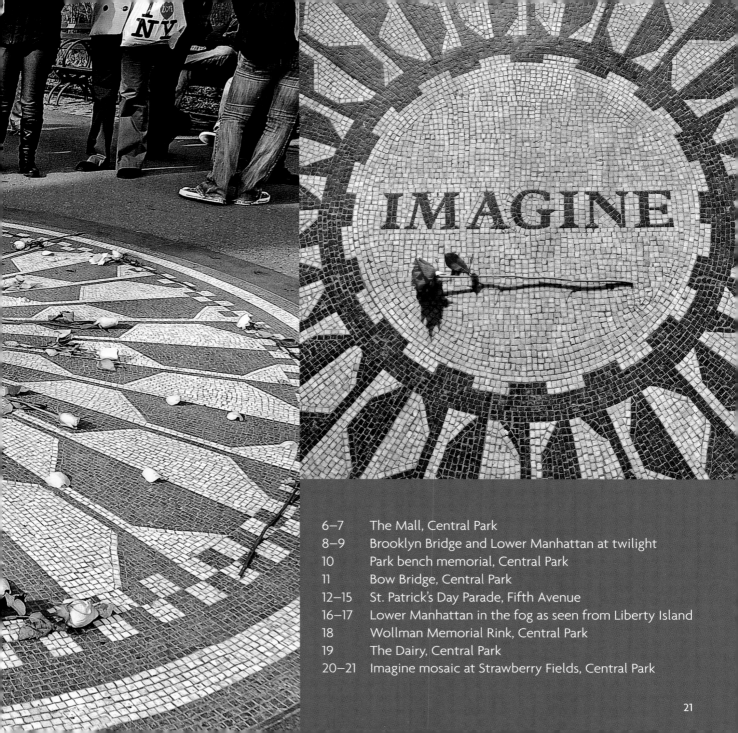

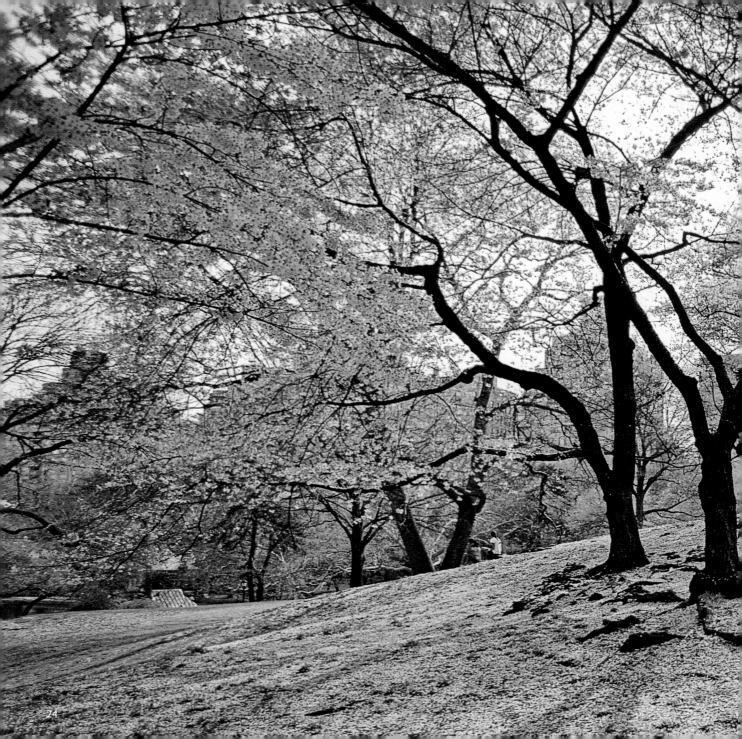

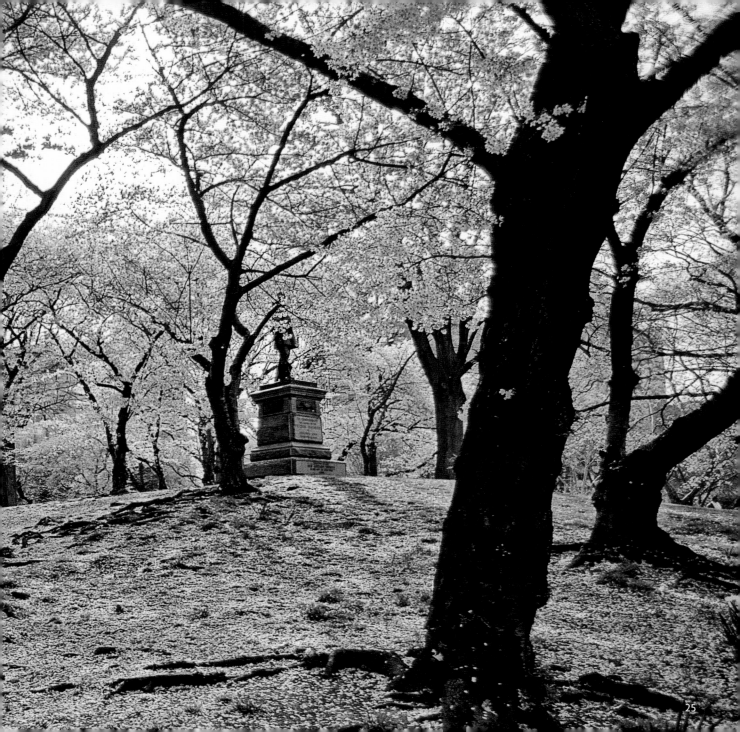

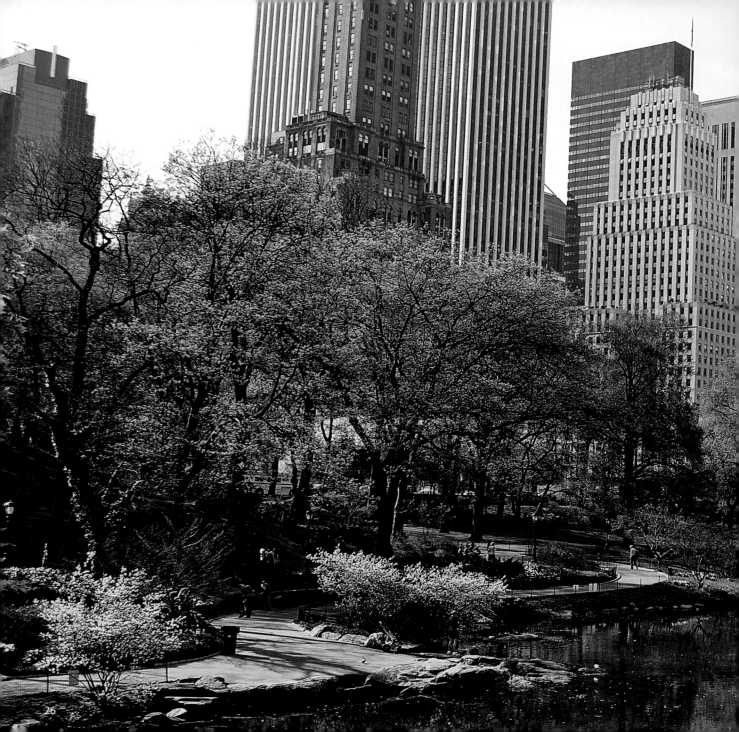

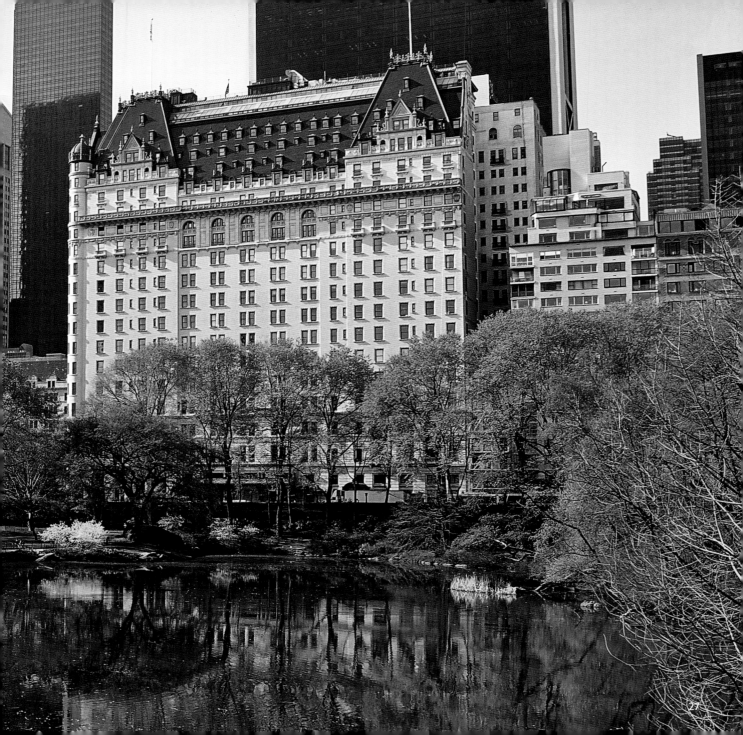

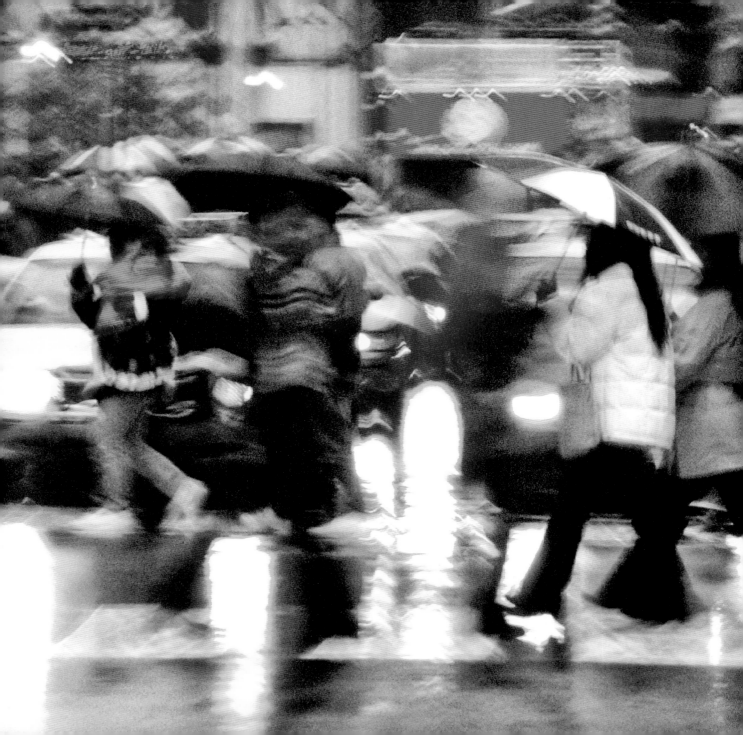

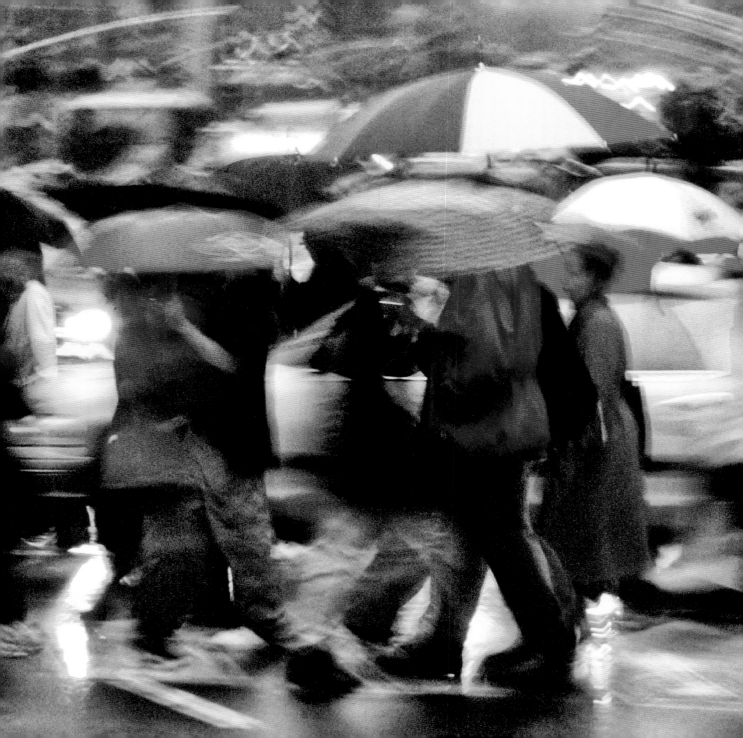

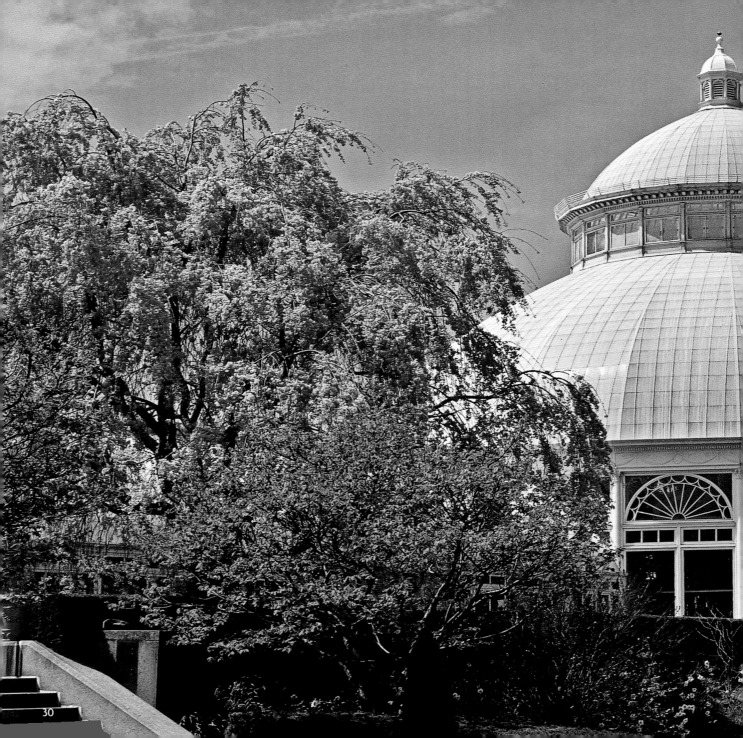

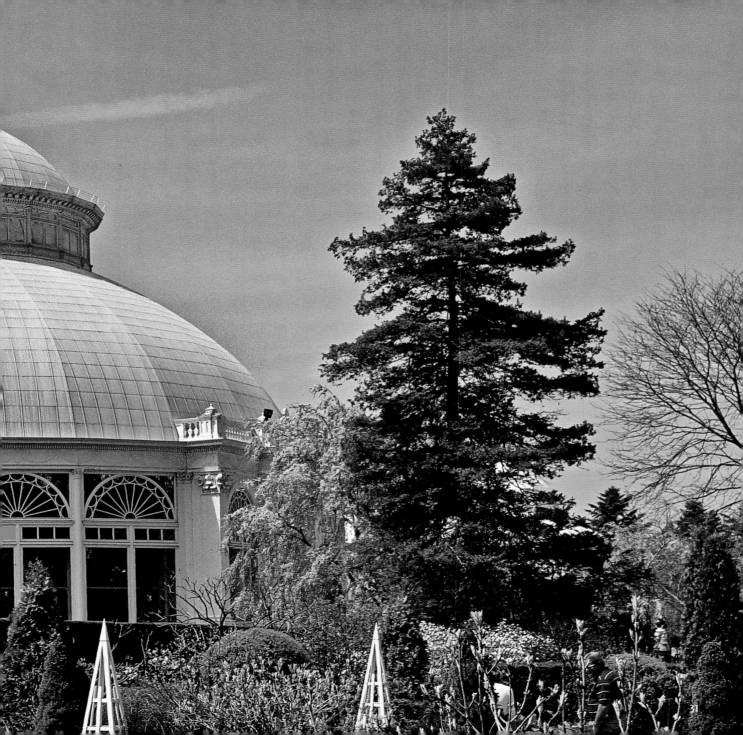

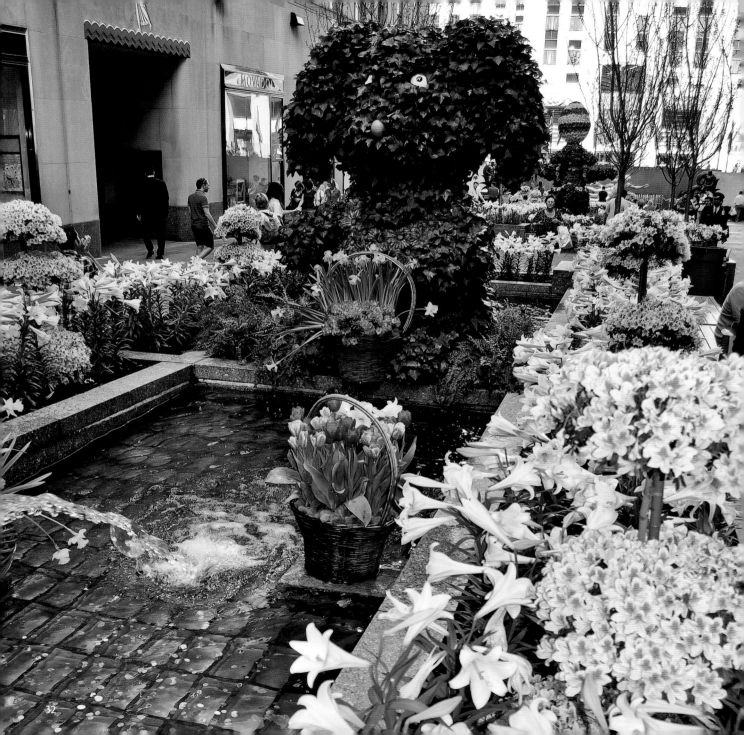

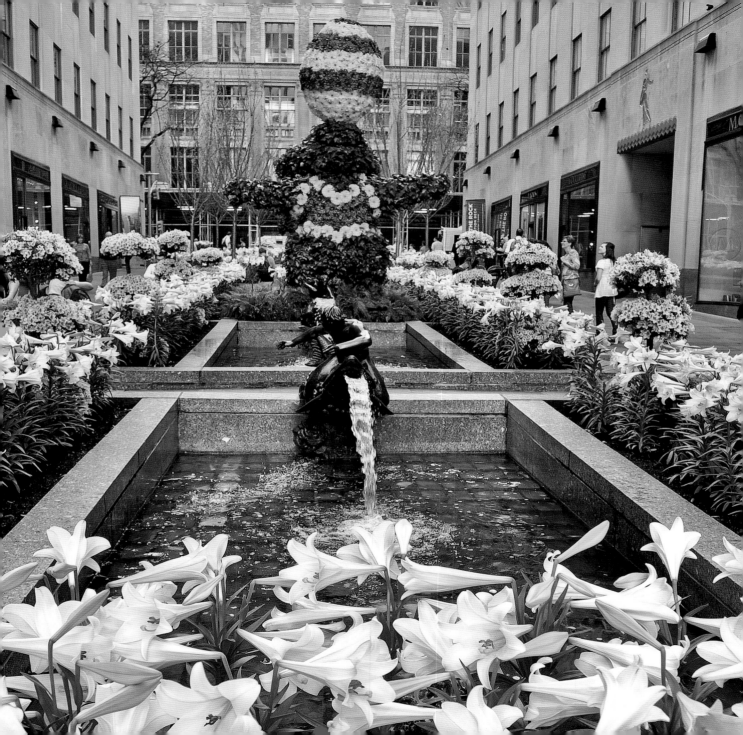

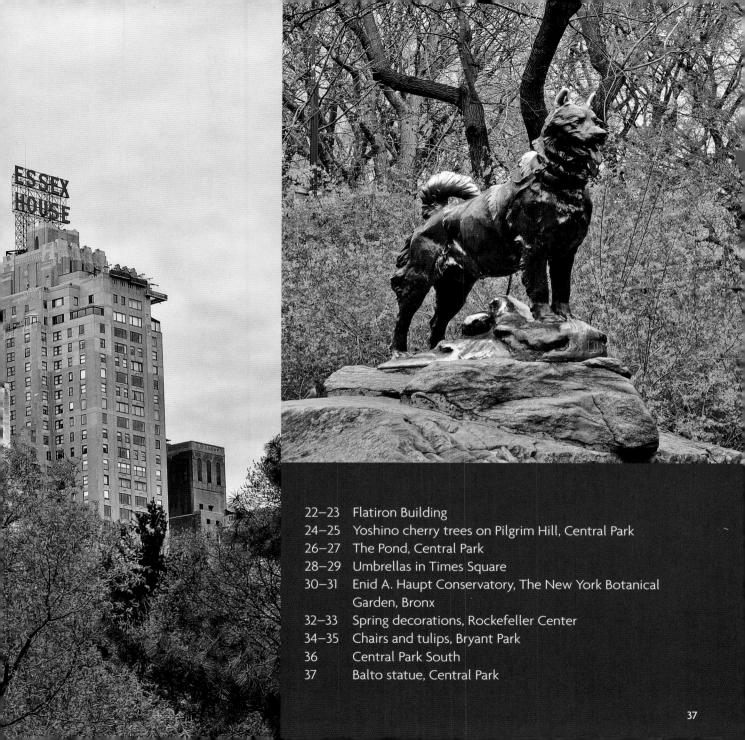

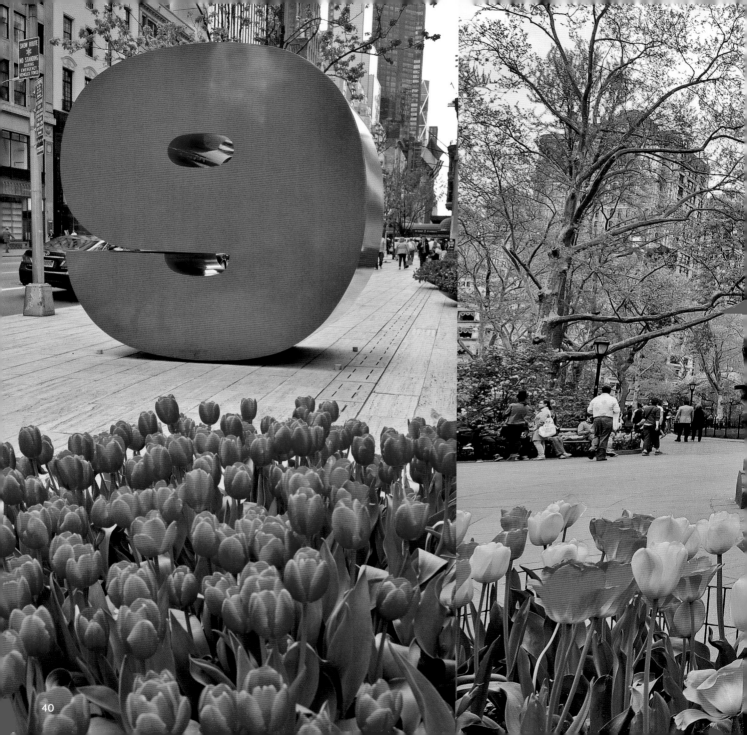

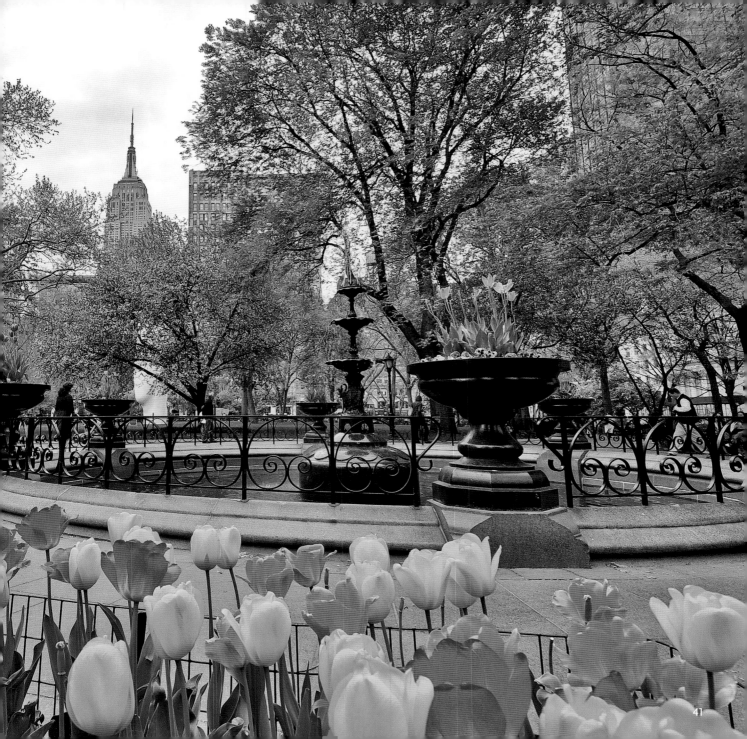

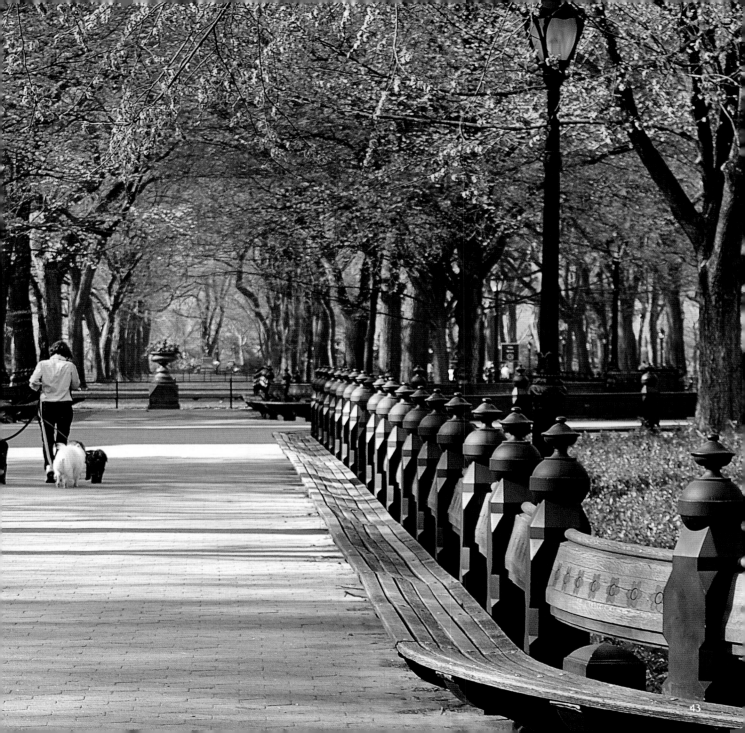

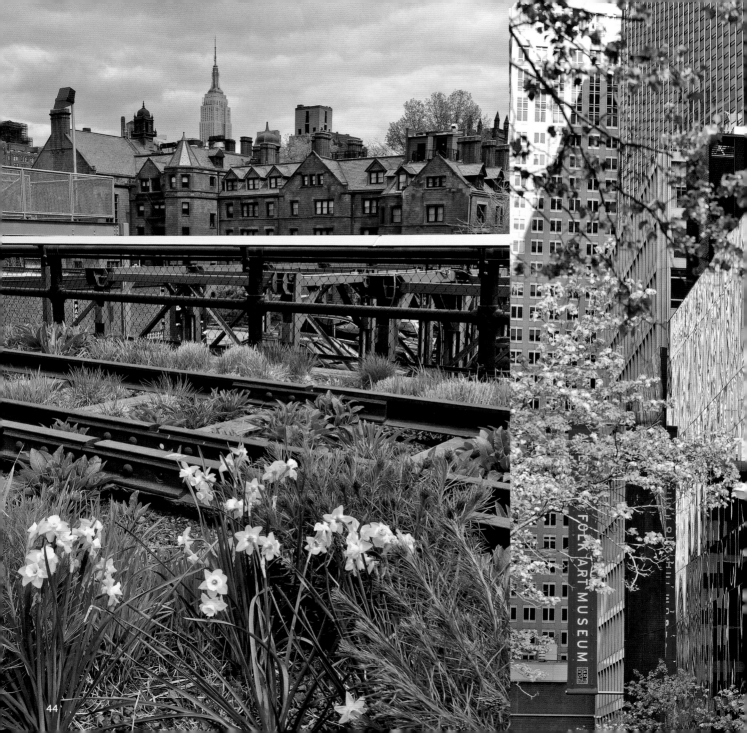

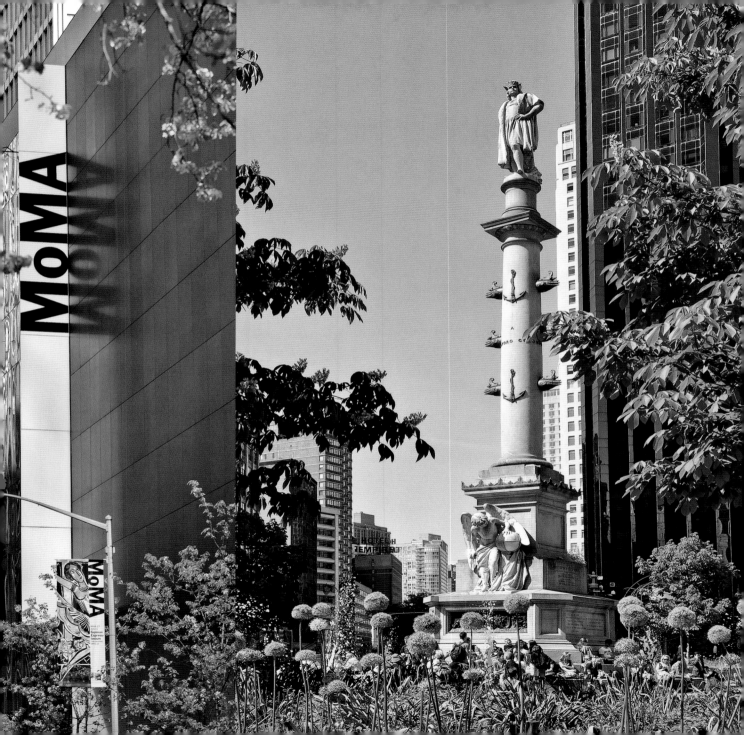

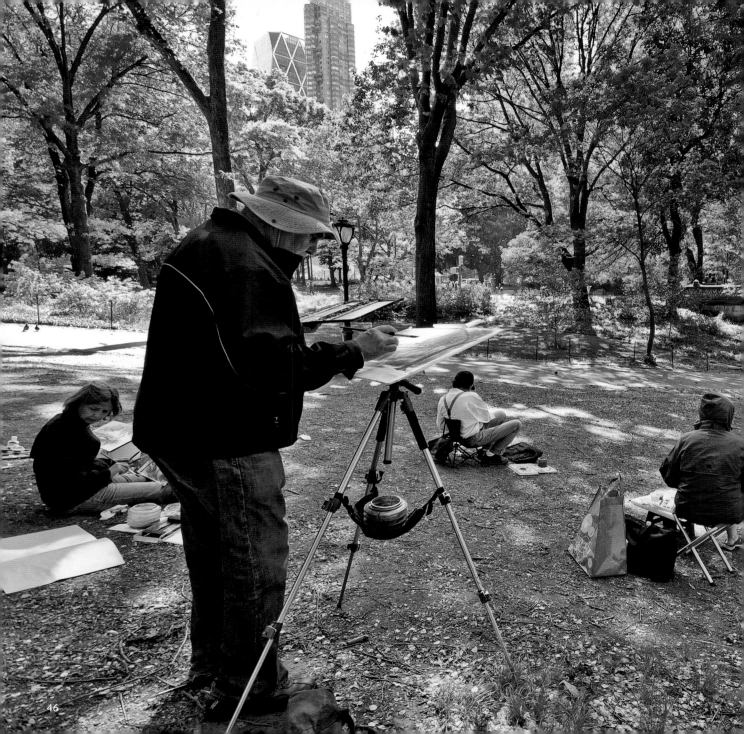

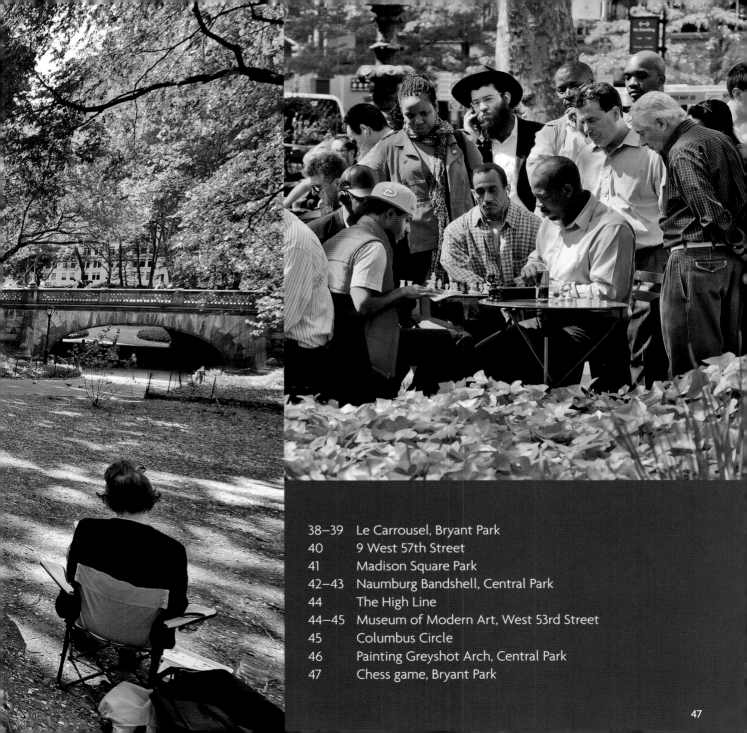

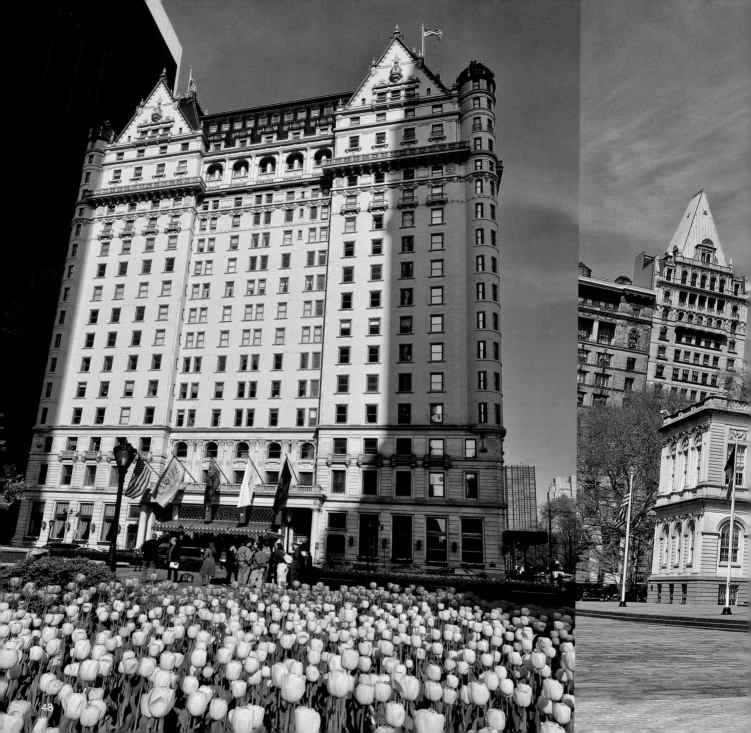

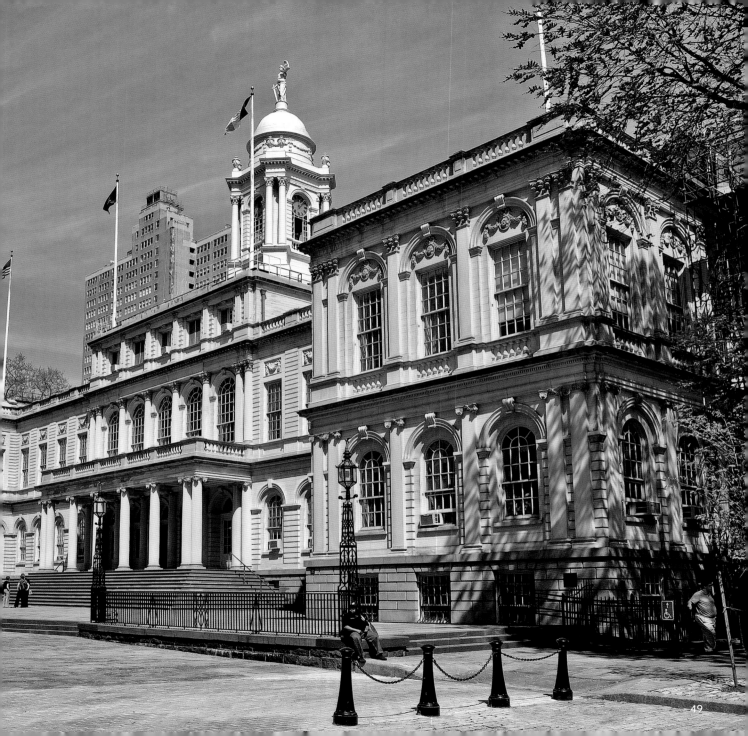

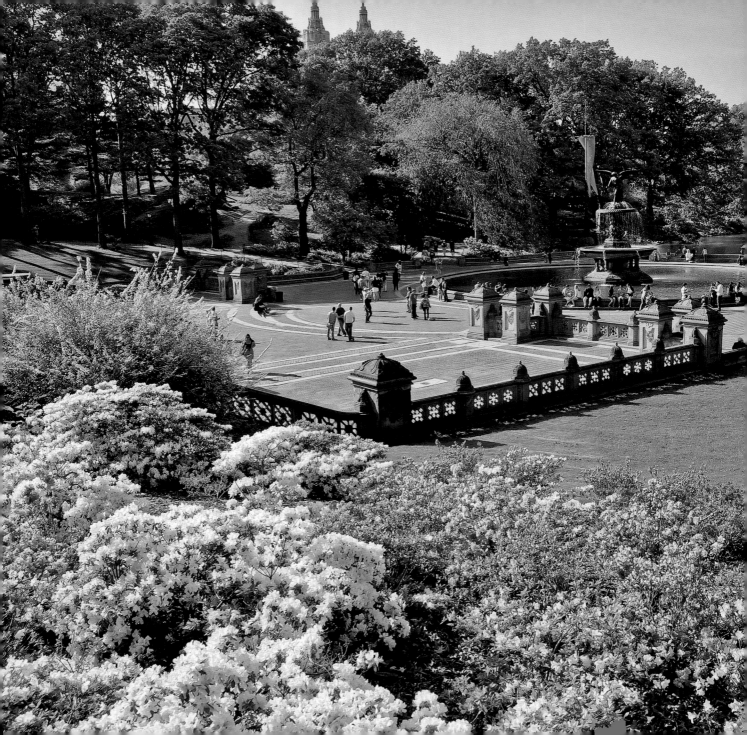

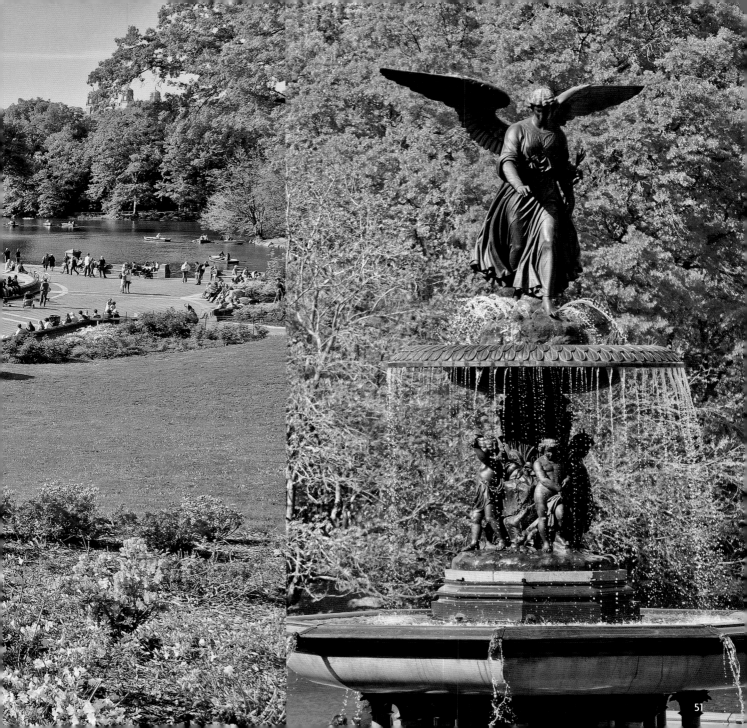

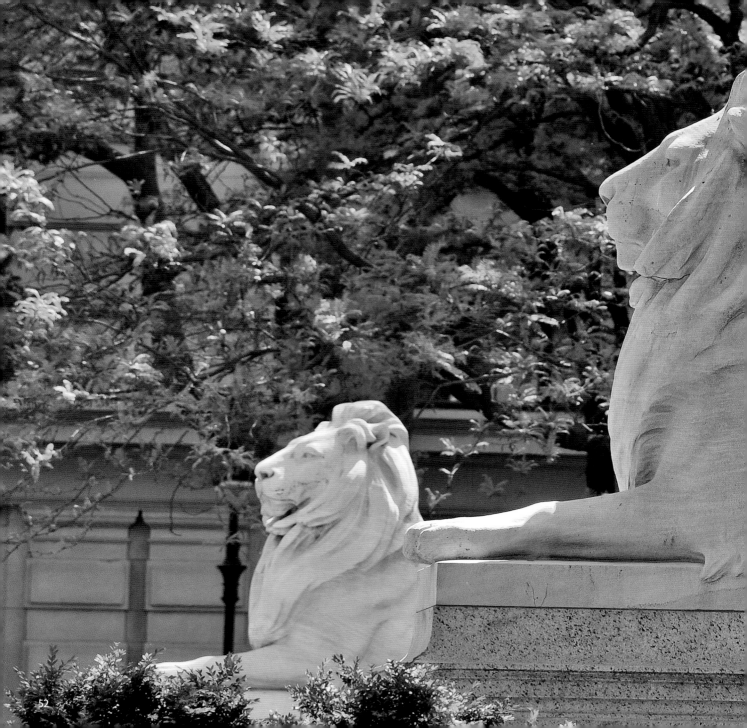

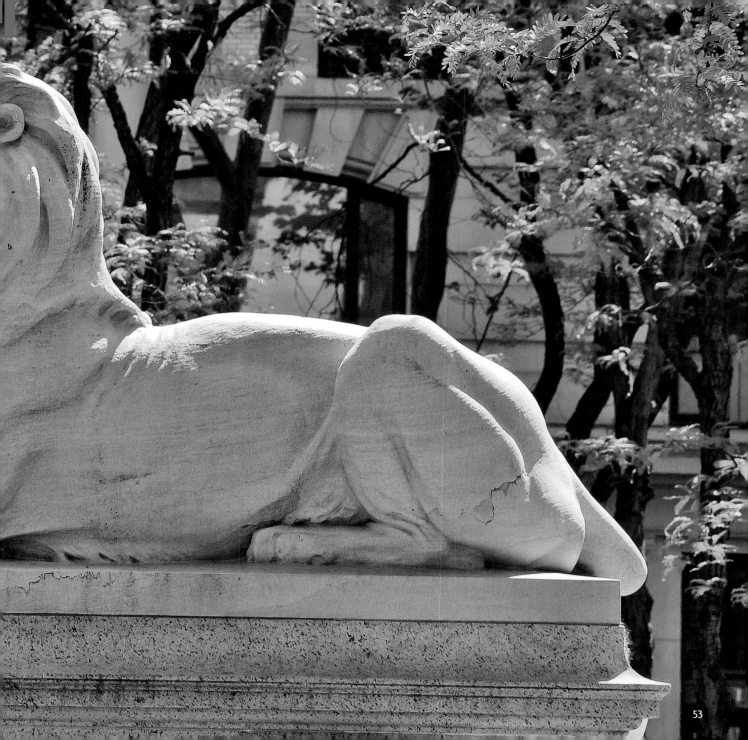

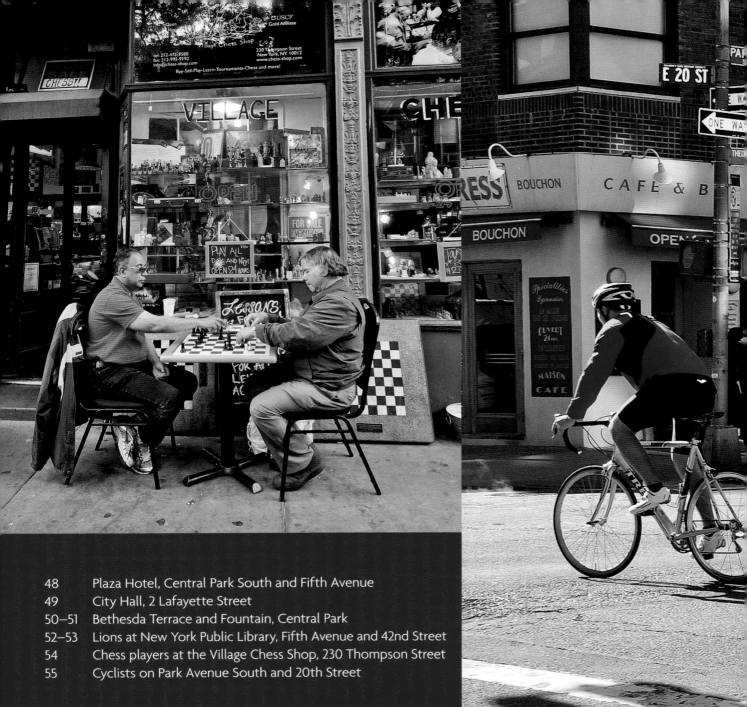

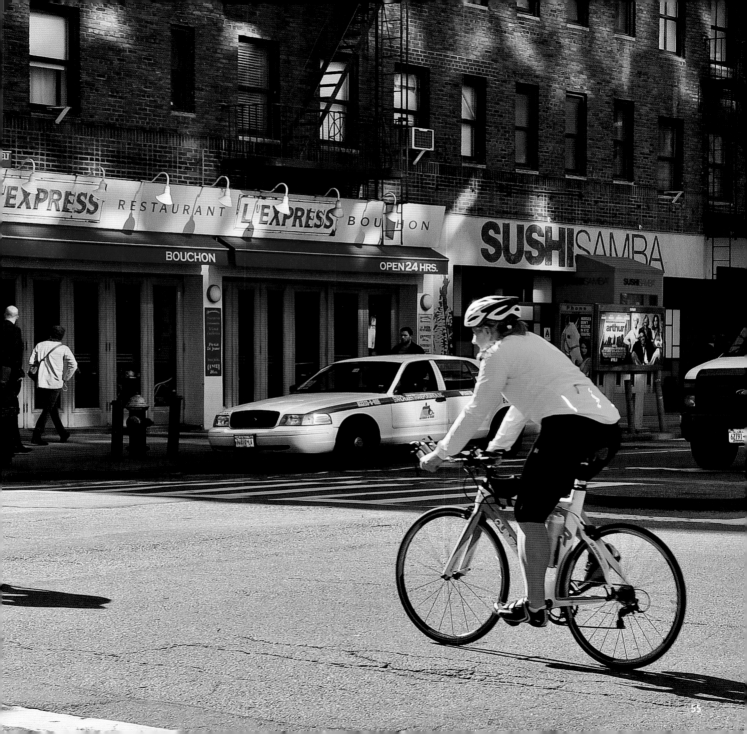

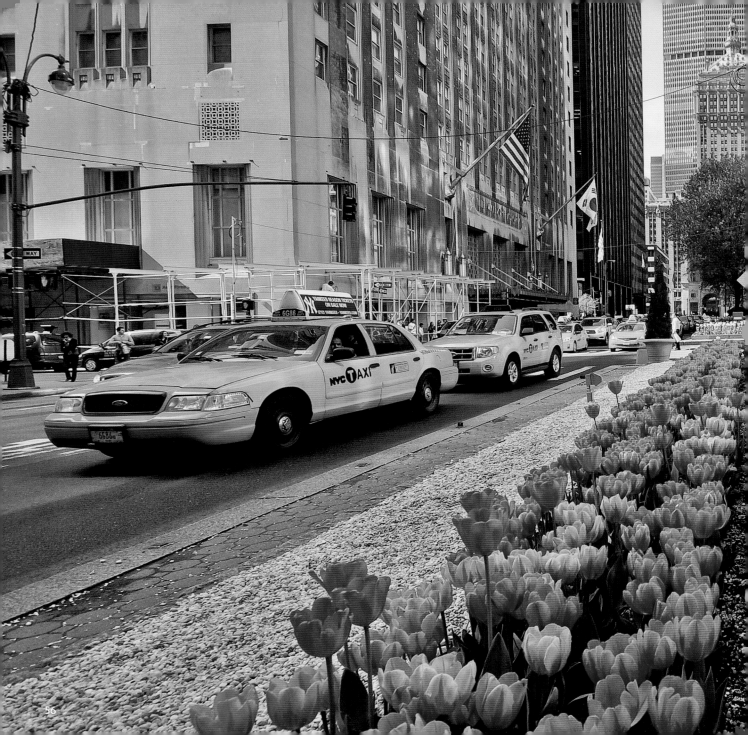

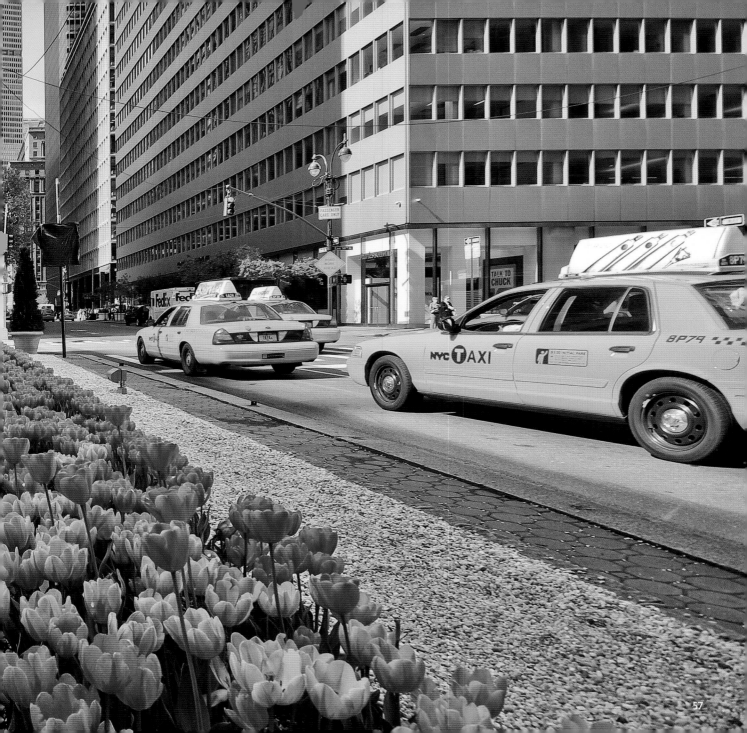

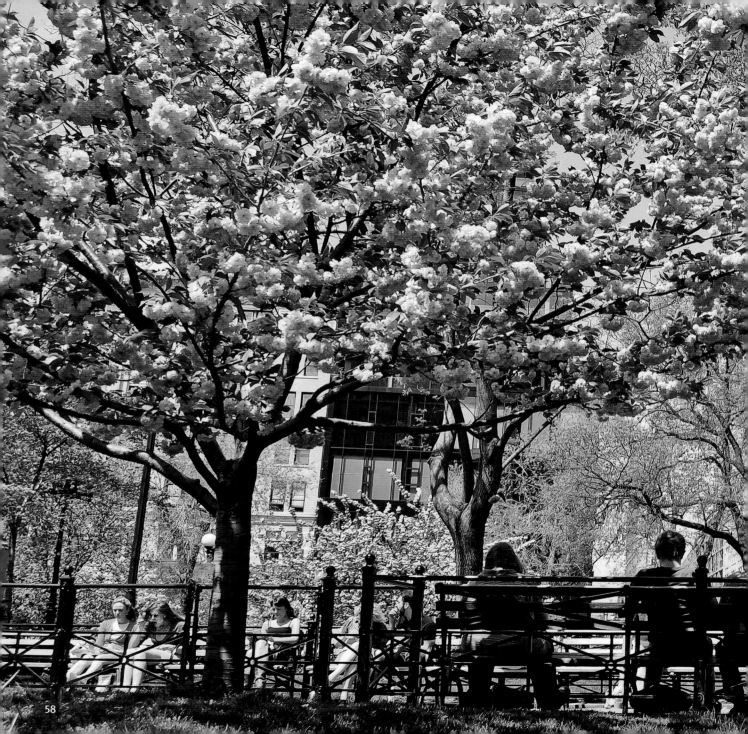

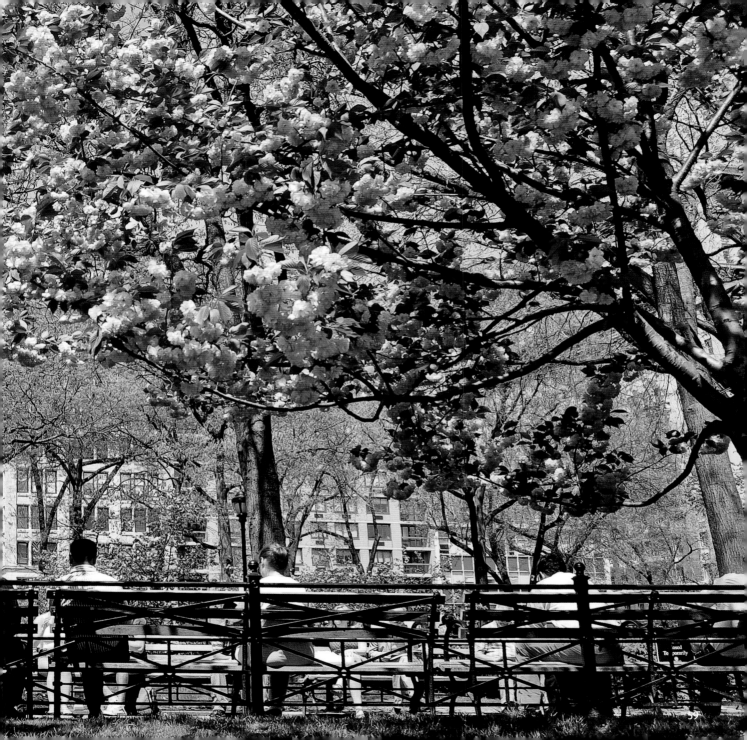

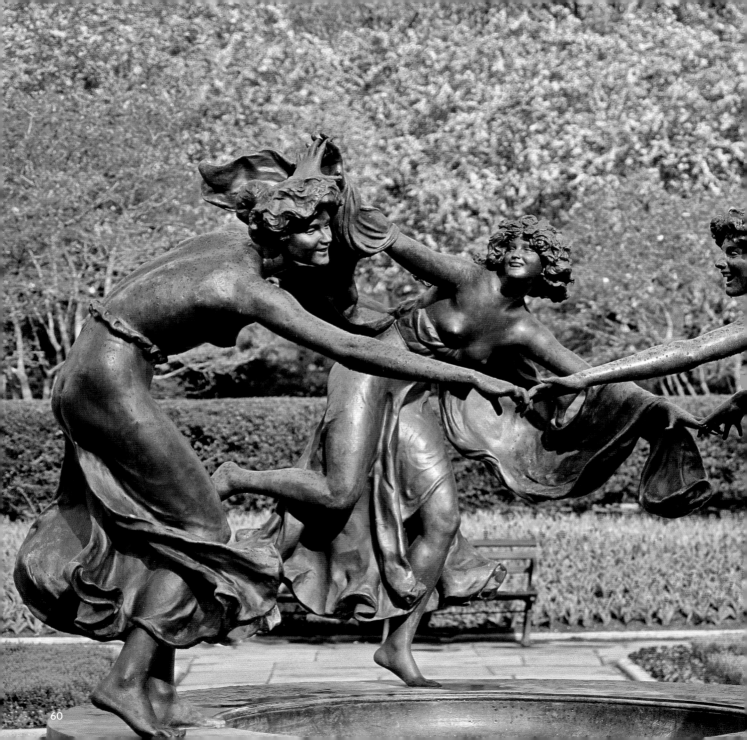

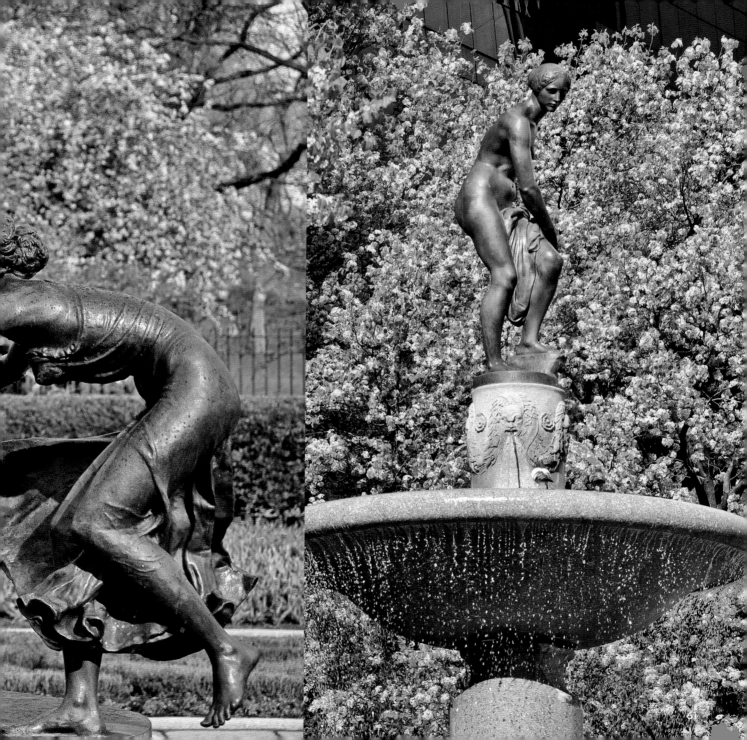

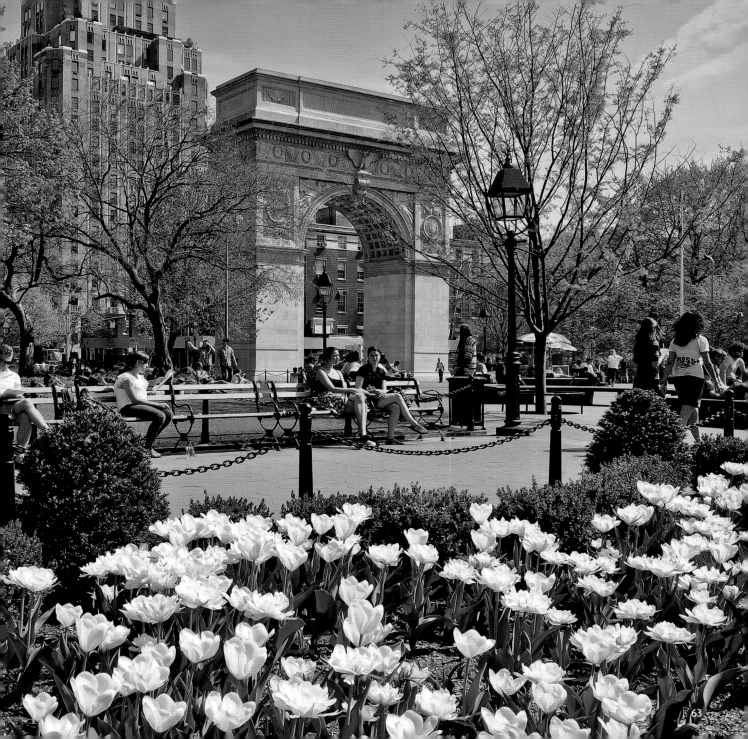

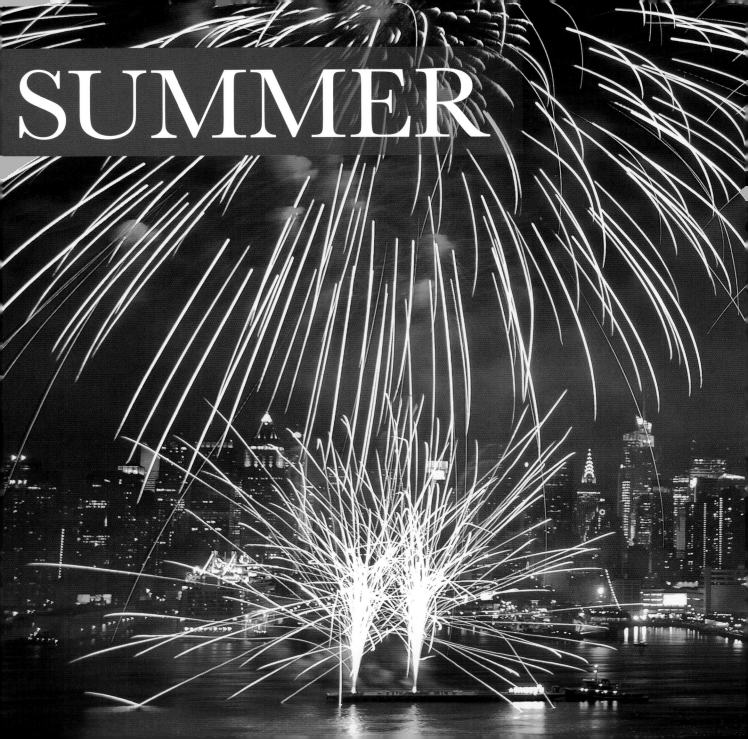

SUMMER

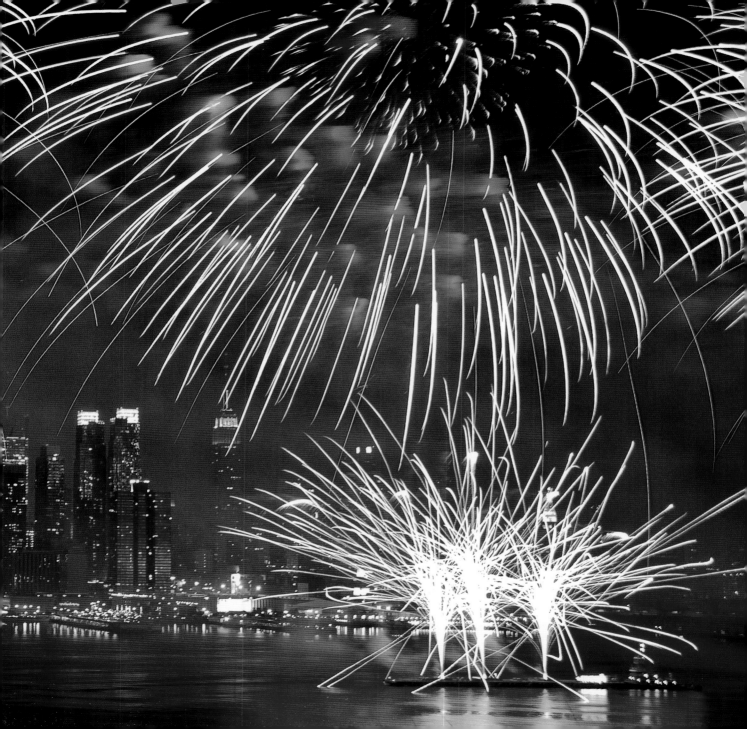

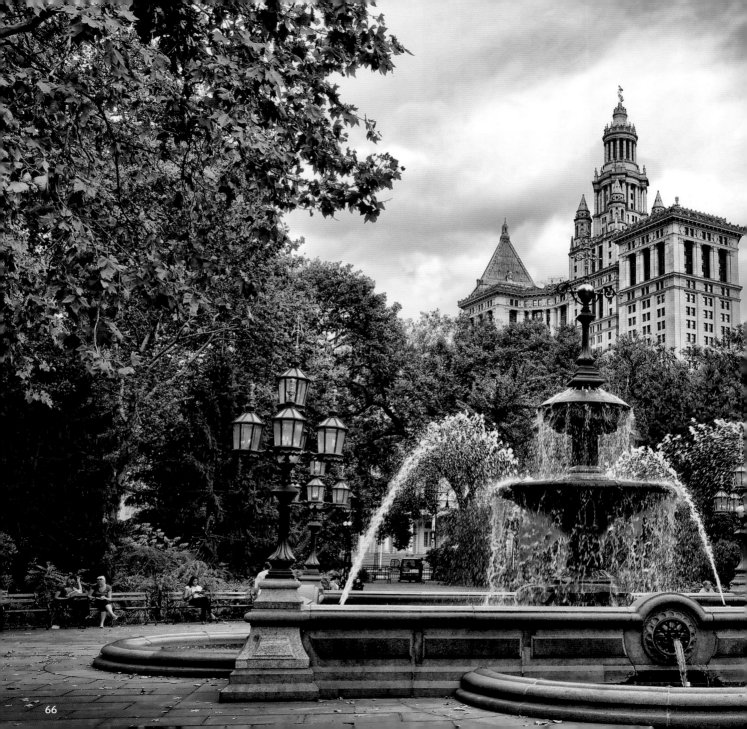

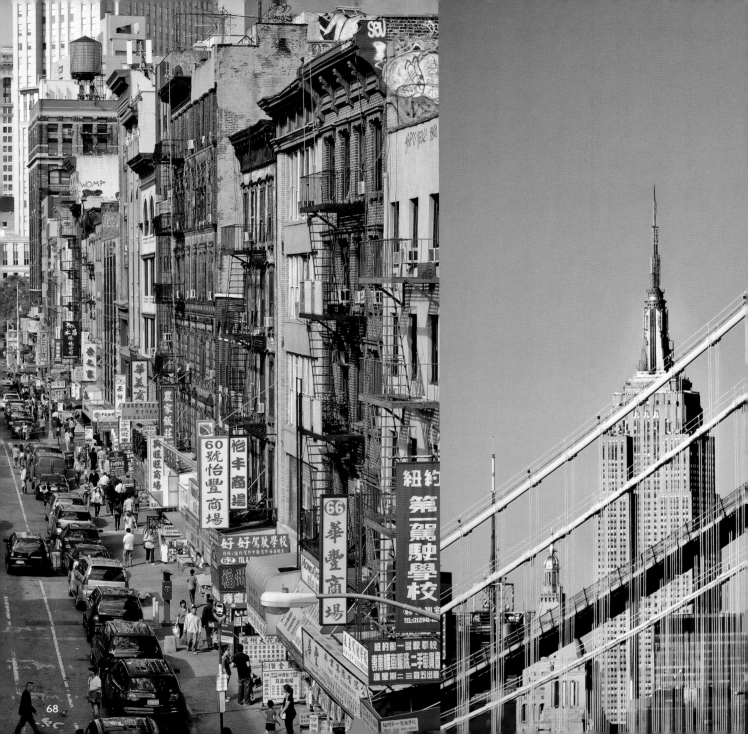

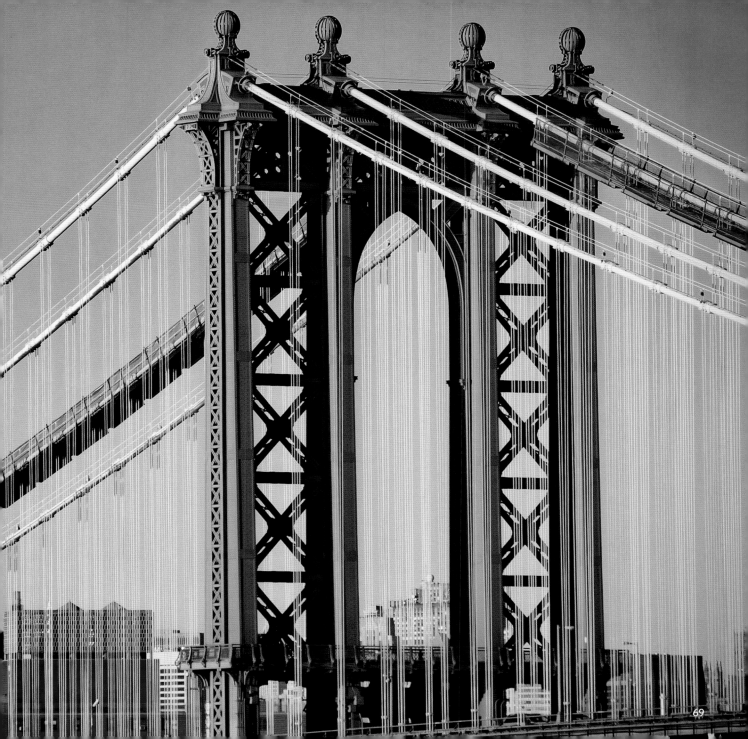

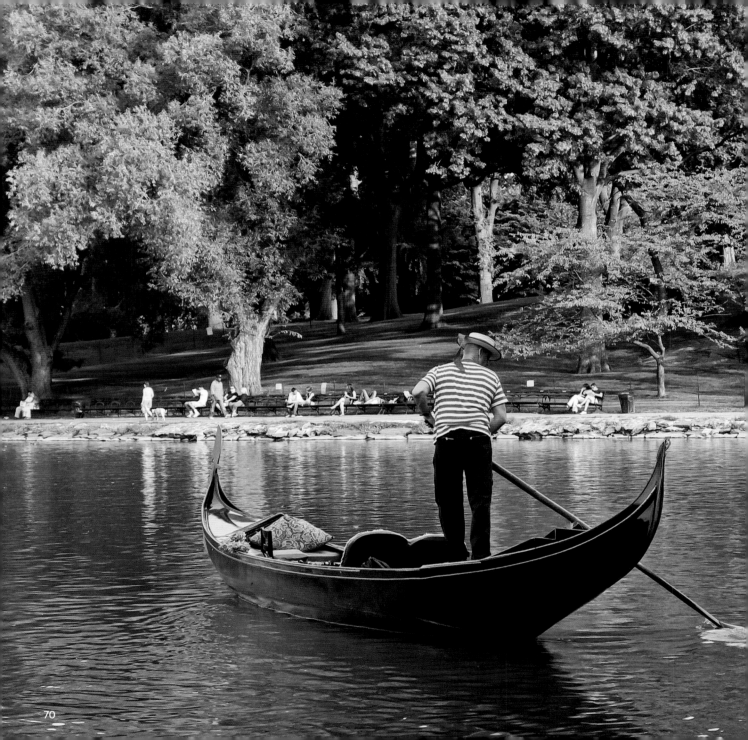

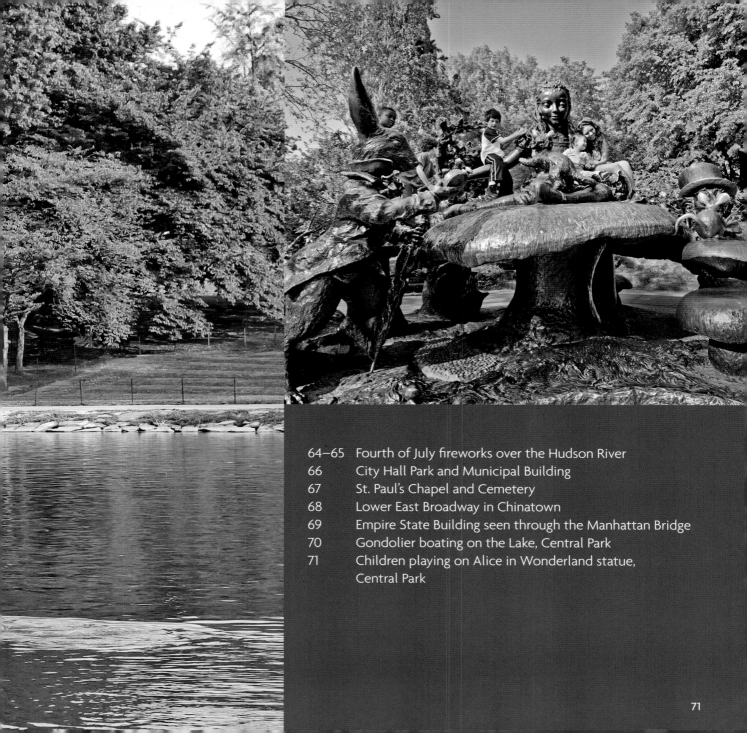

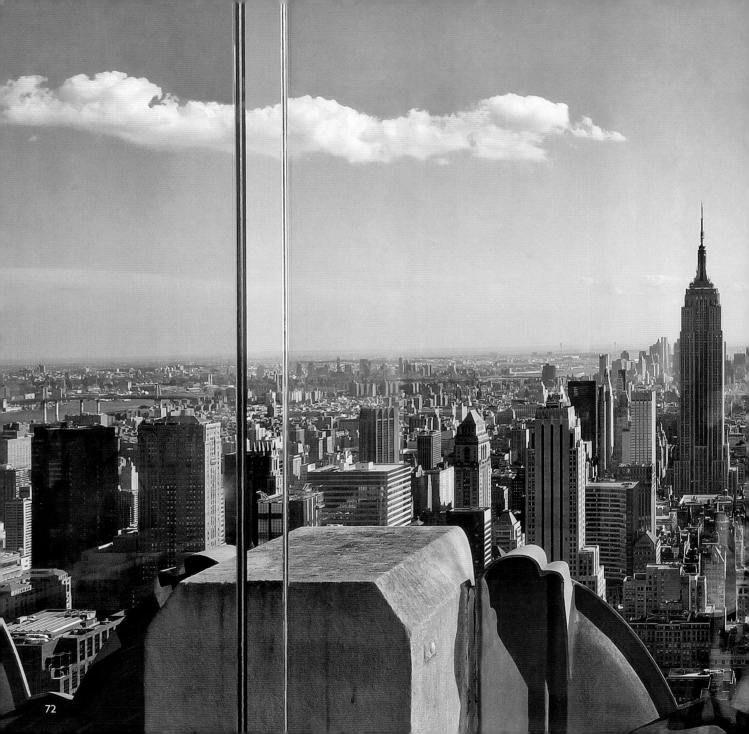

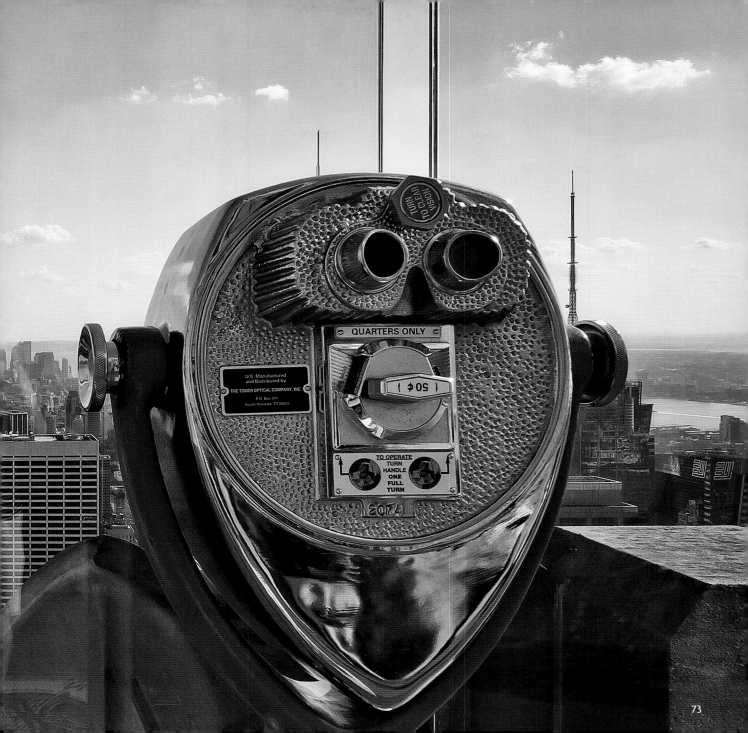

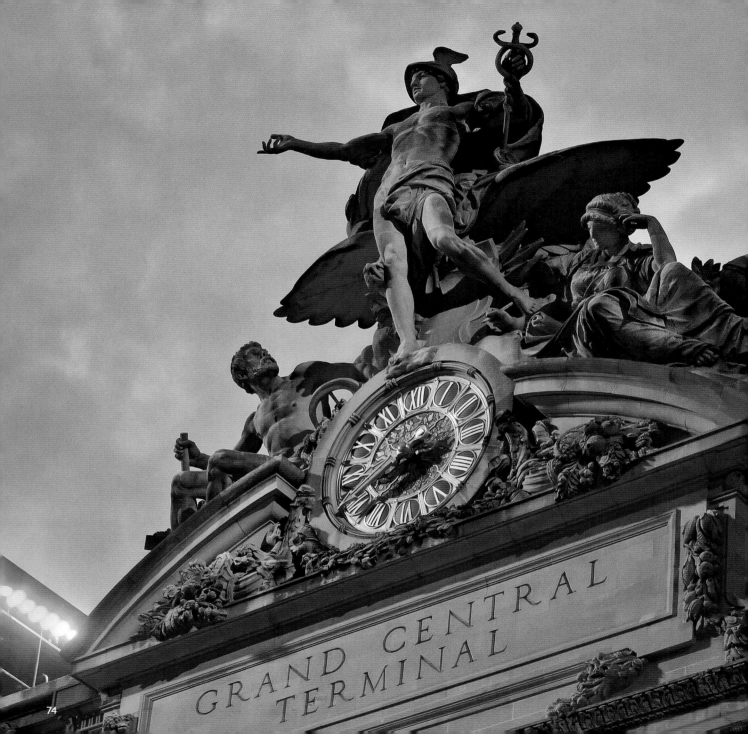

GRAND CENTRAL
TERMINAL

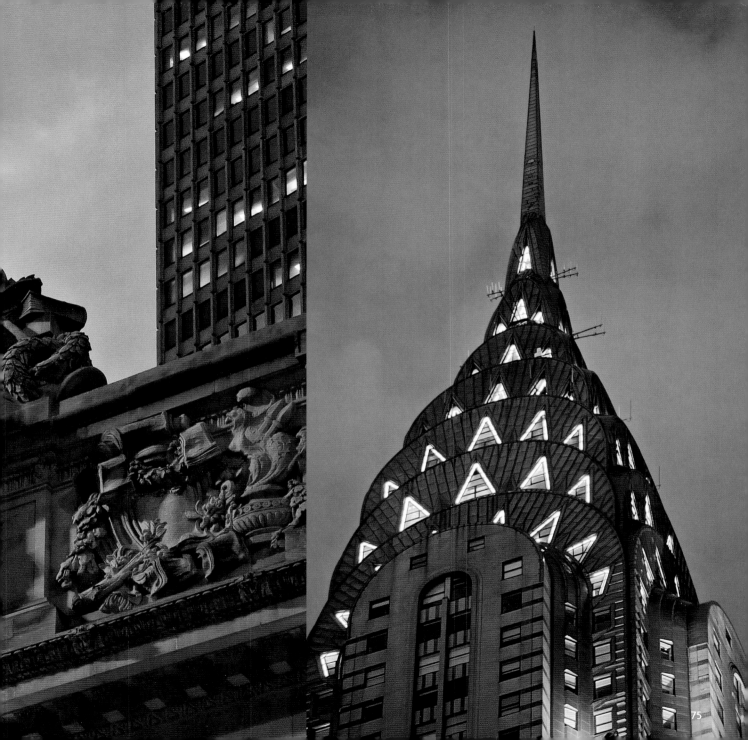

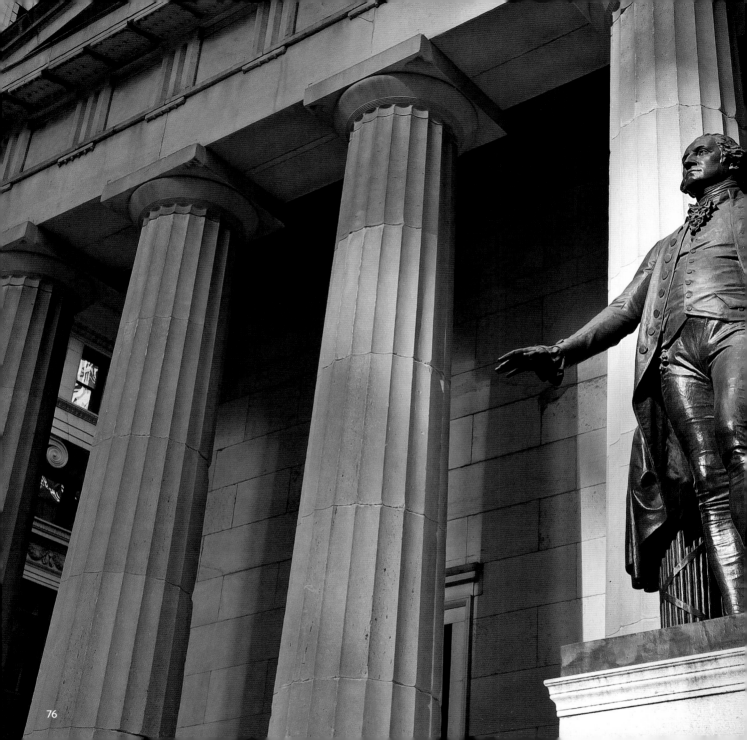

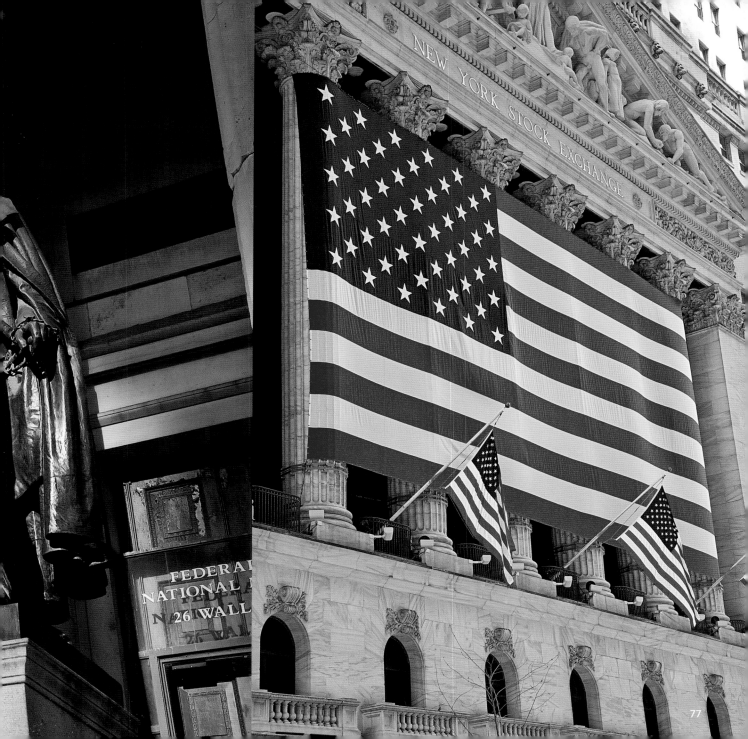

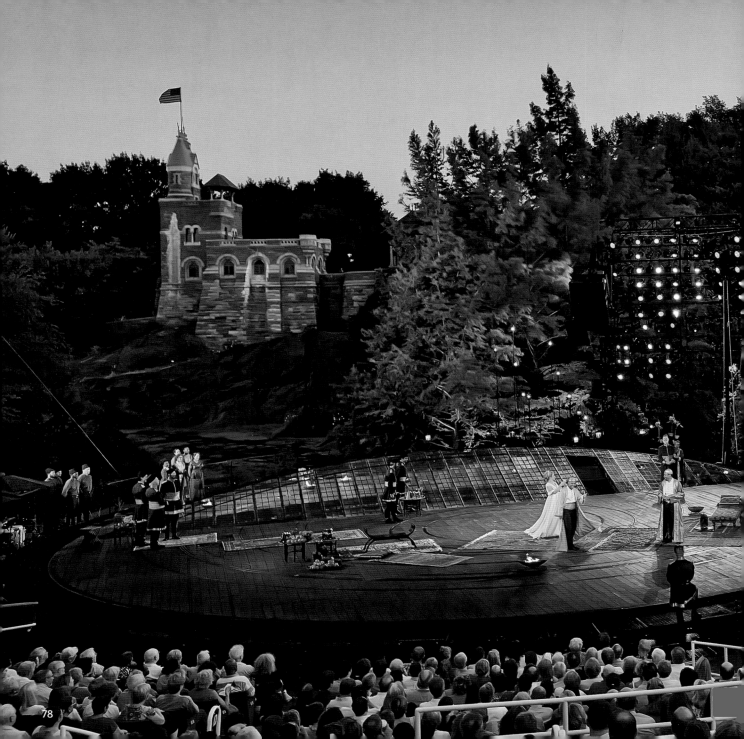

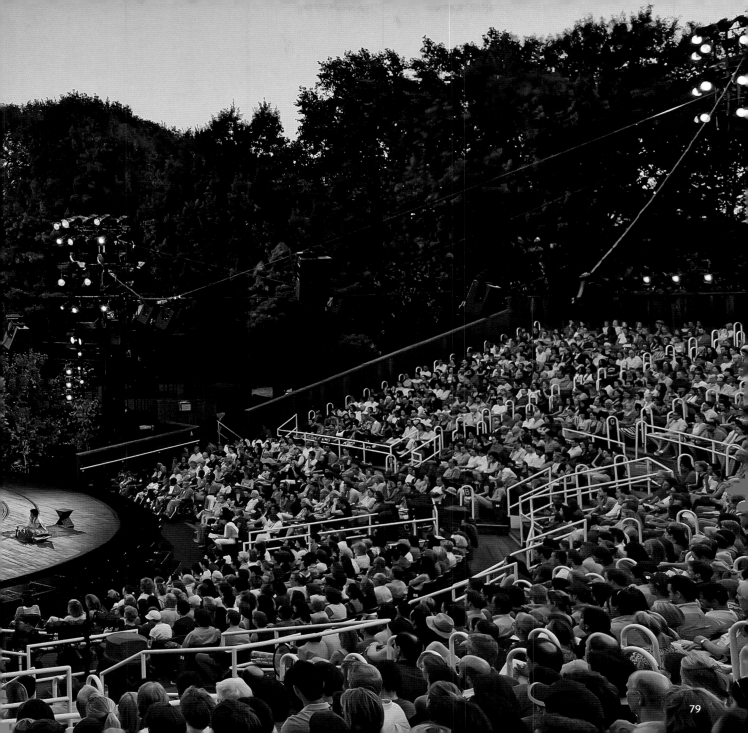

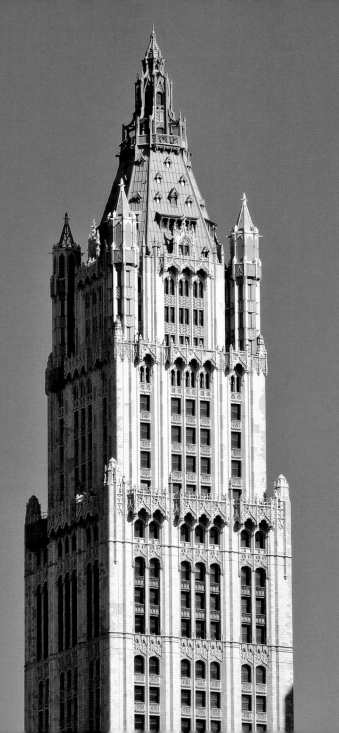

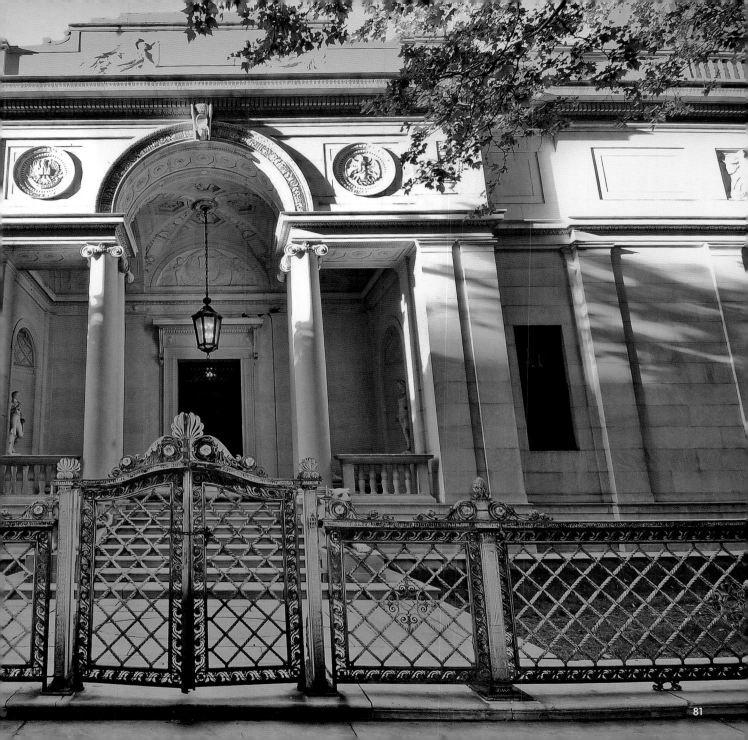

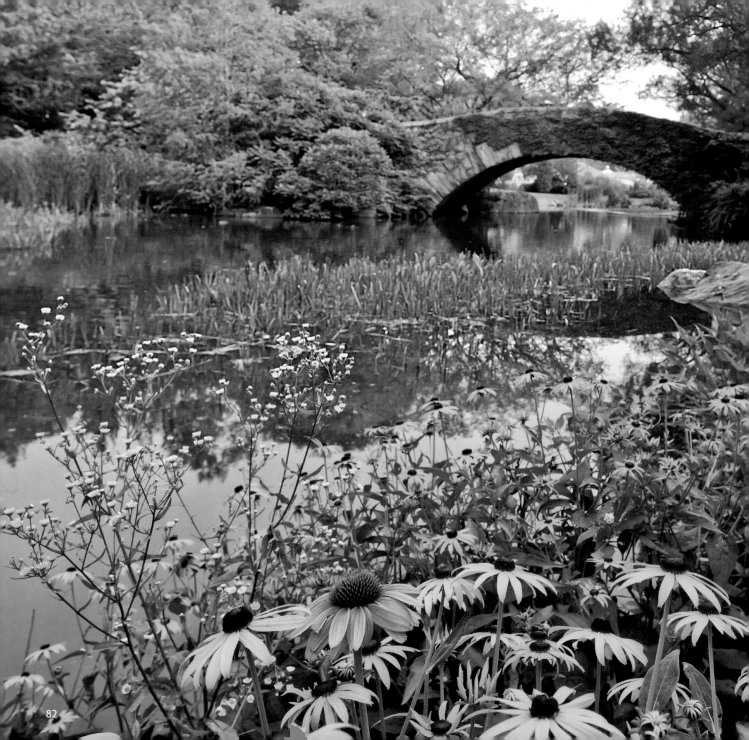

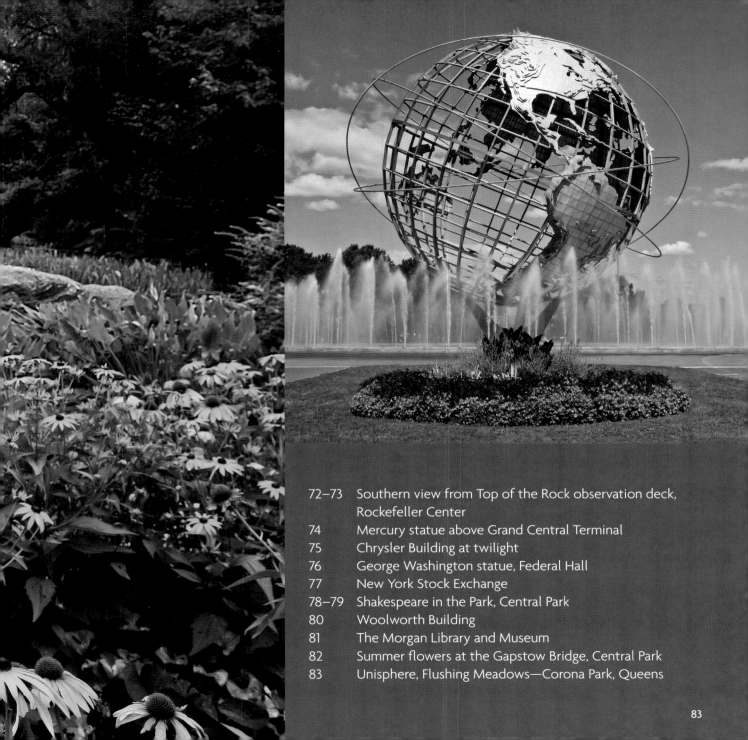

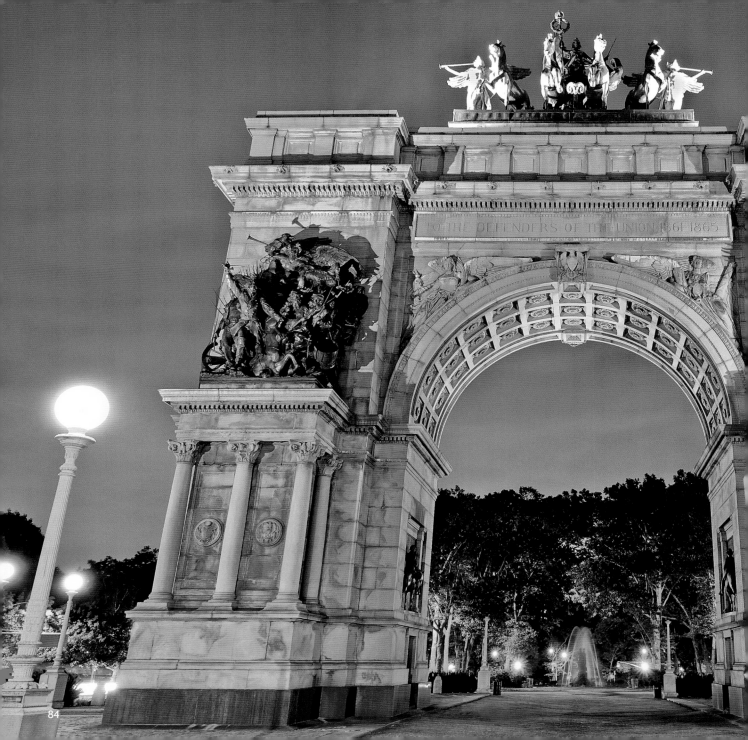

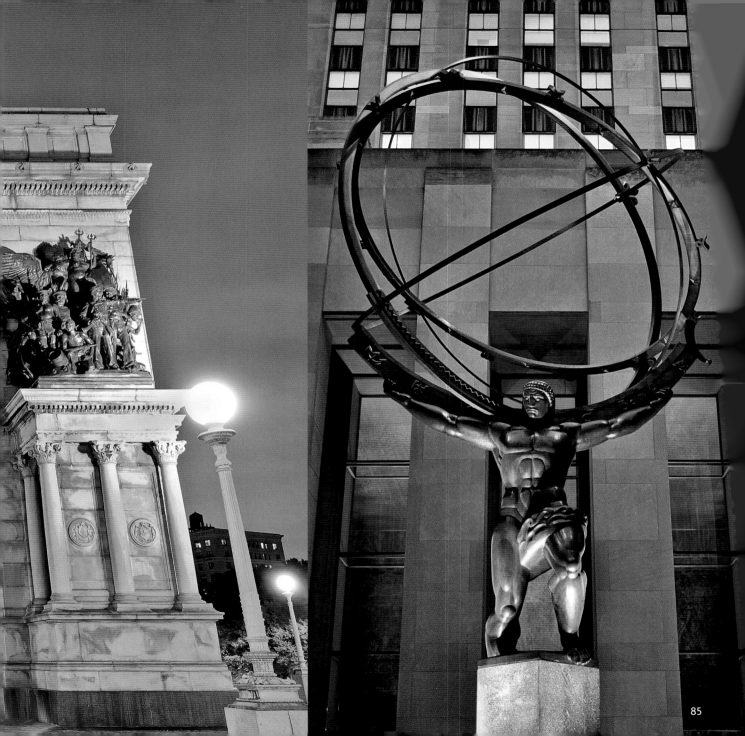

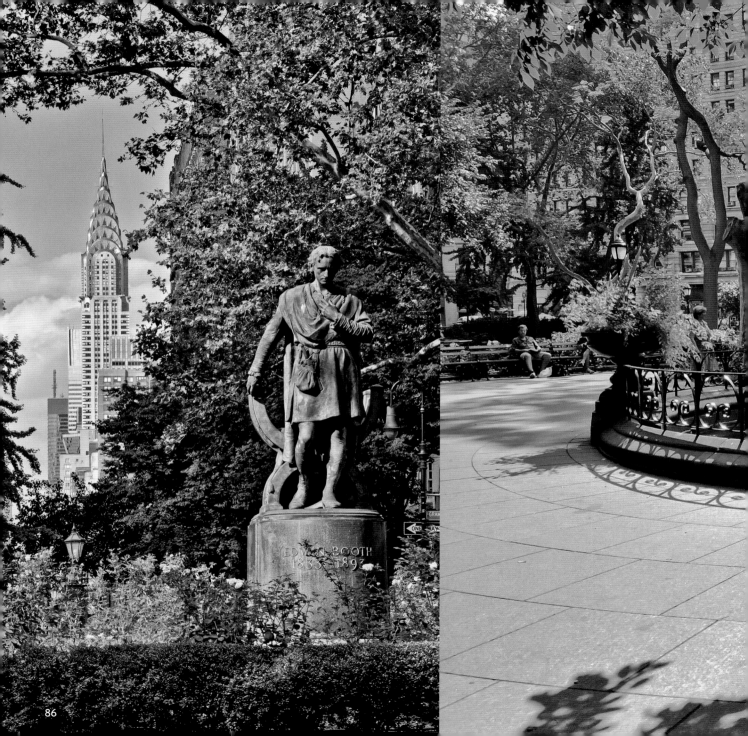

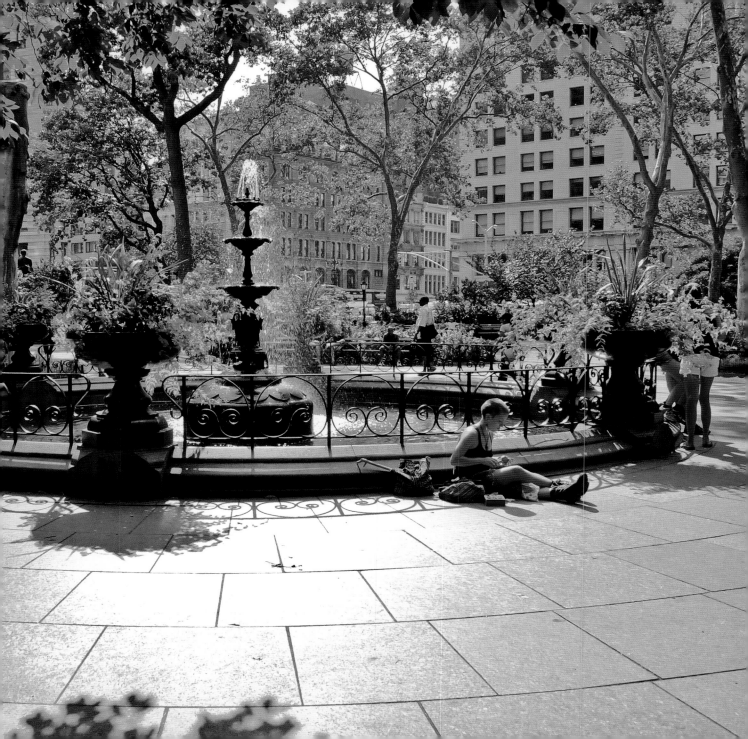

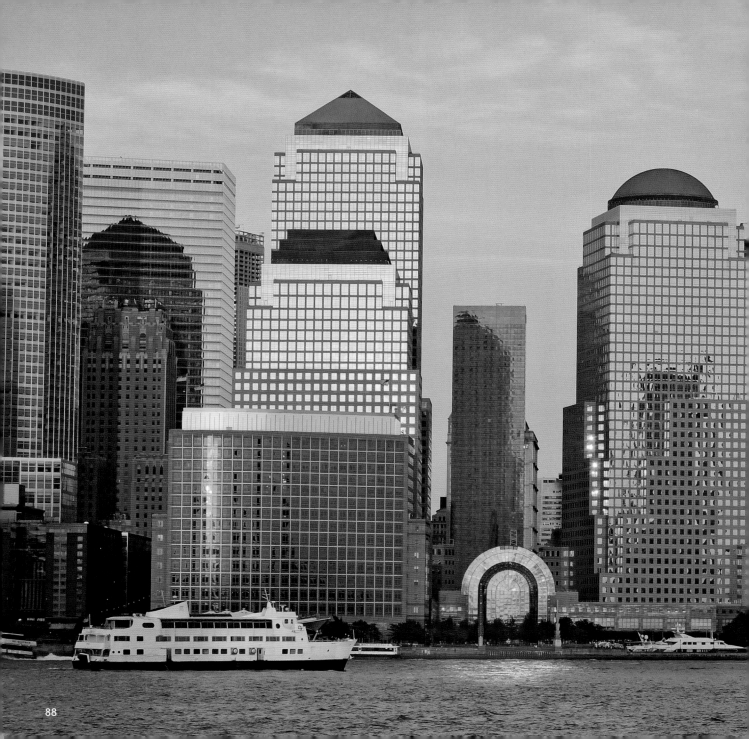

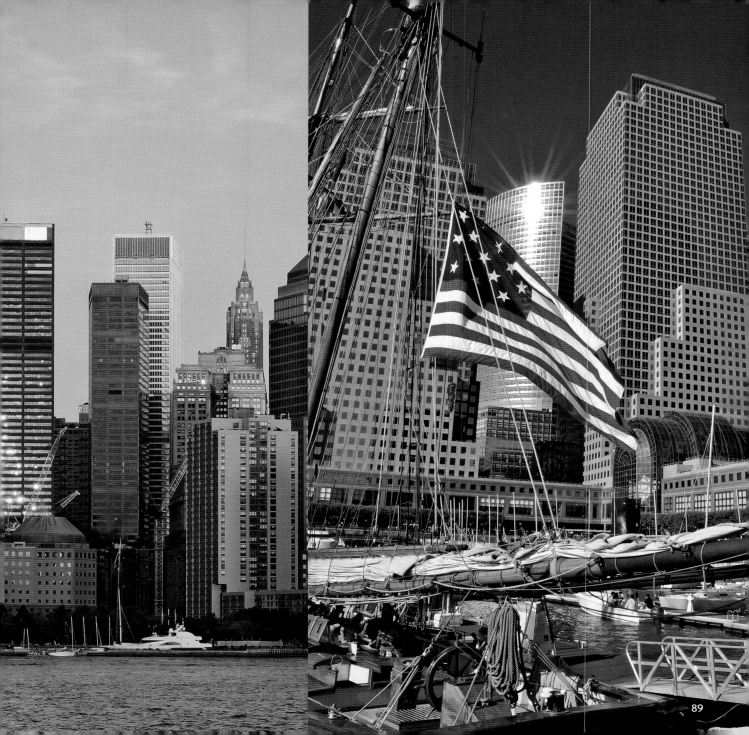

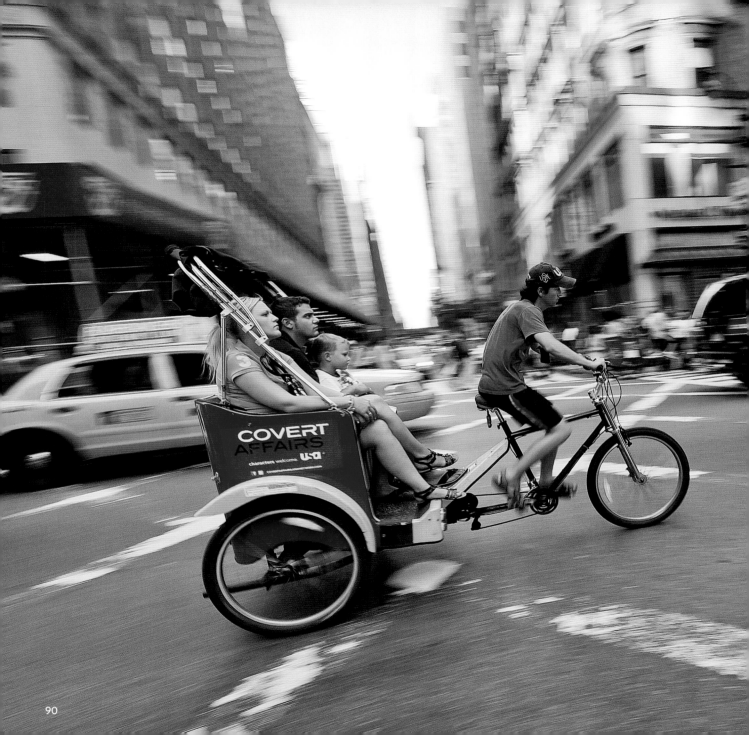

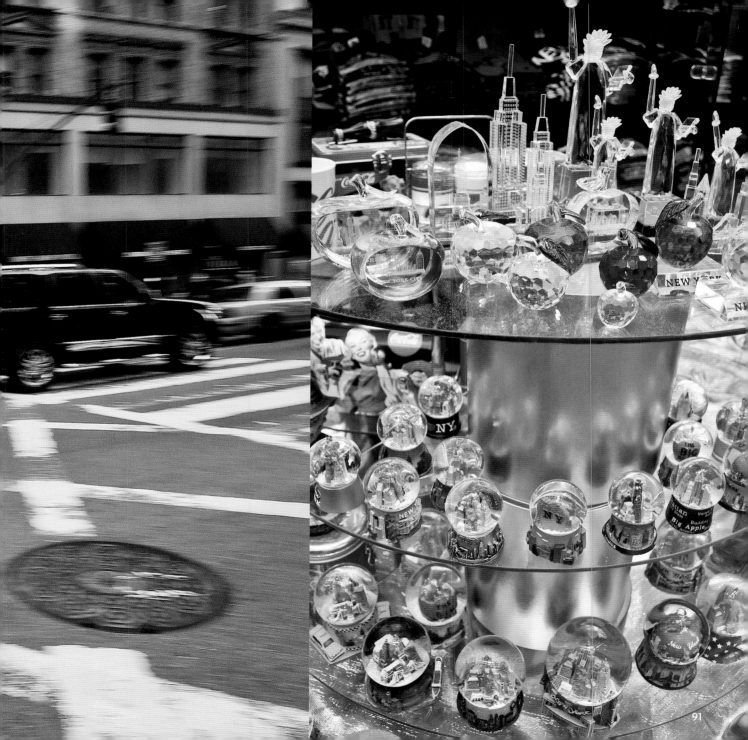

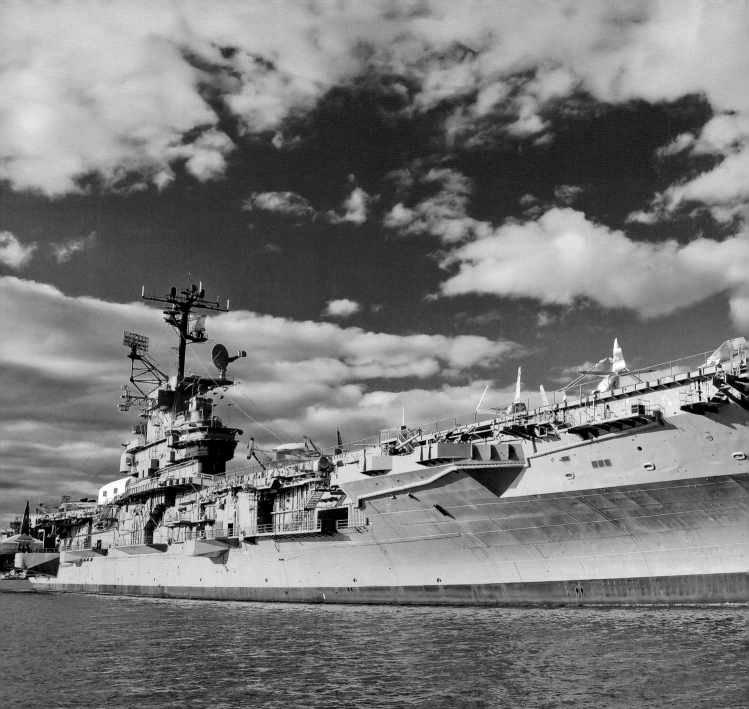

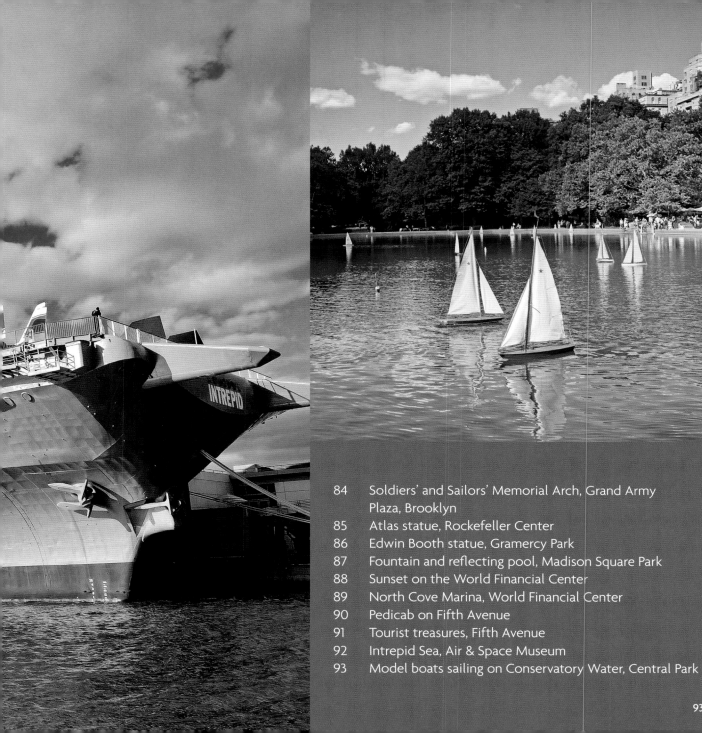

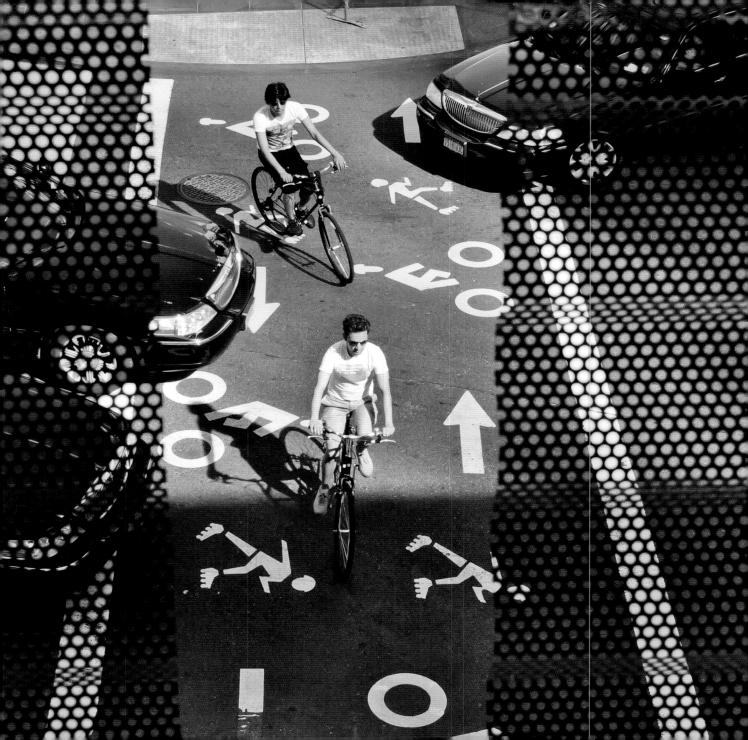

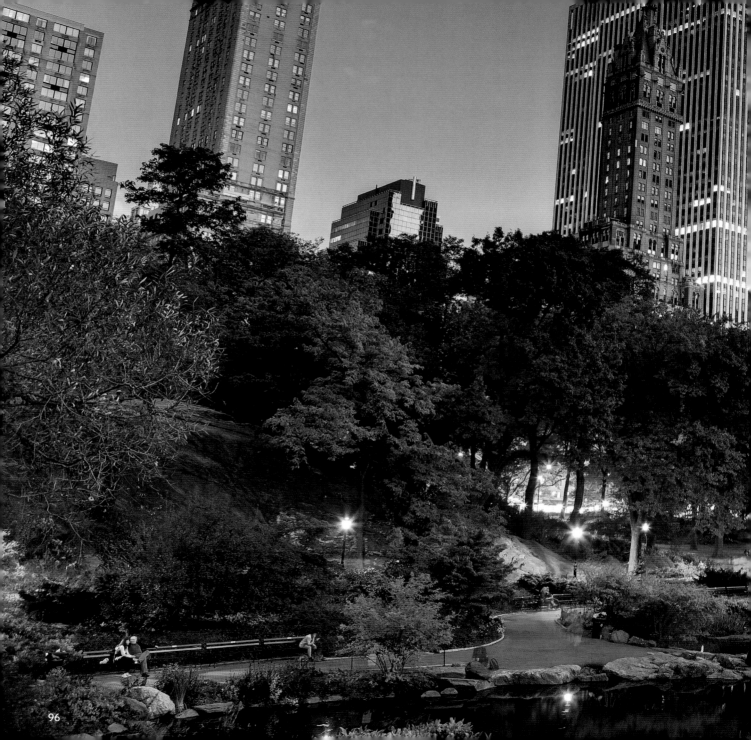

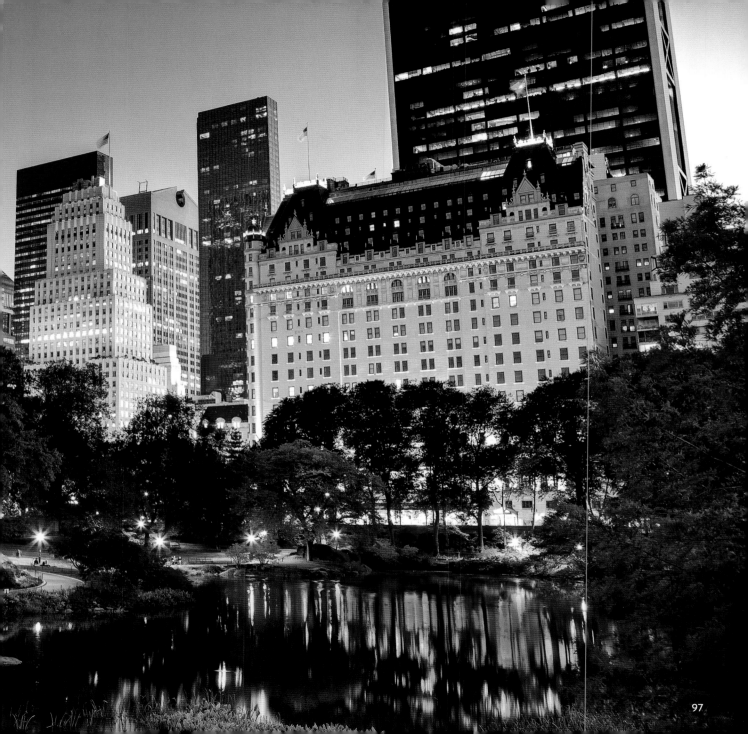

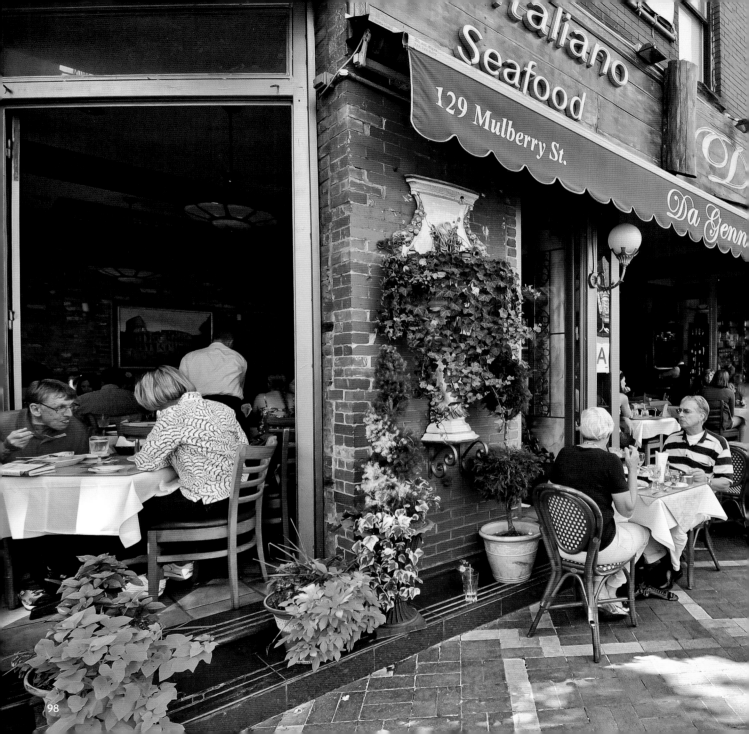

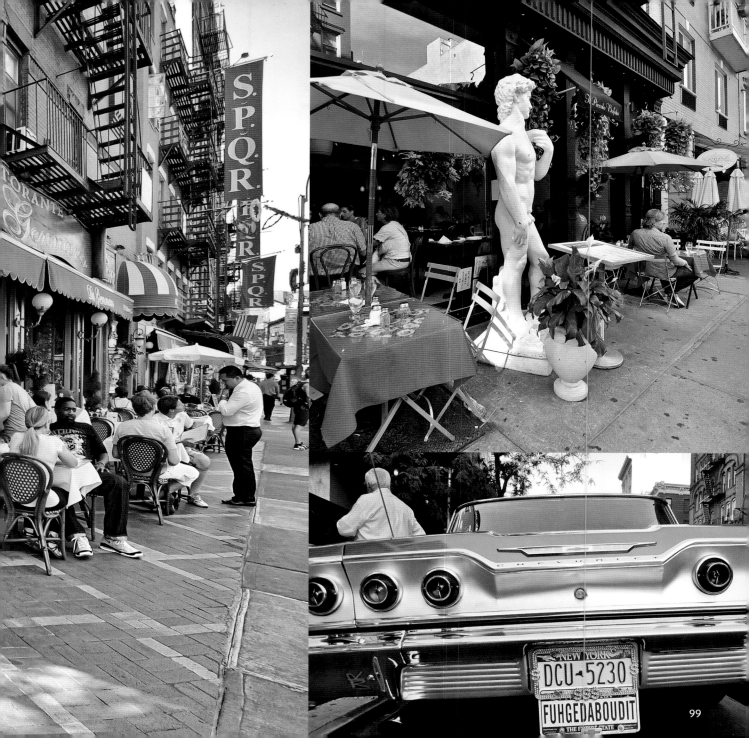

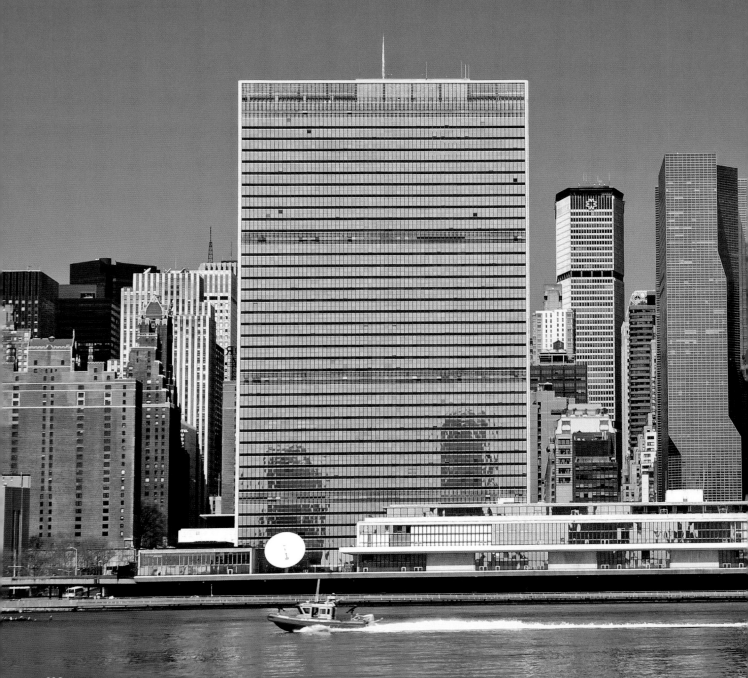

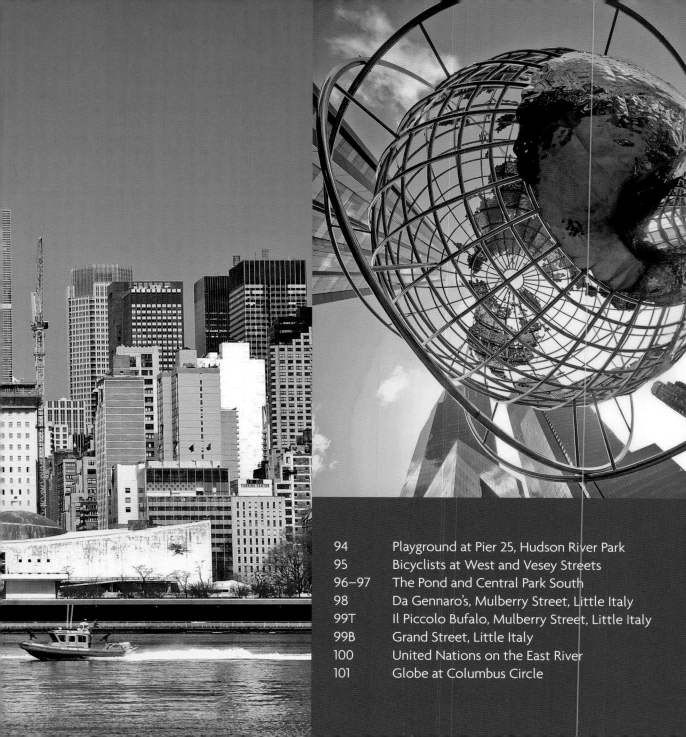

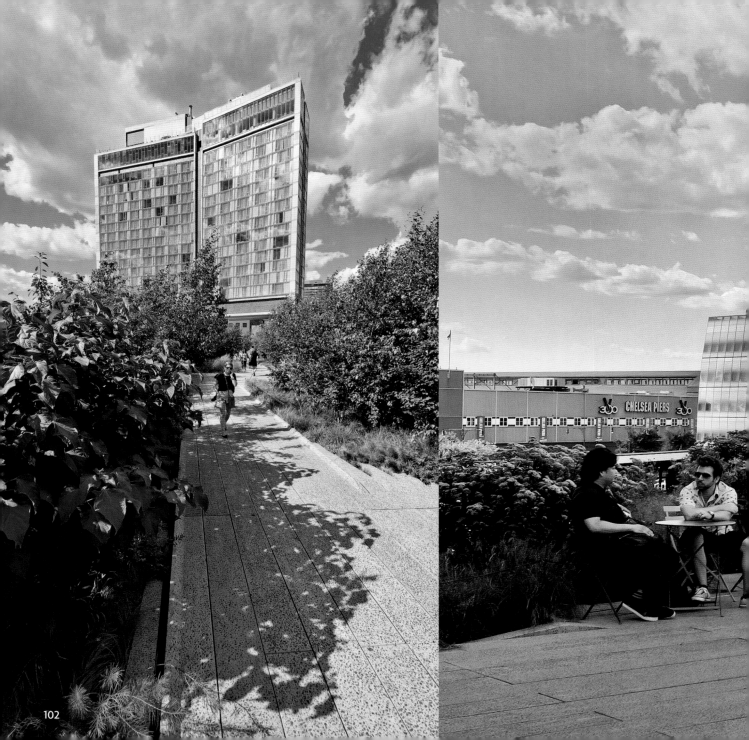

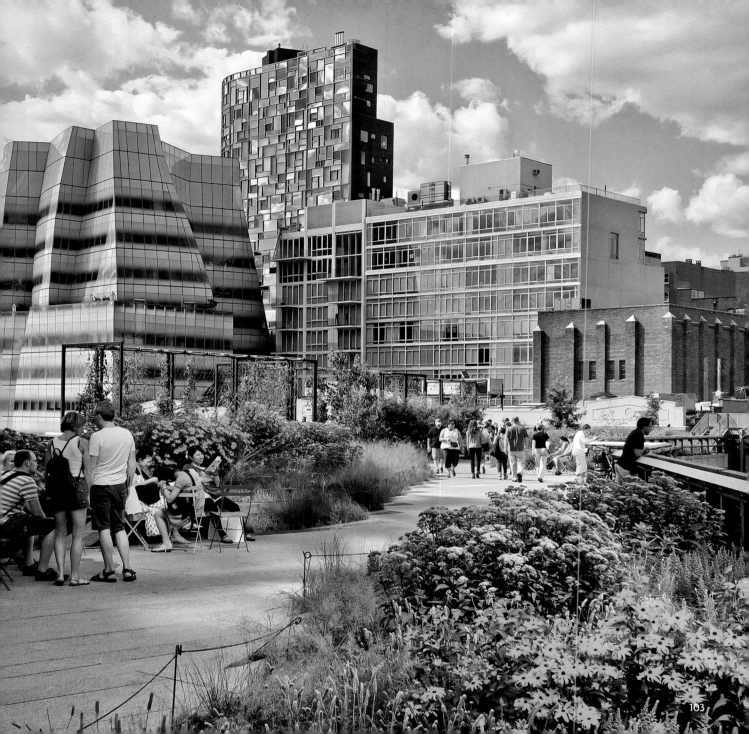

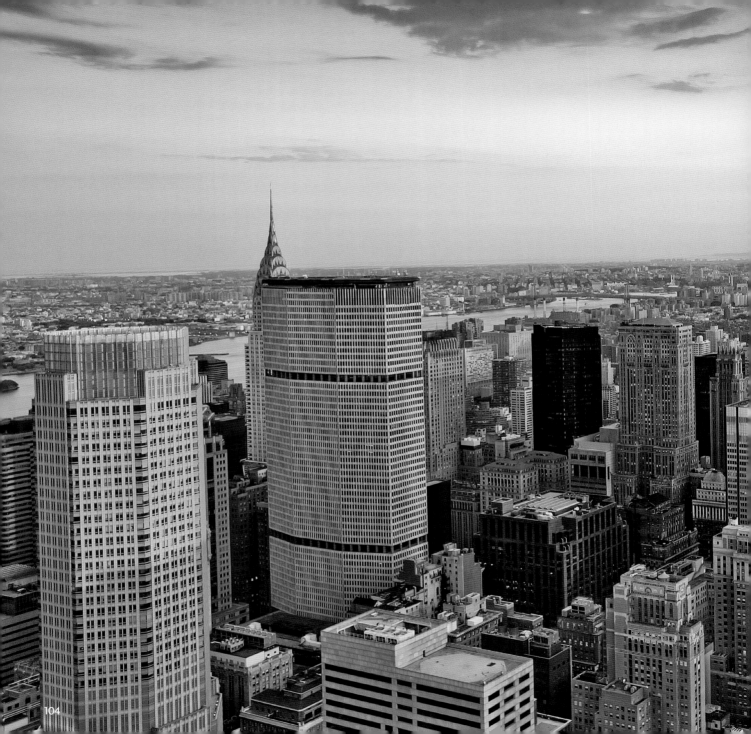

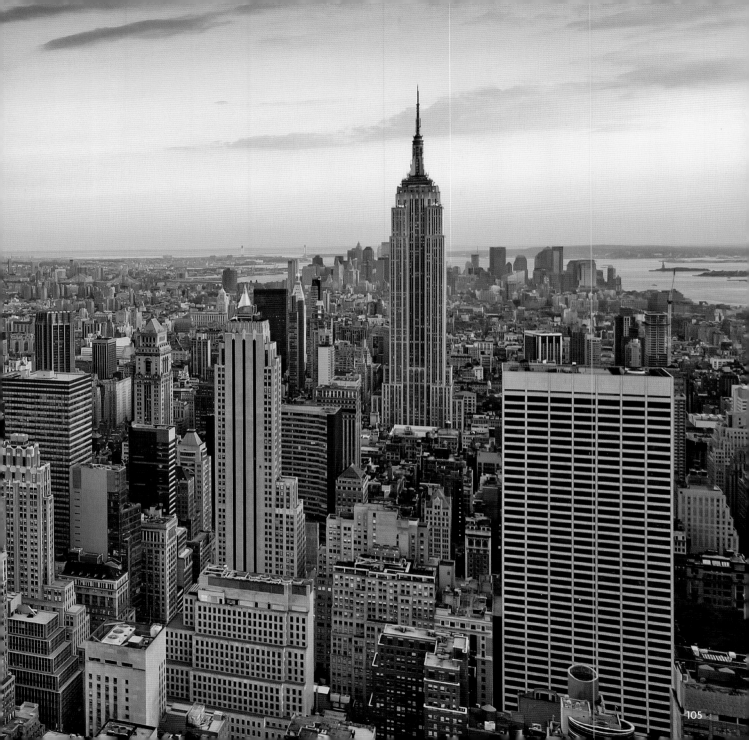

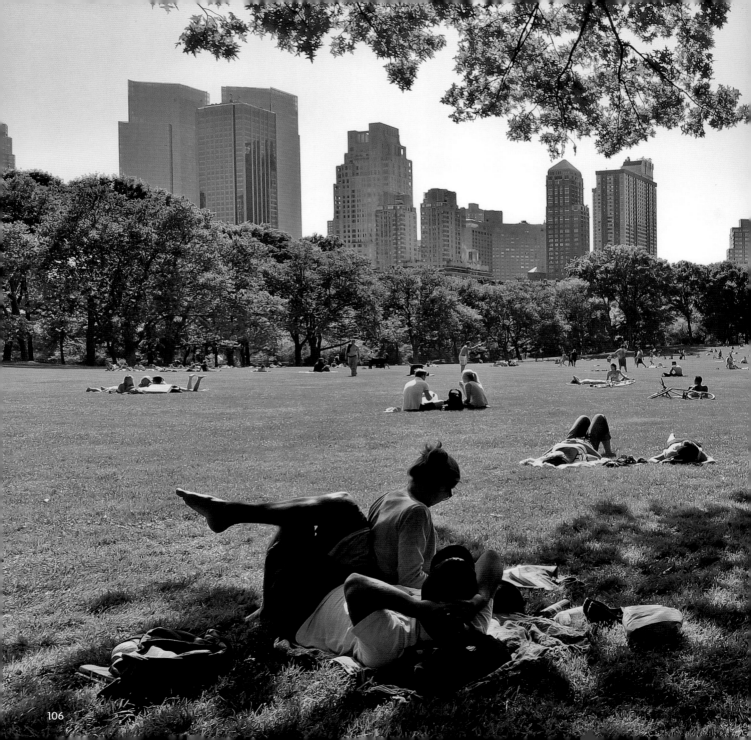

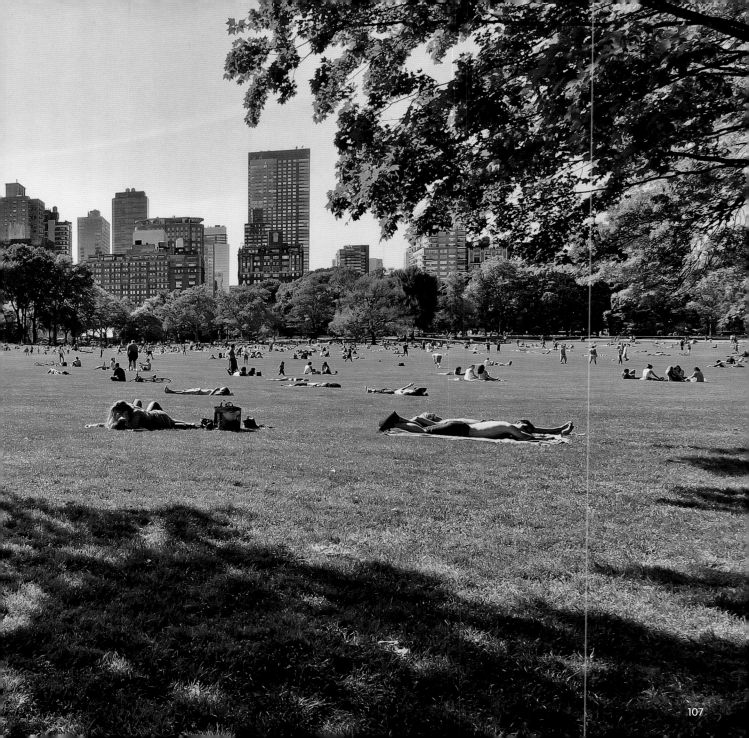

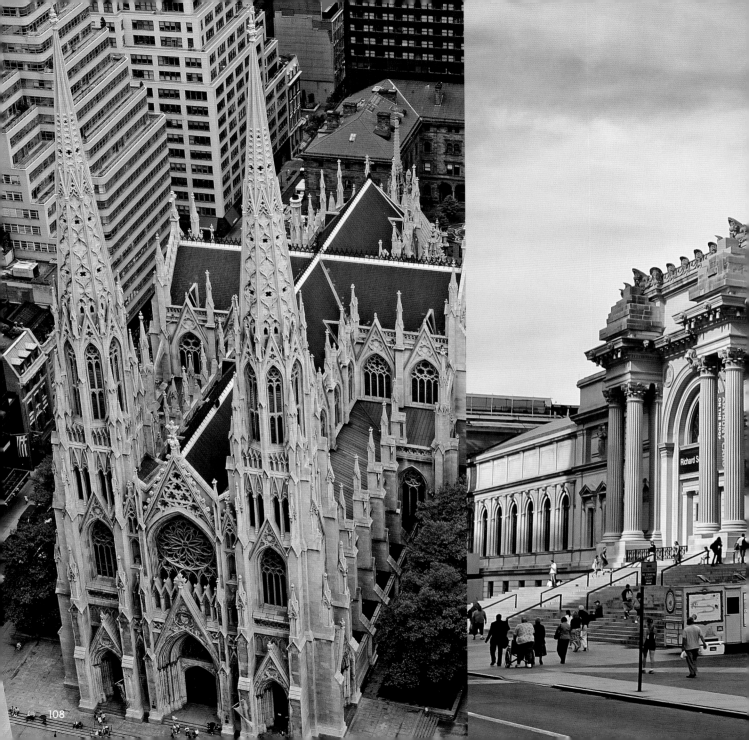

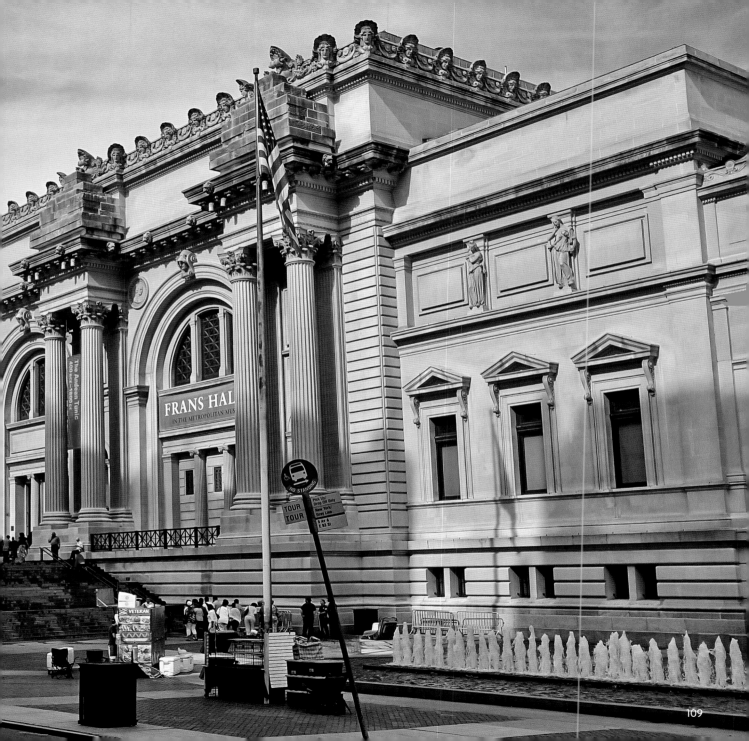

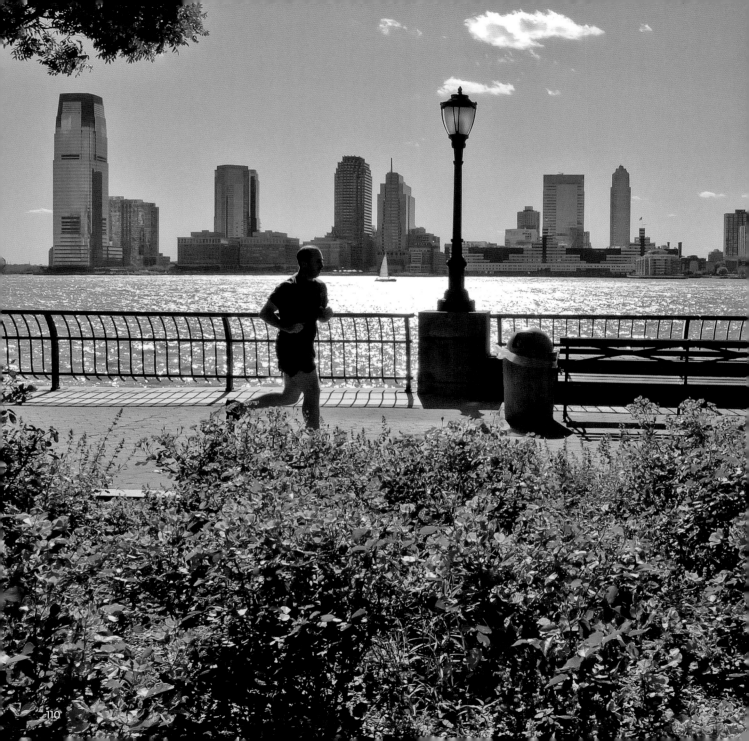

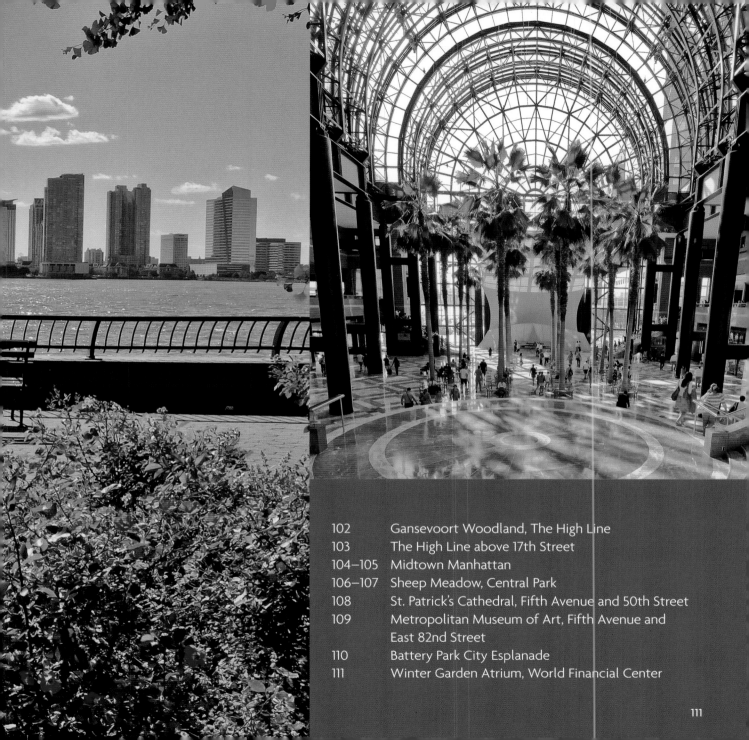

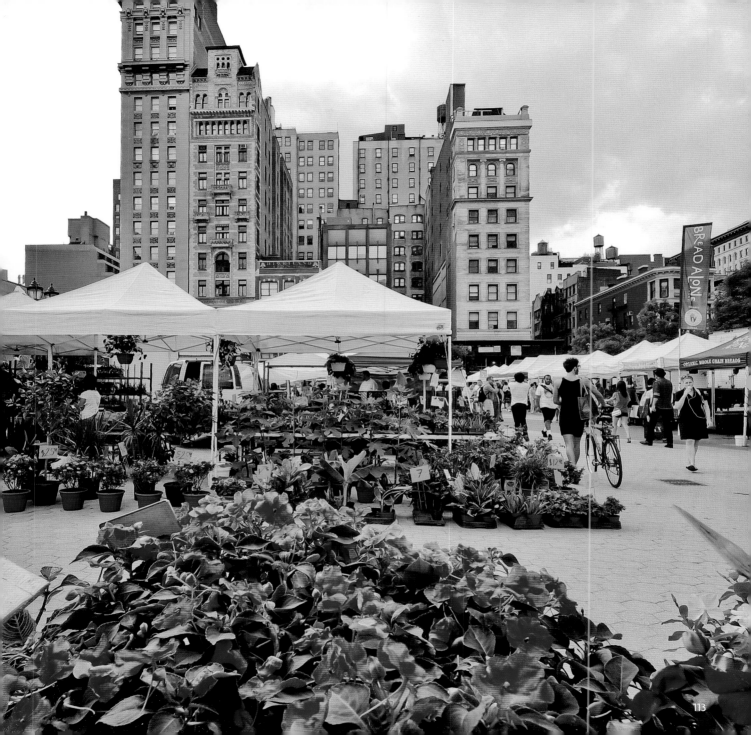

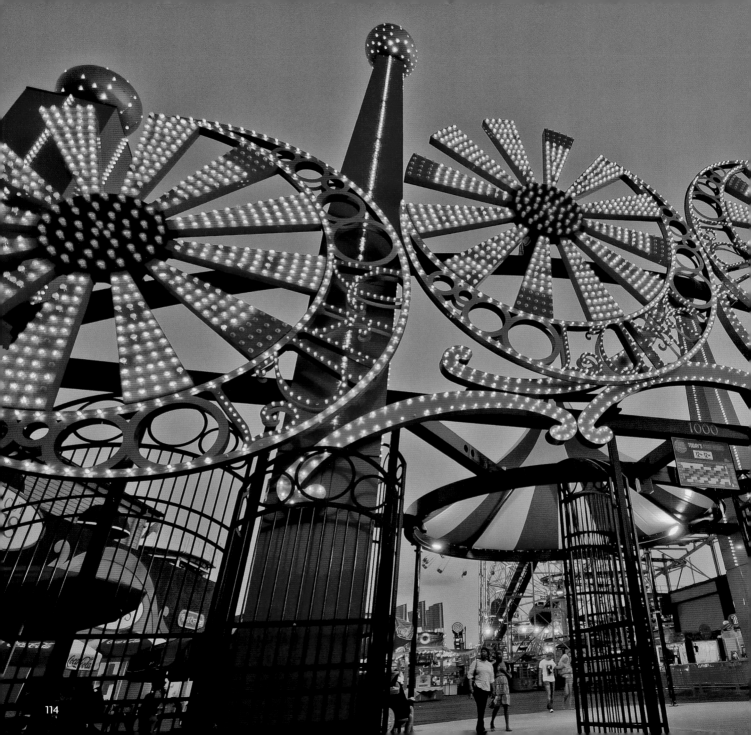

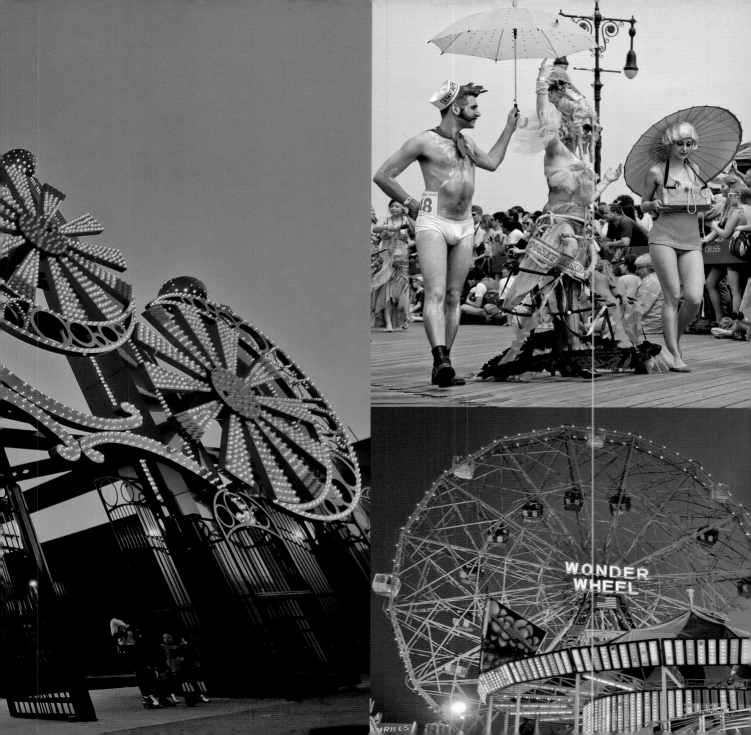

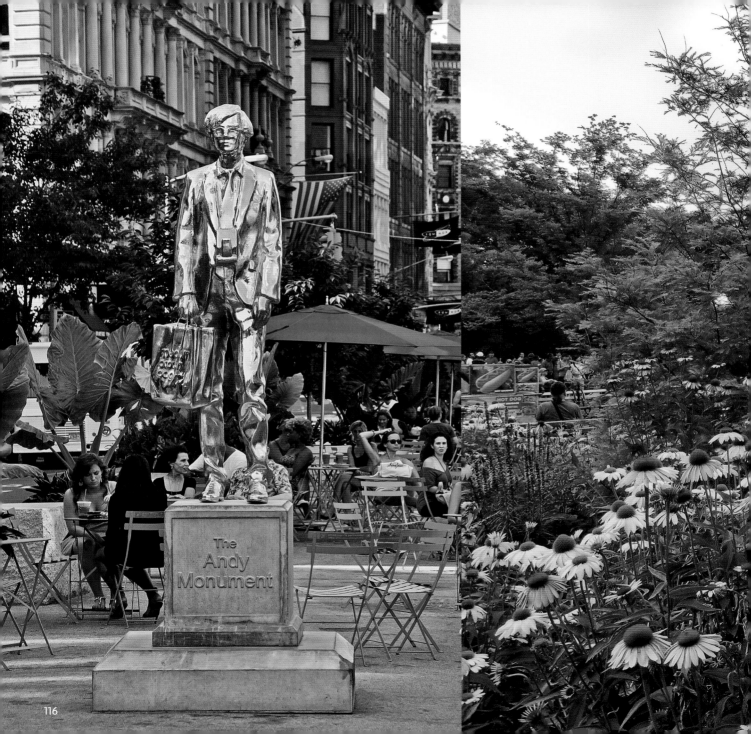

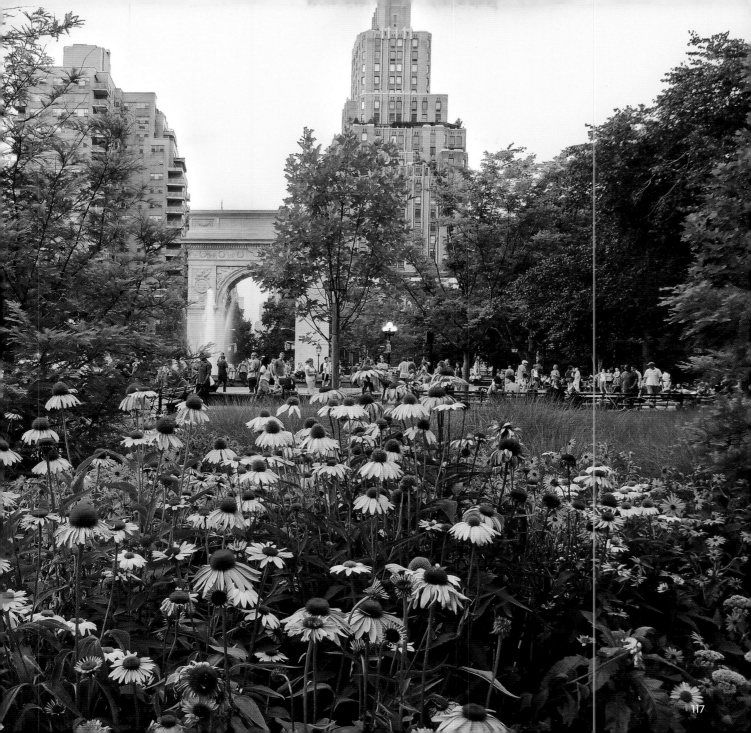

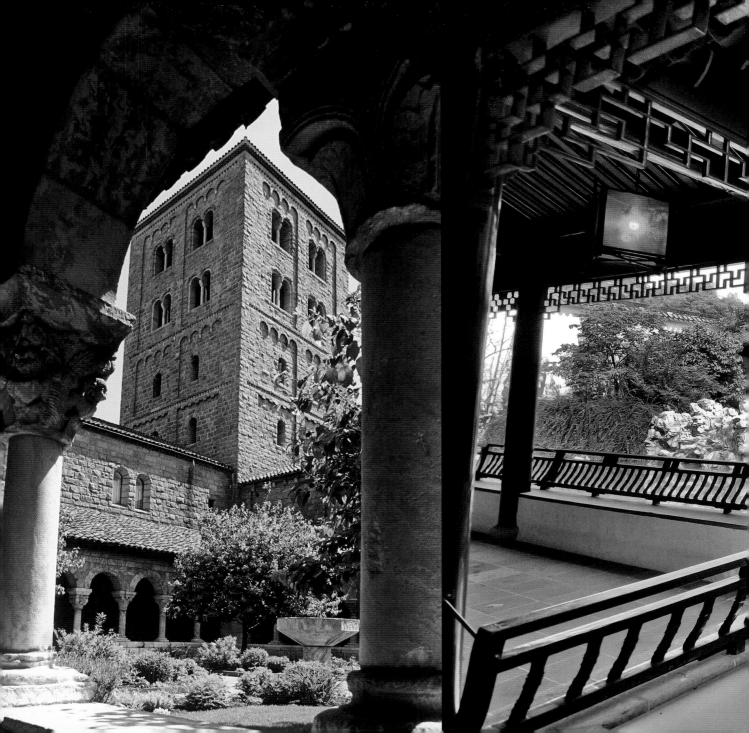

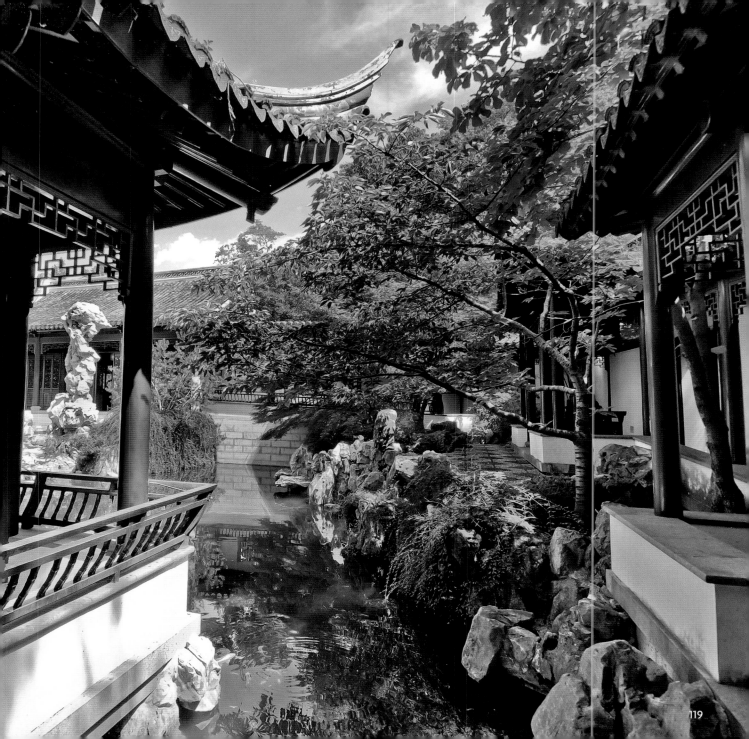

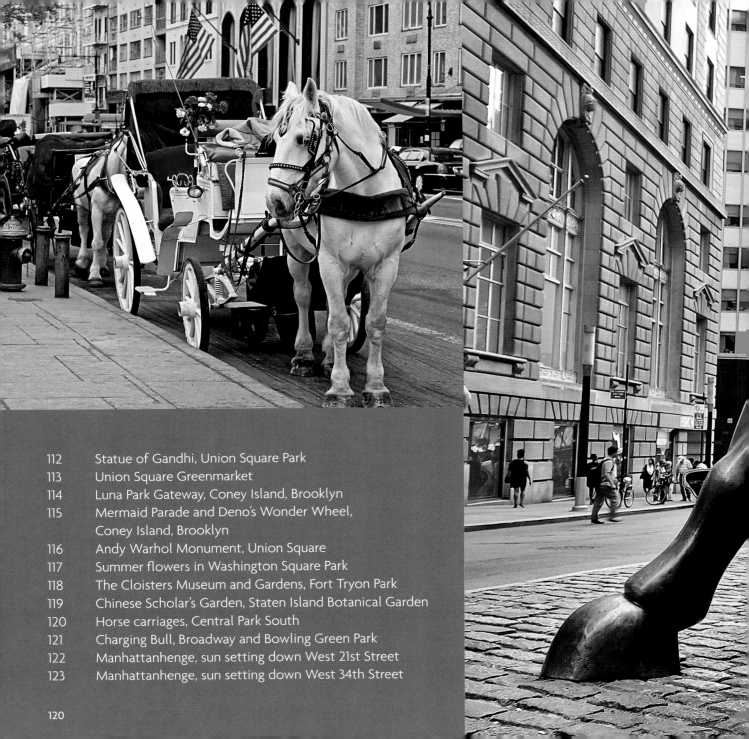

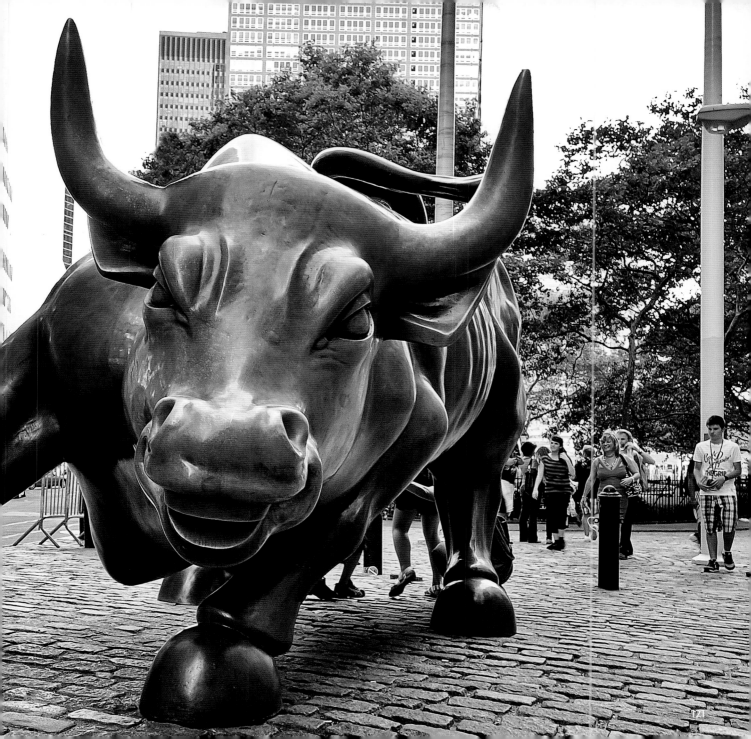

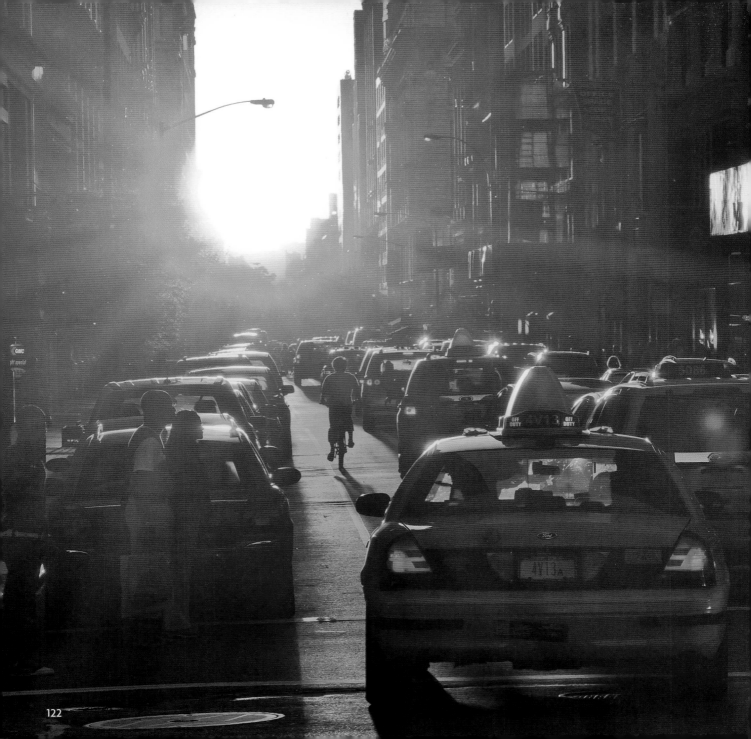

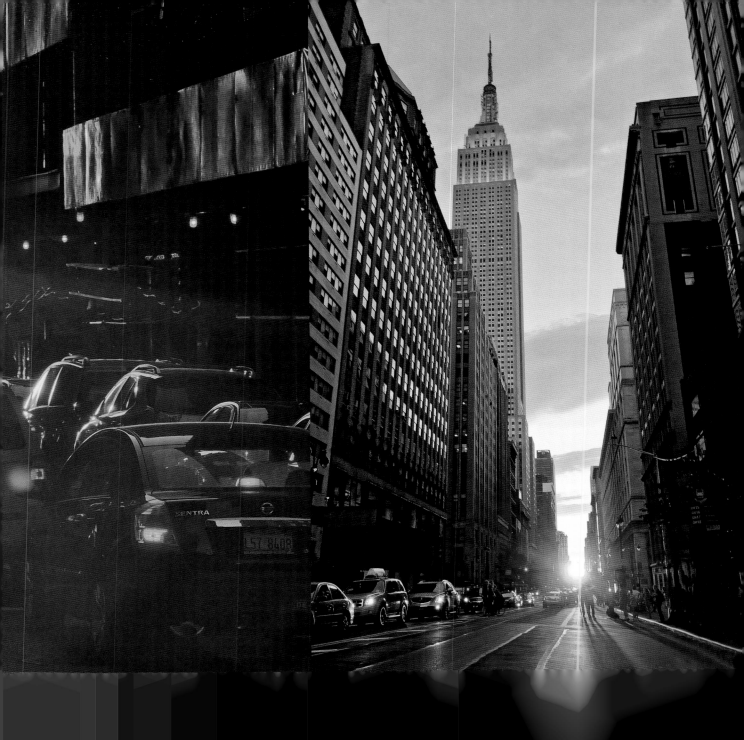

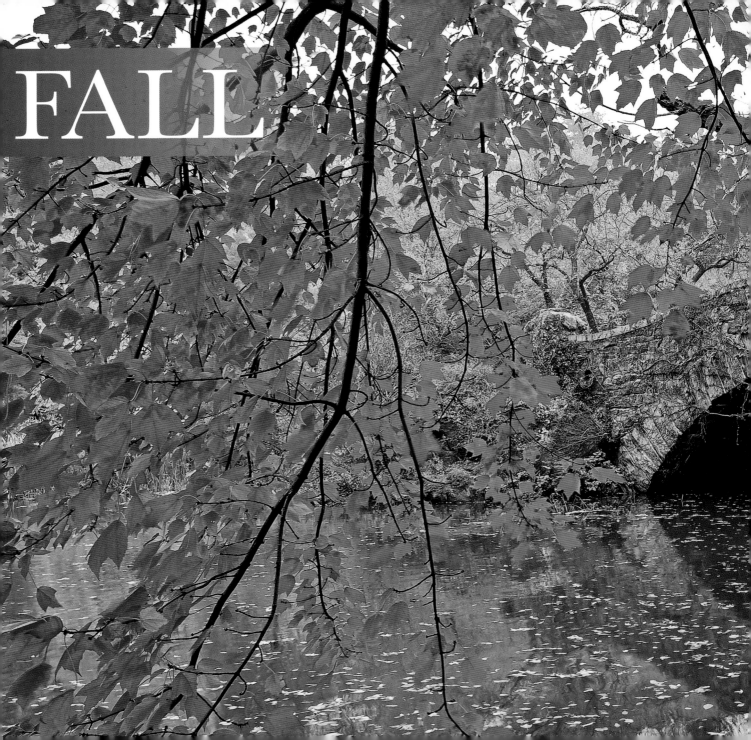

FALL

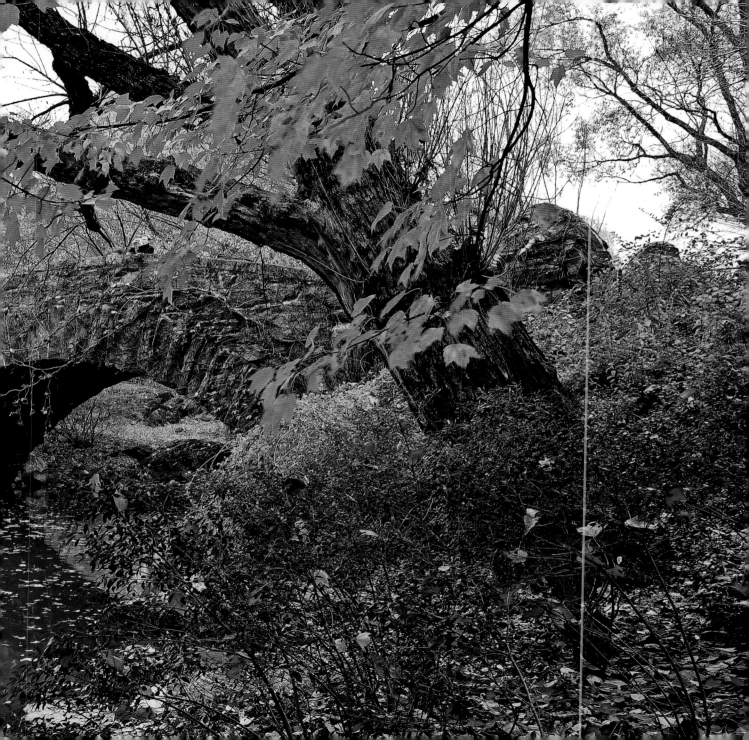

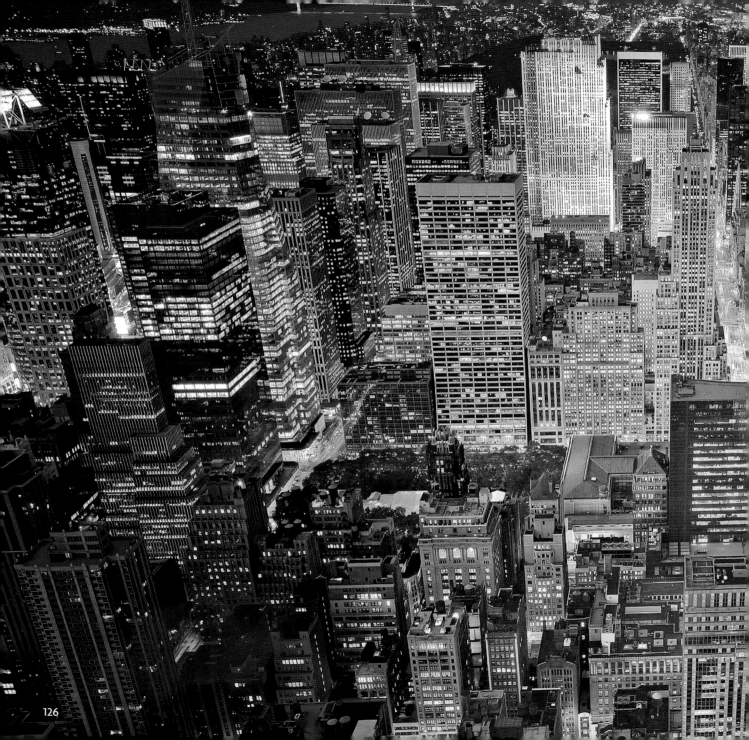

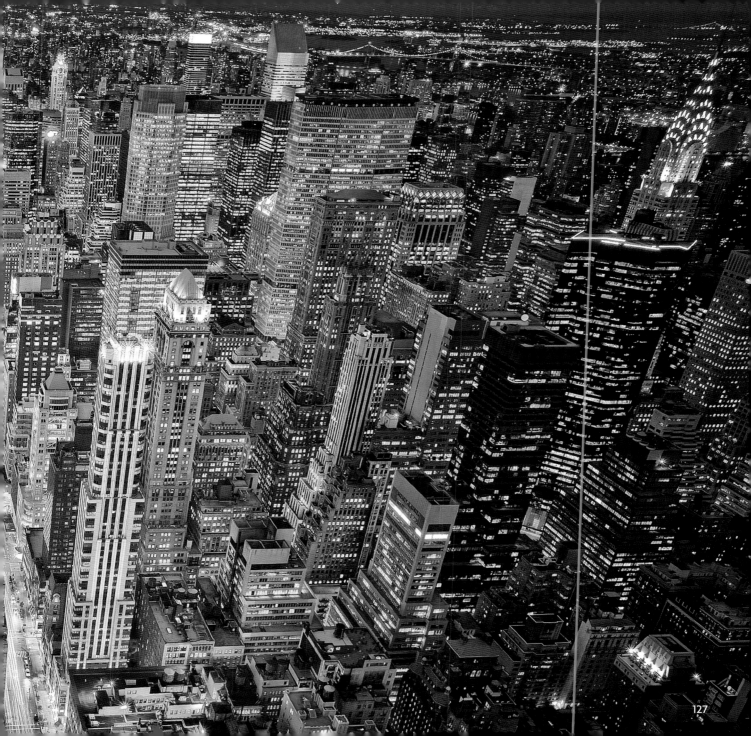

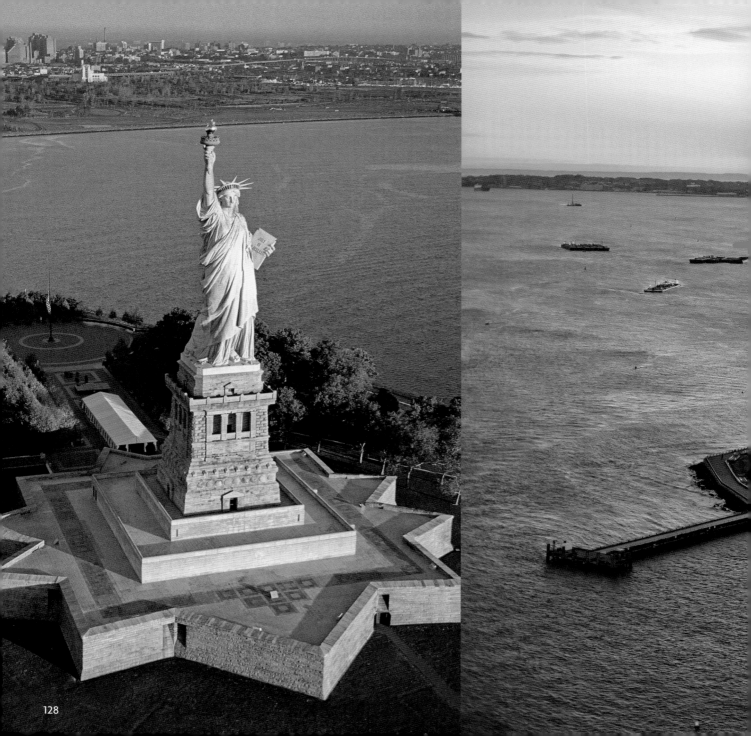

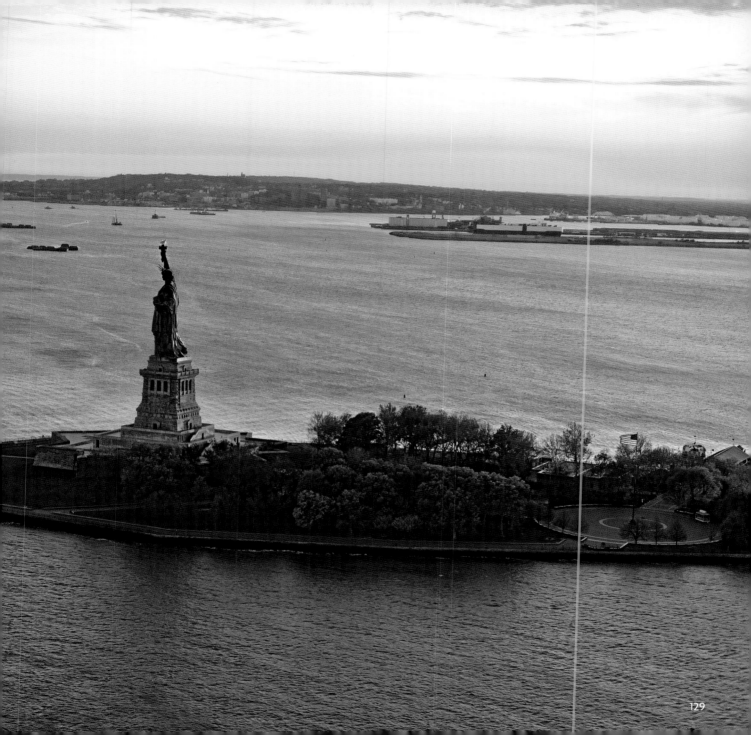

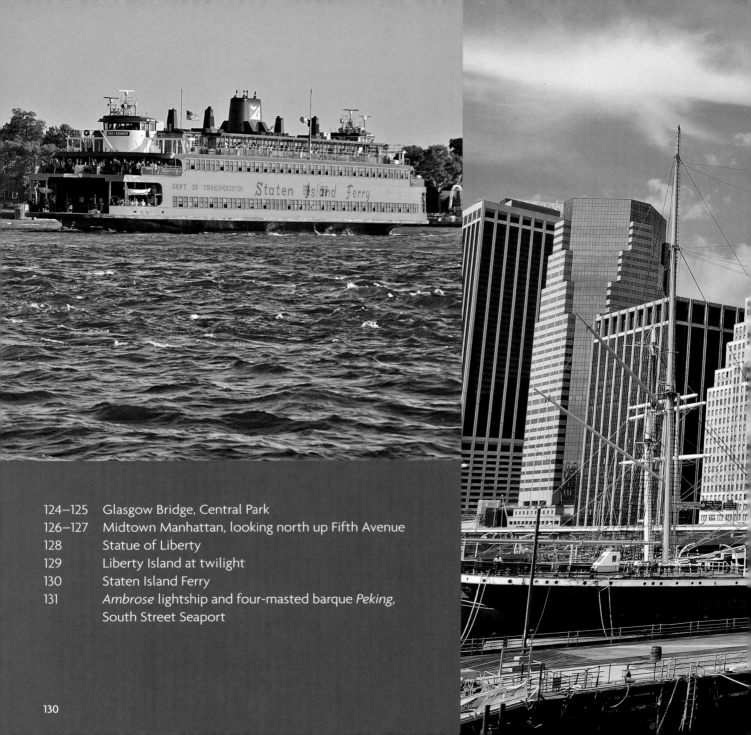

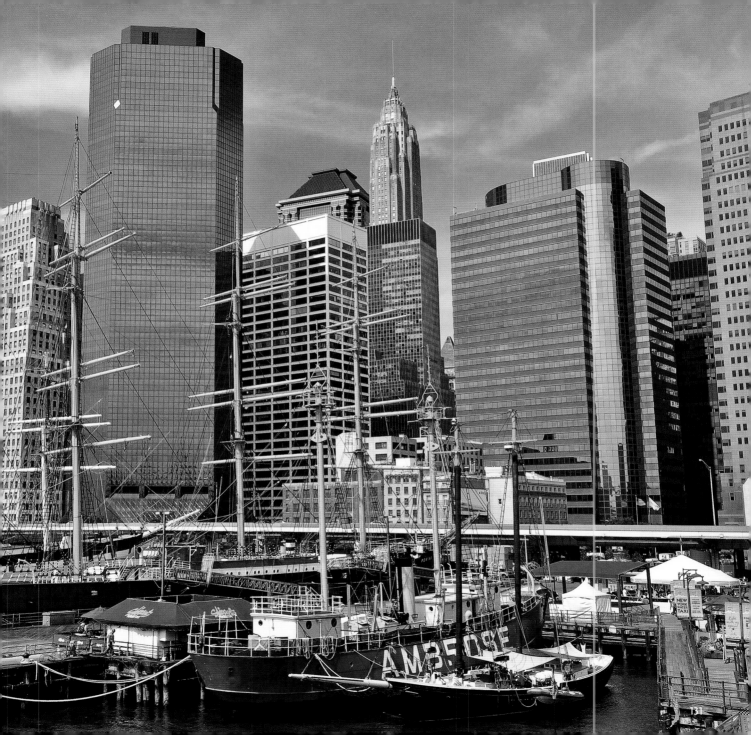

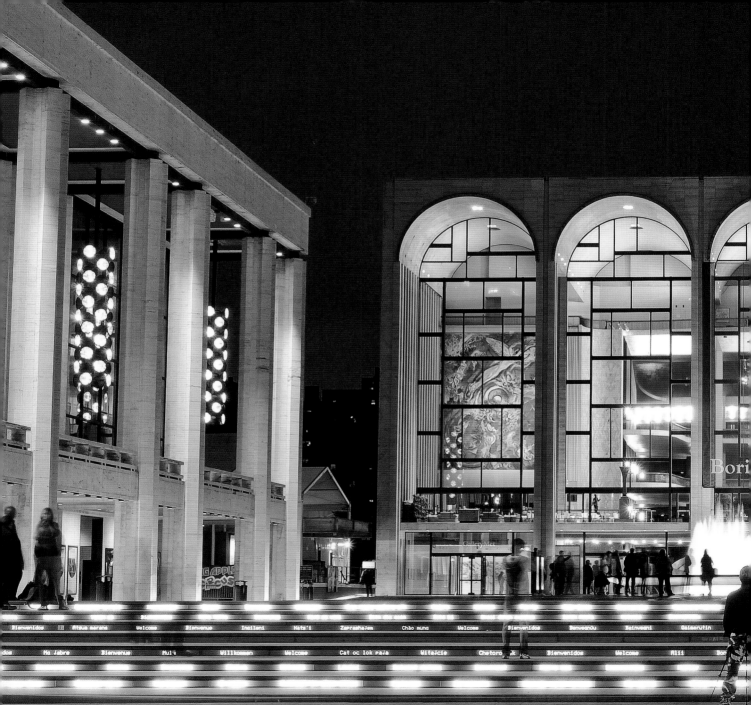

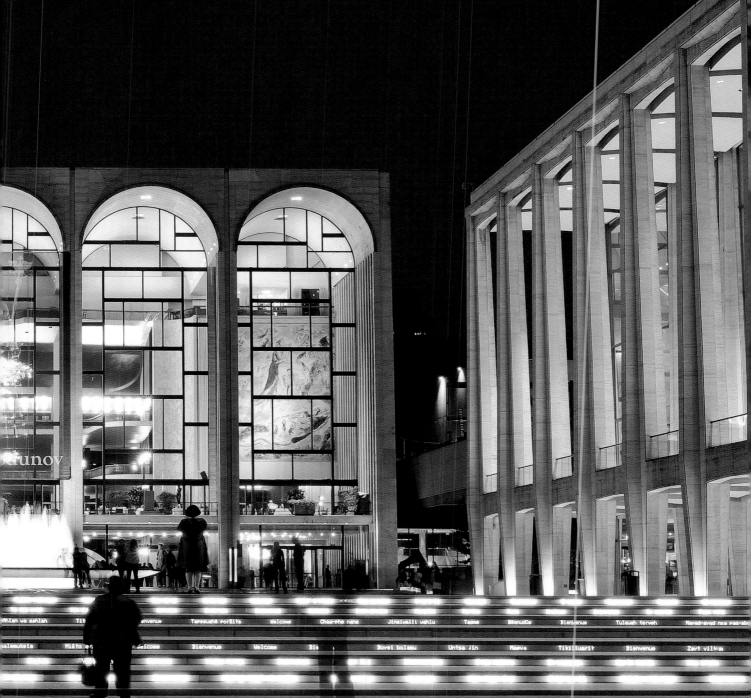

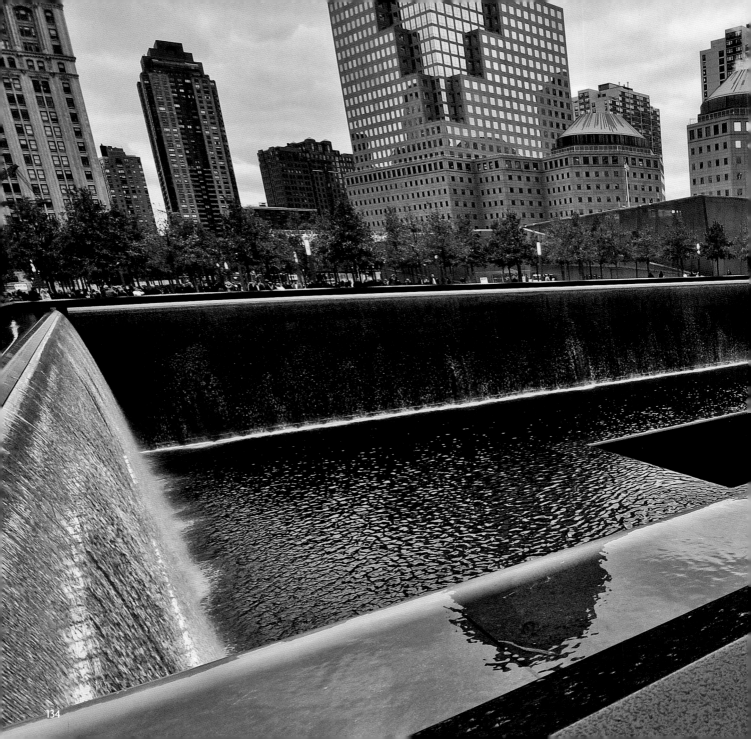

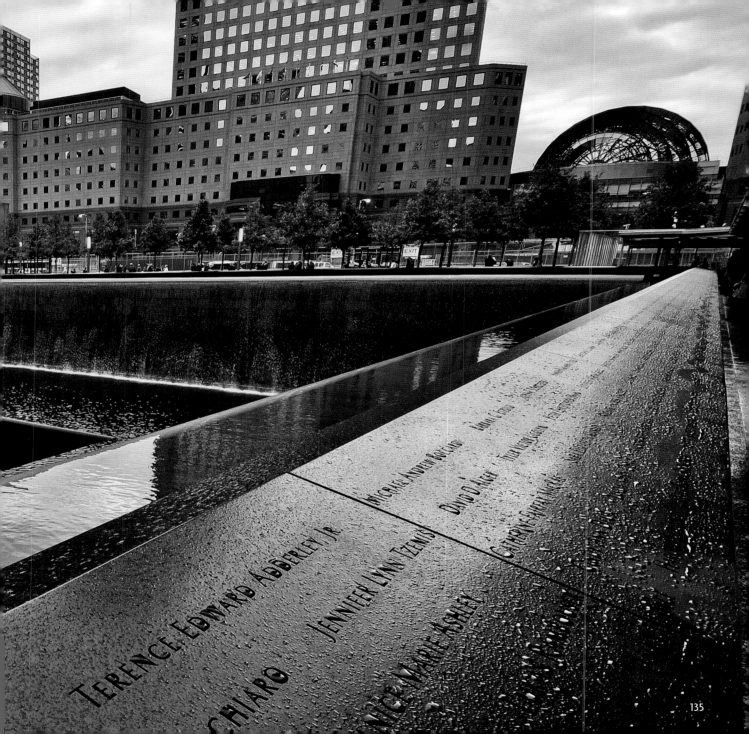

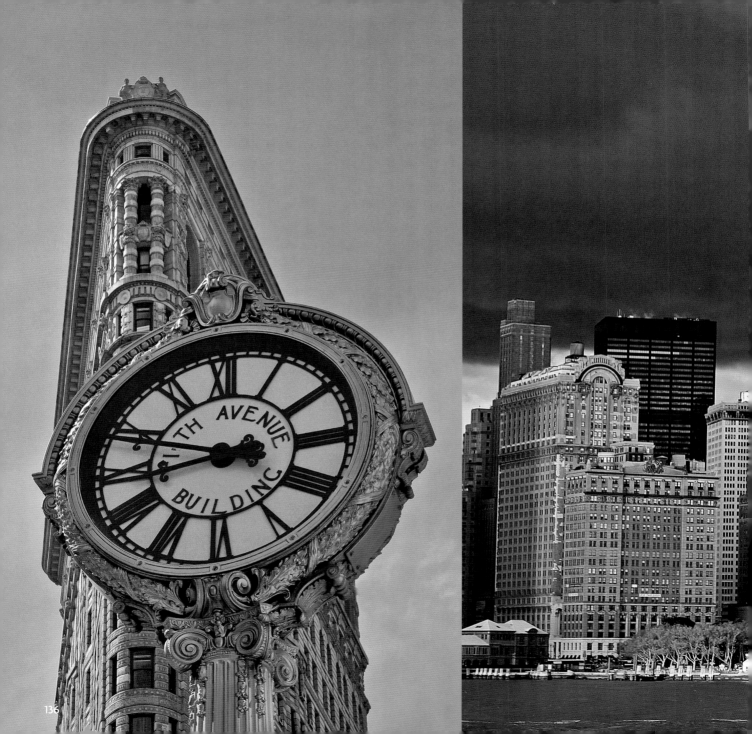

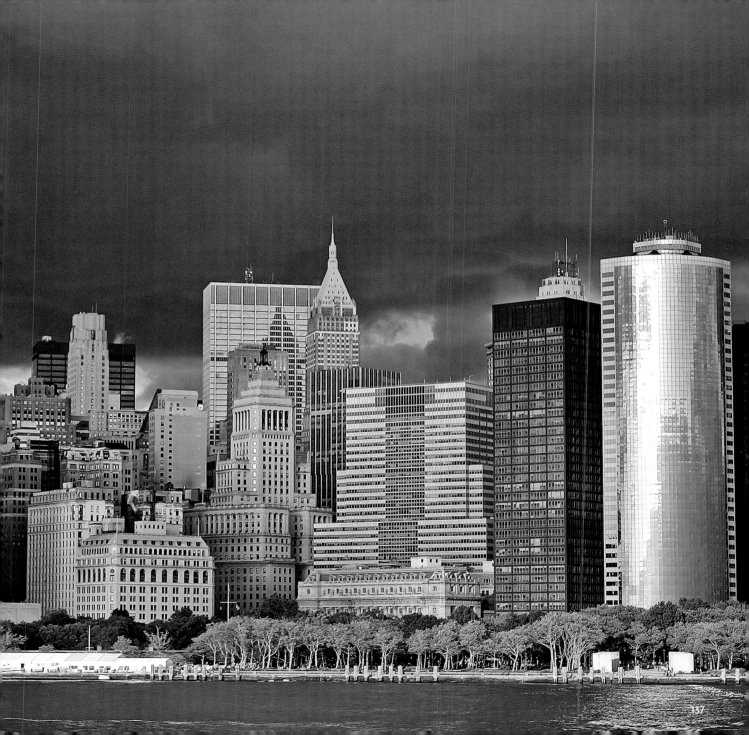

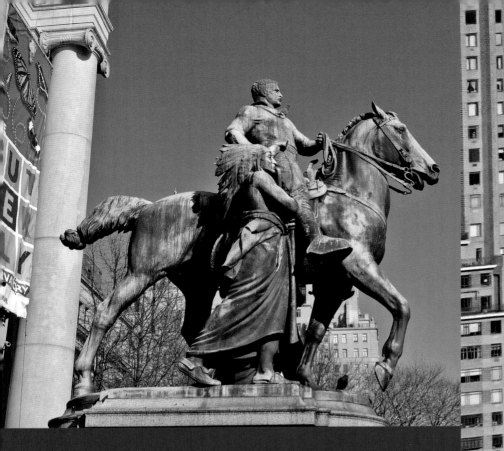

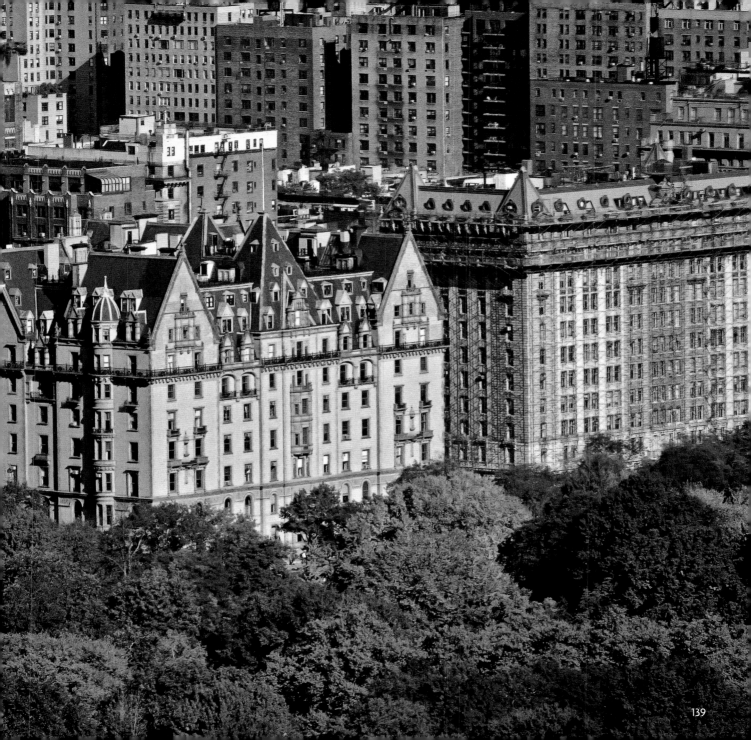

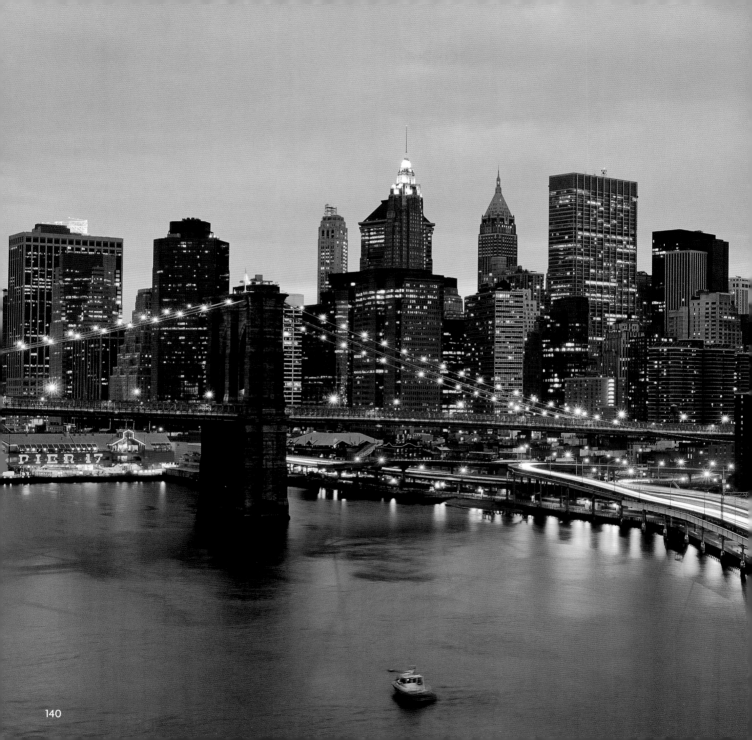

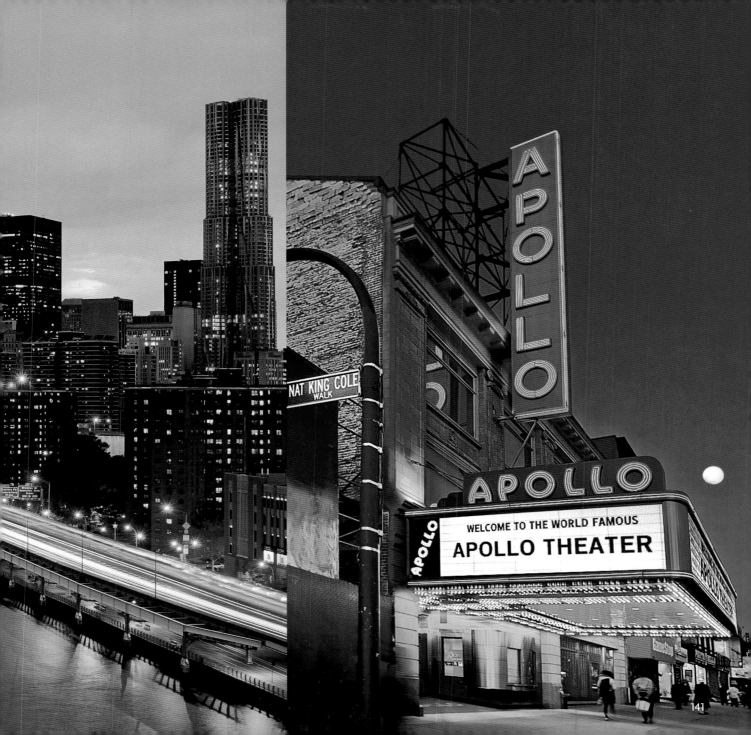

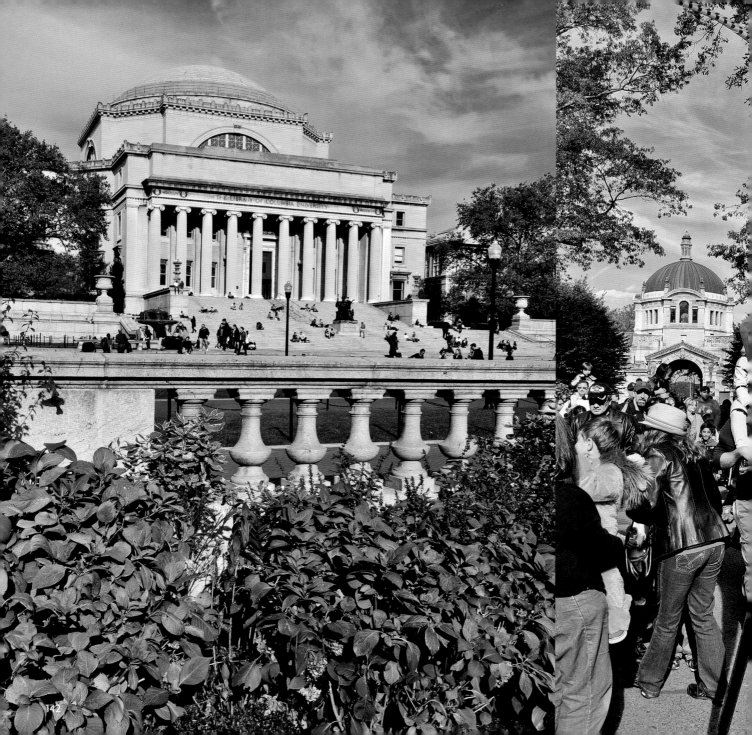

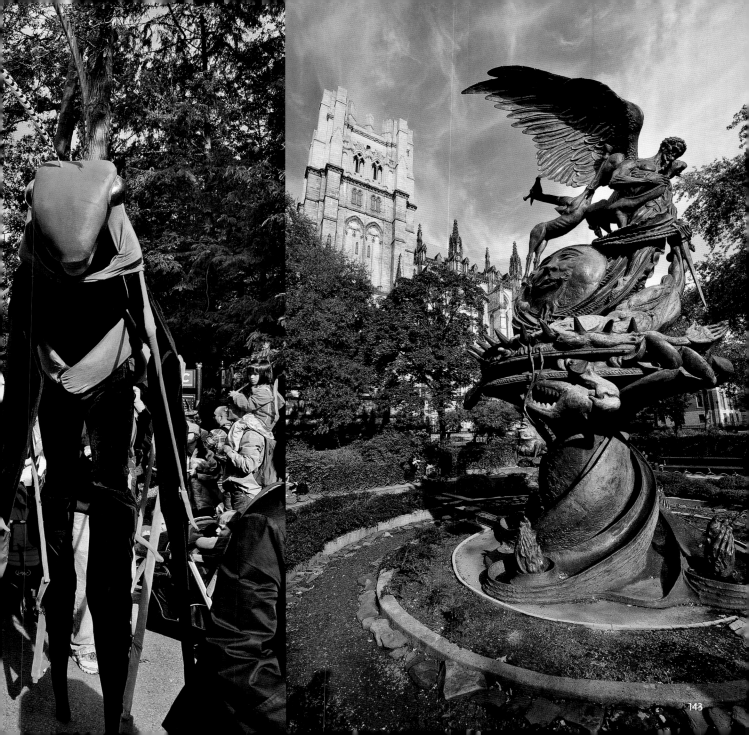

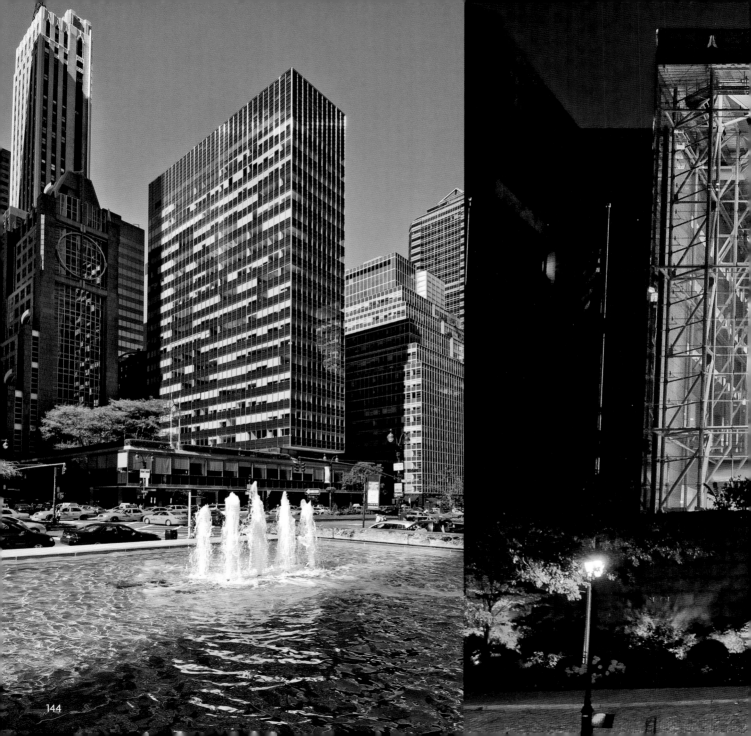

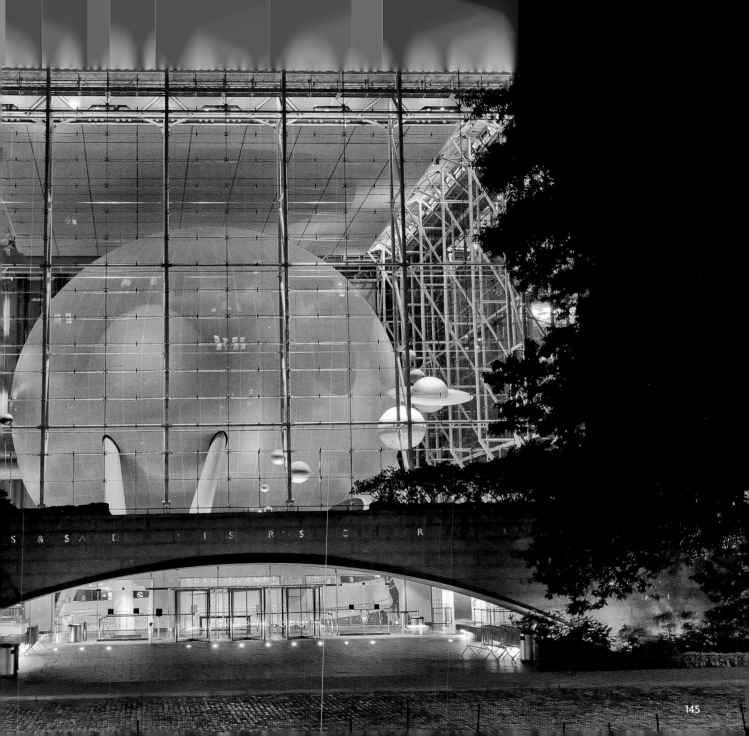

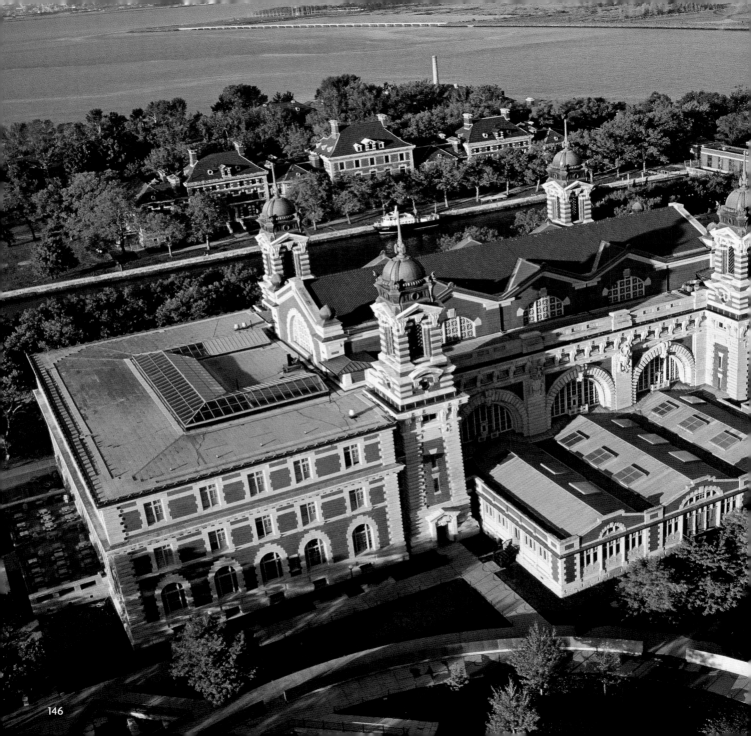

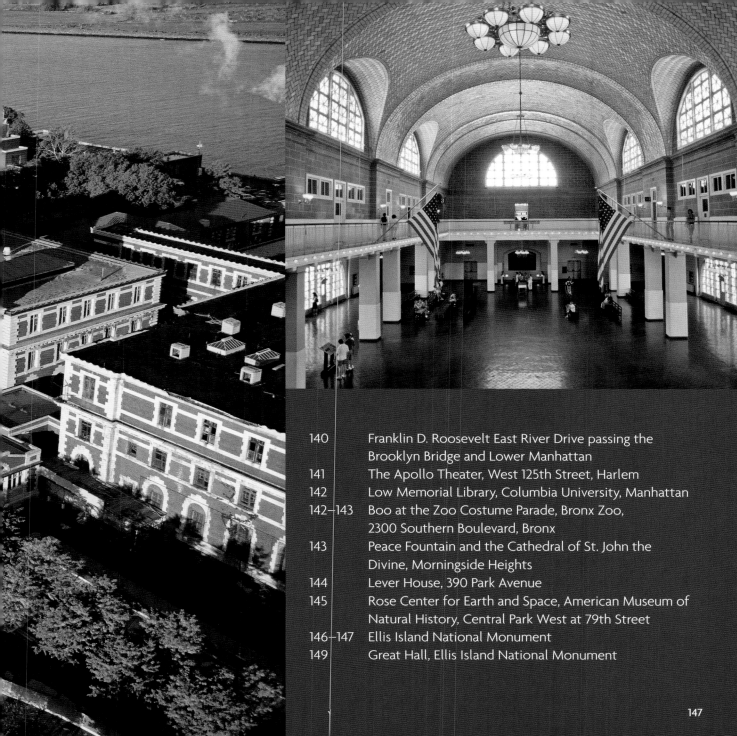

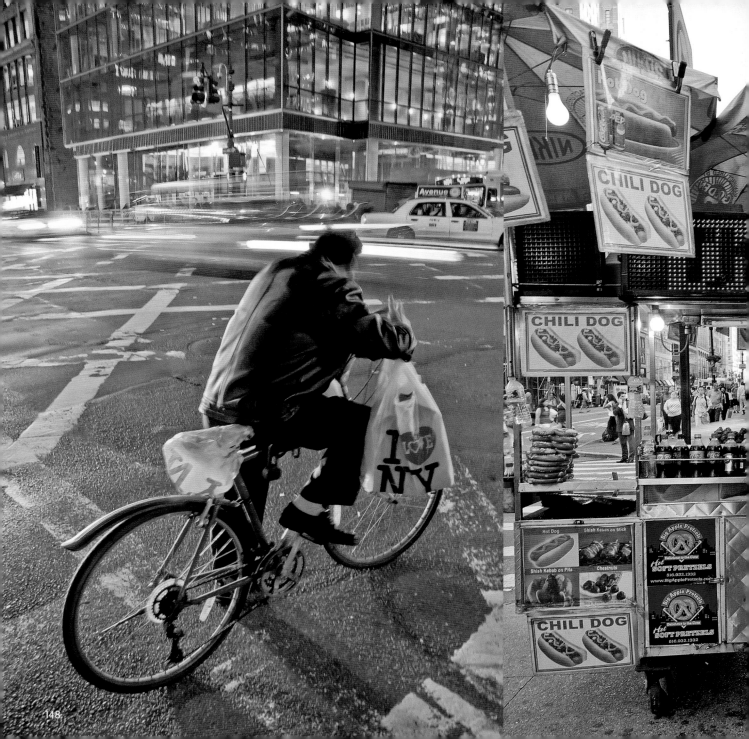

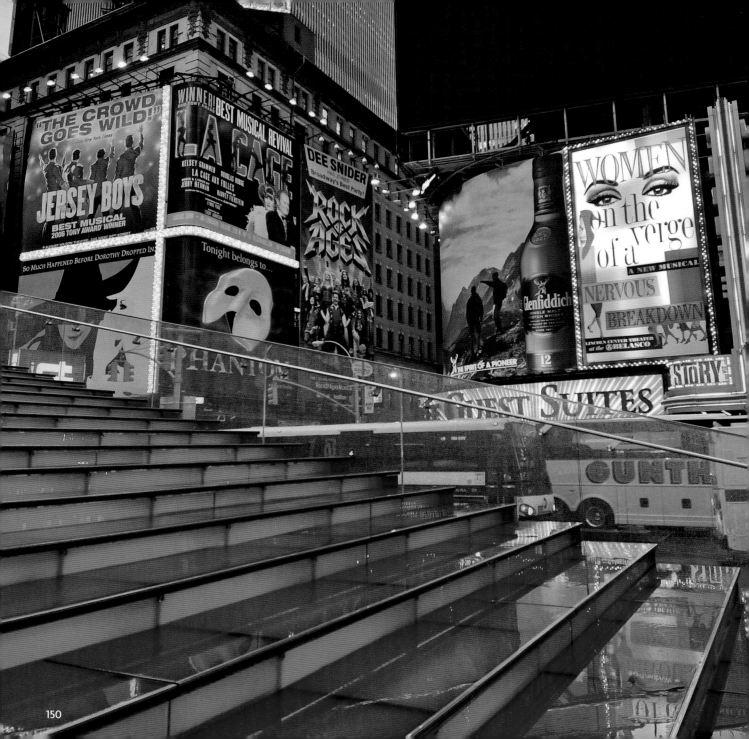

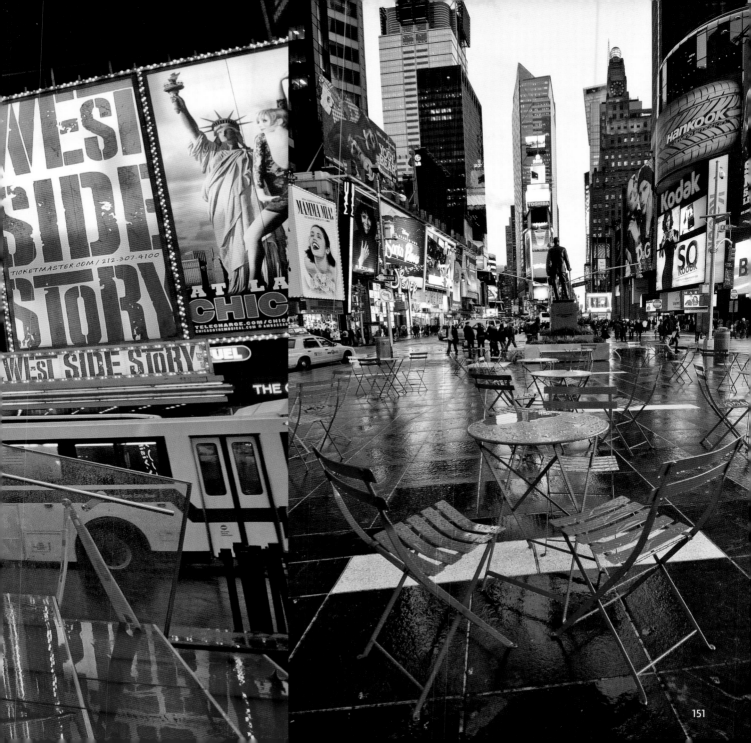

151

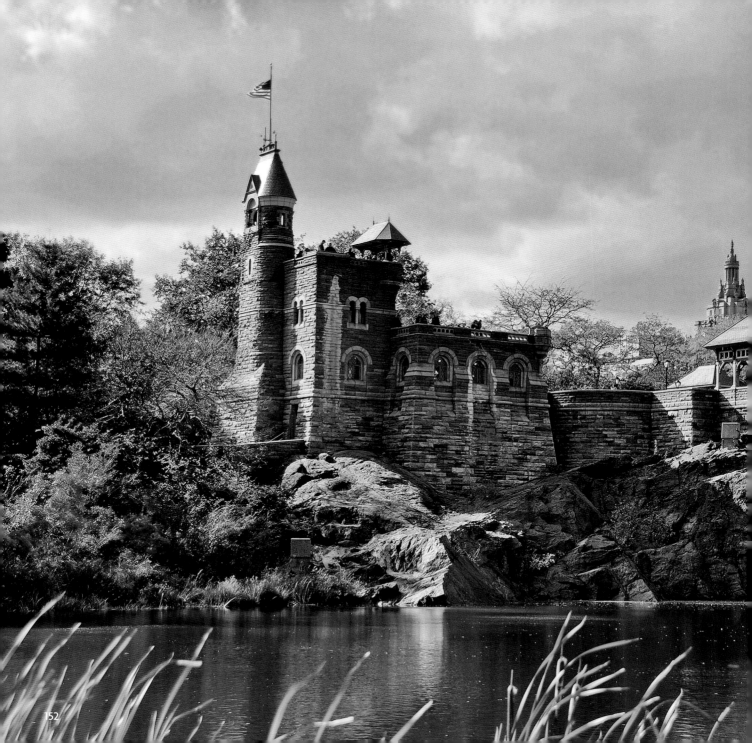

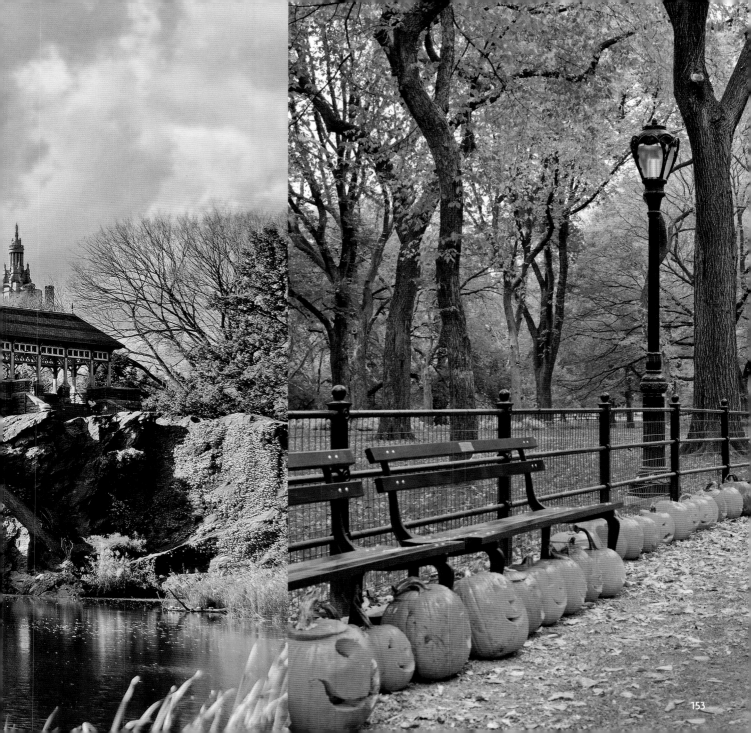

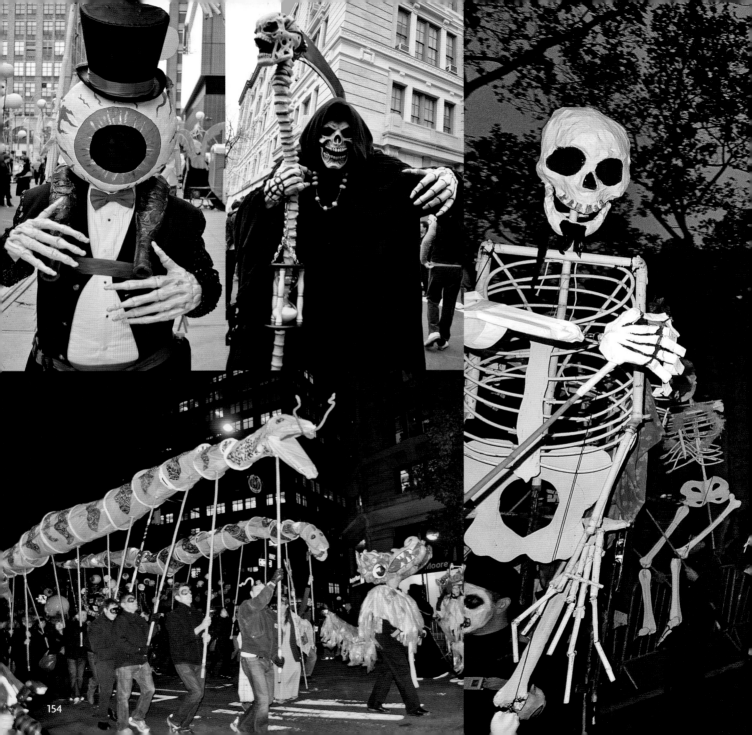

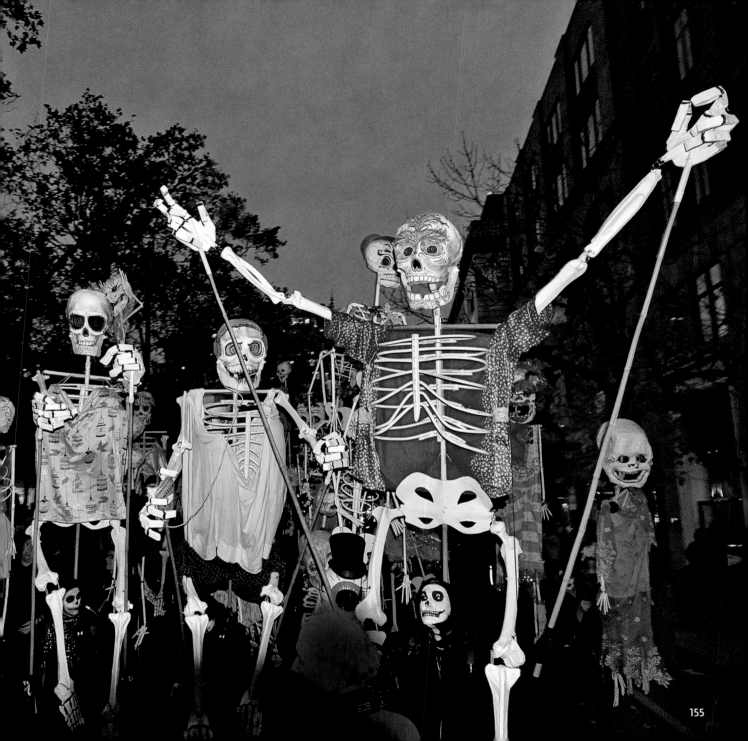

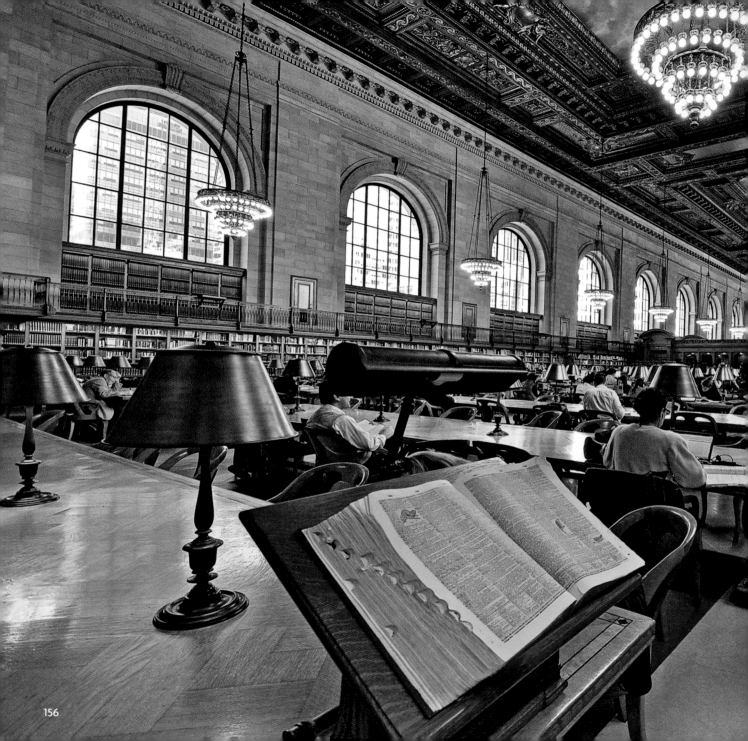

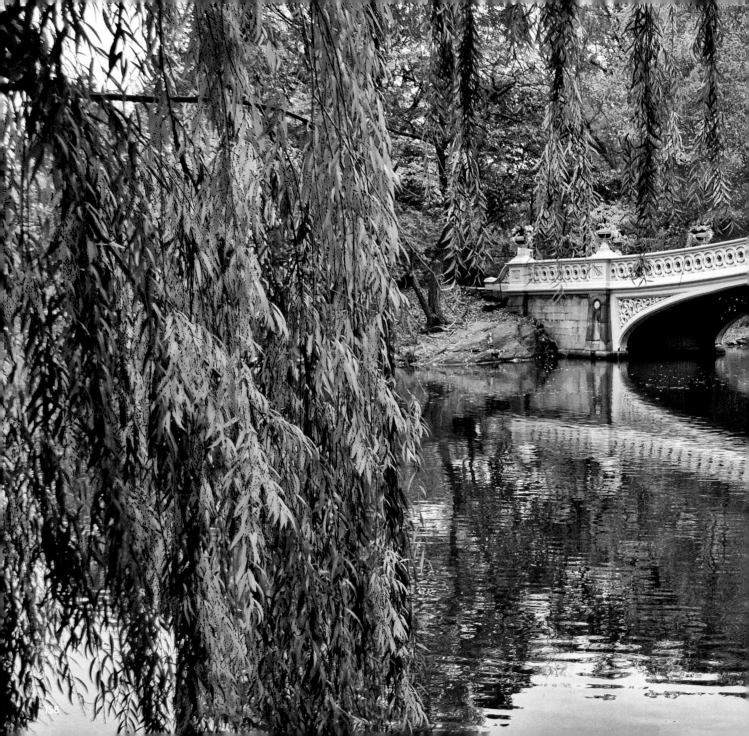

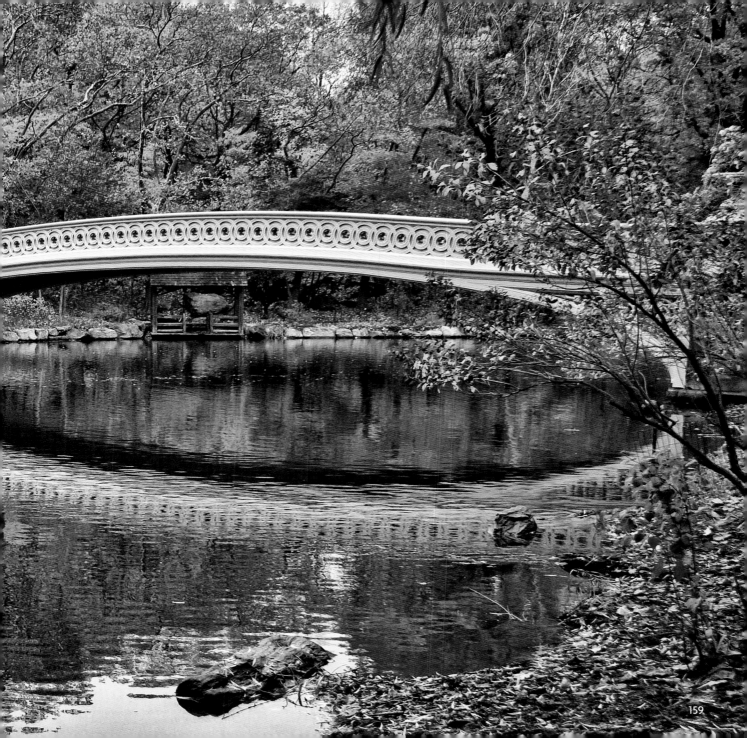

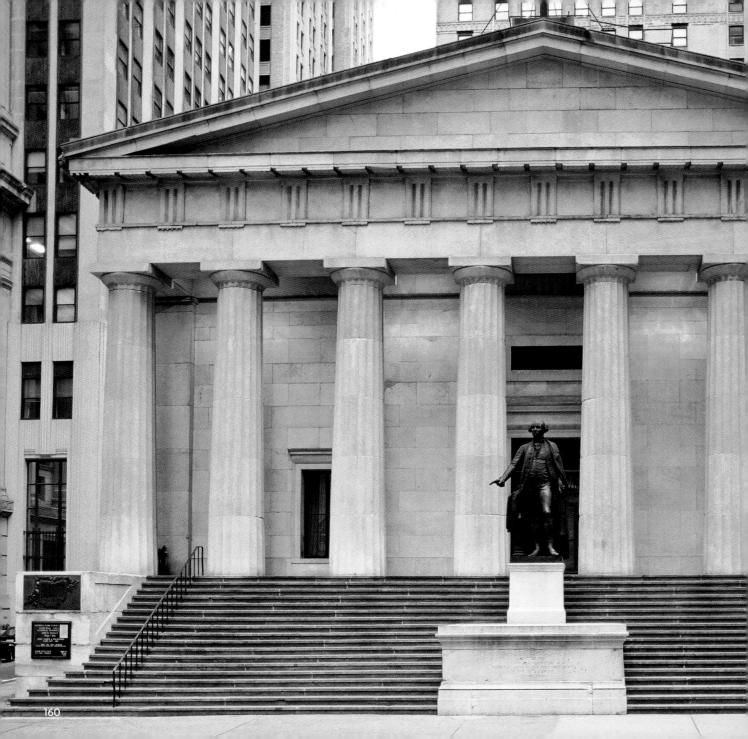

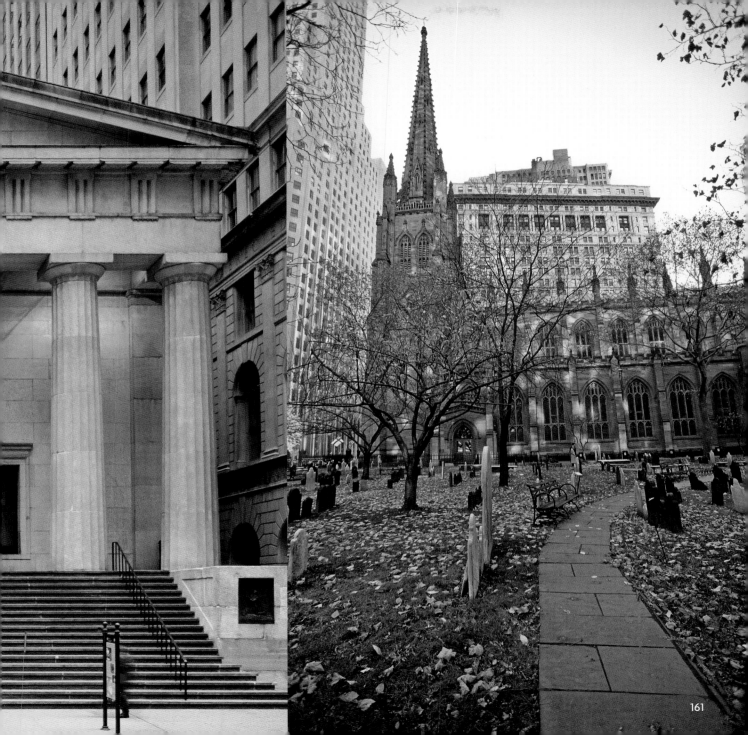

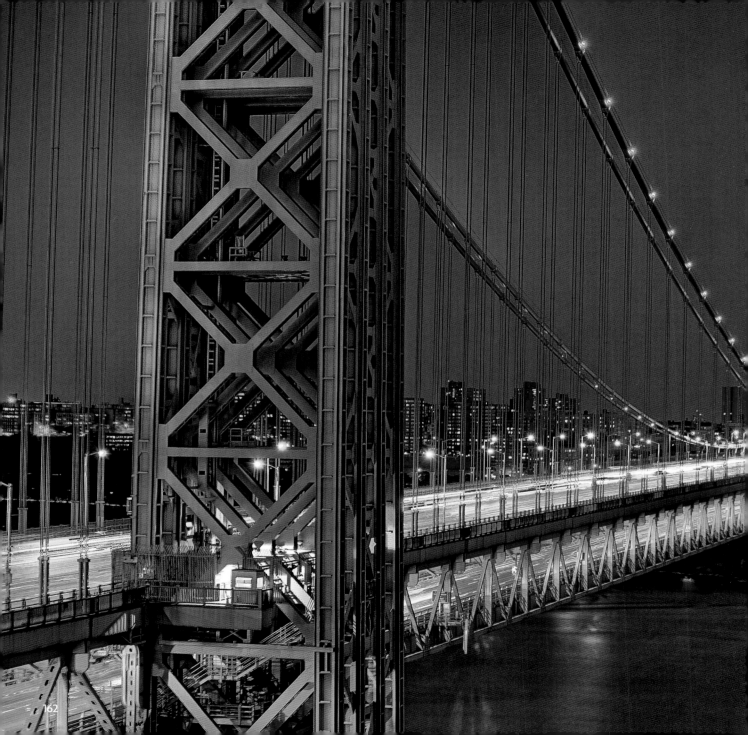

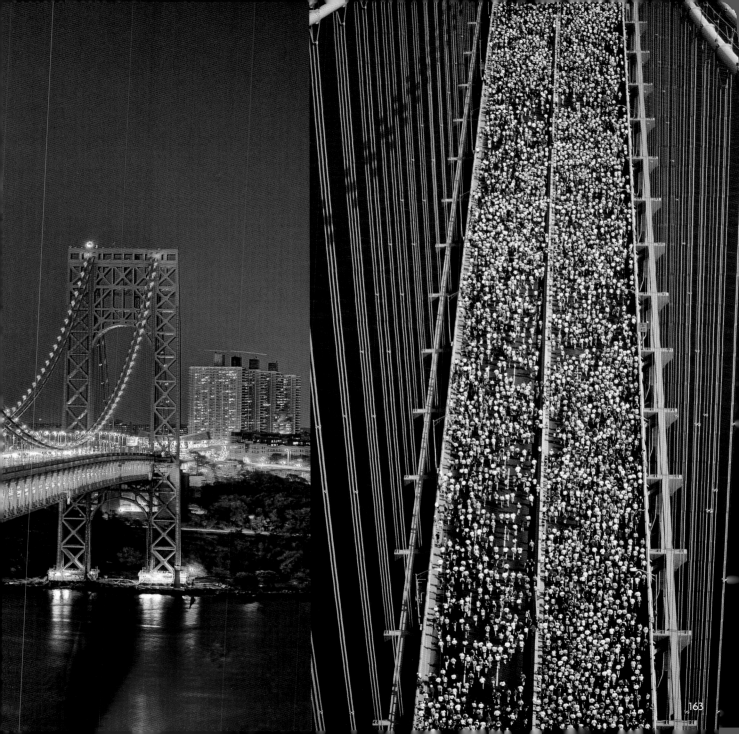

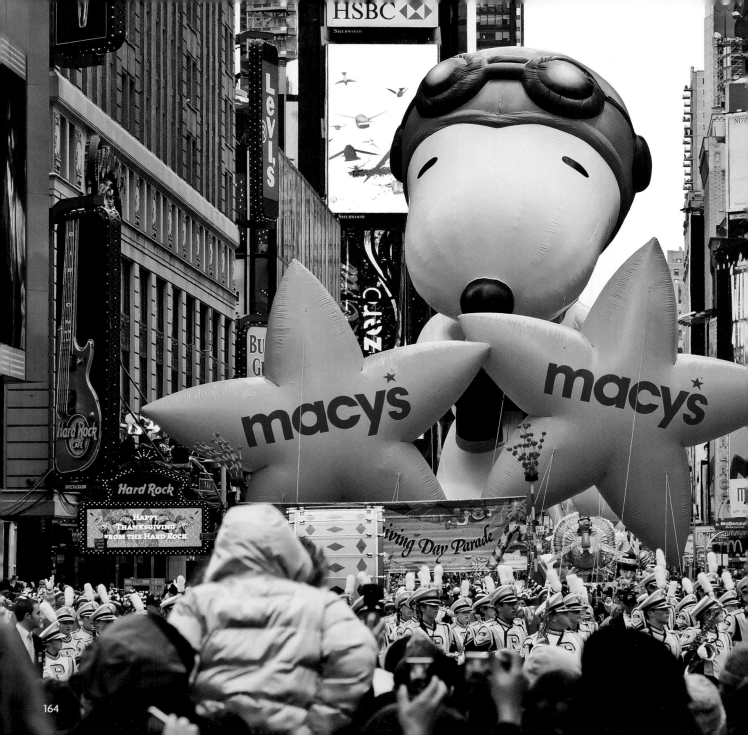

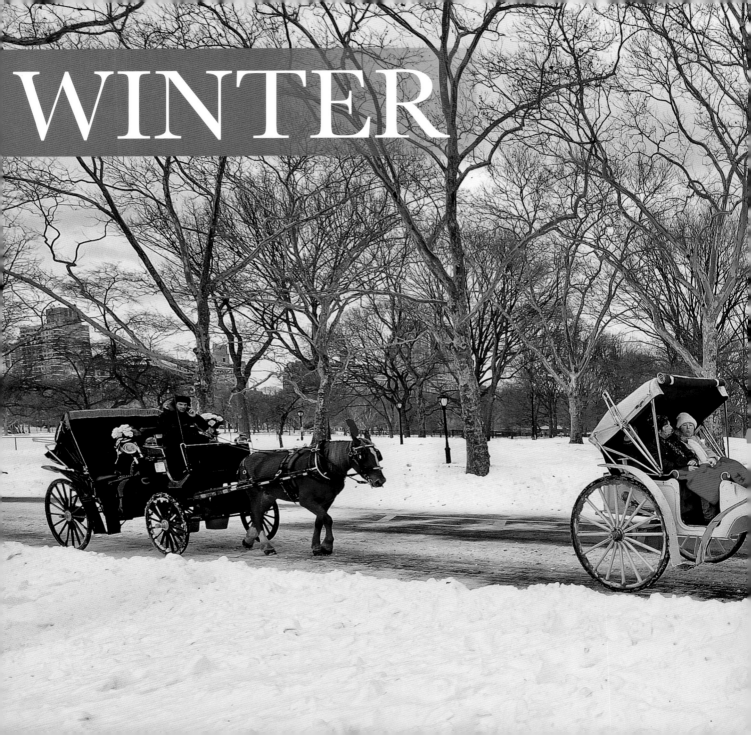

WINTER

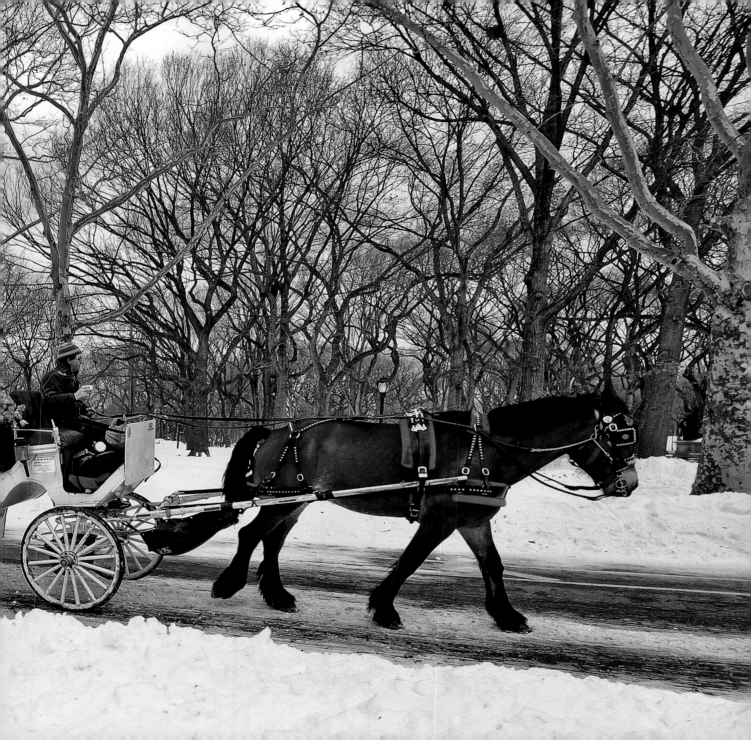

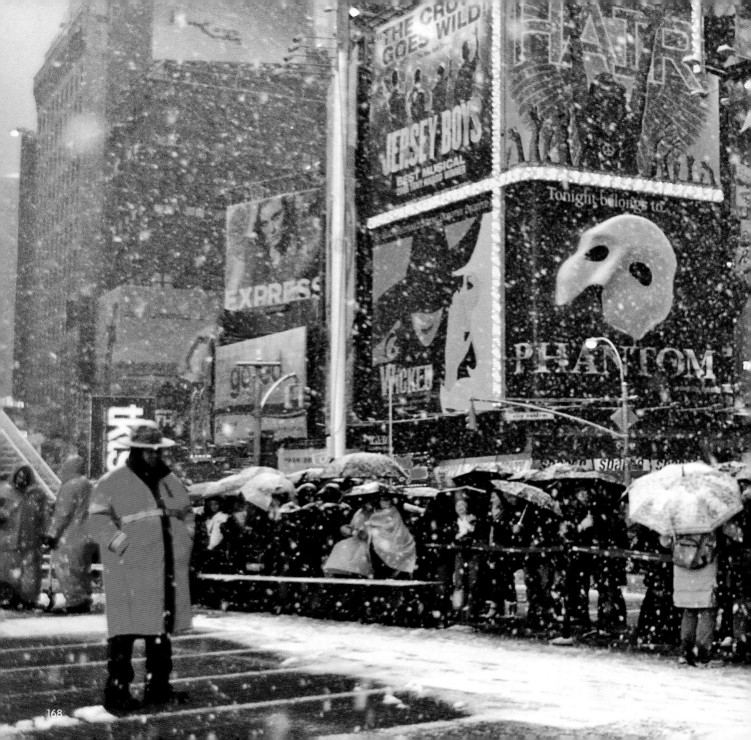

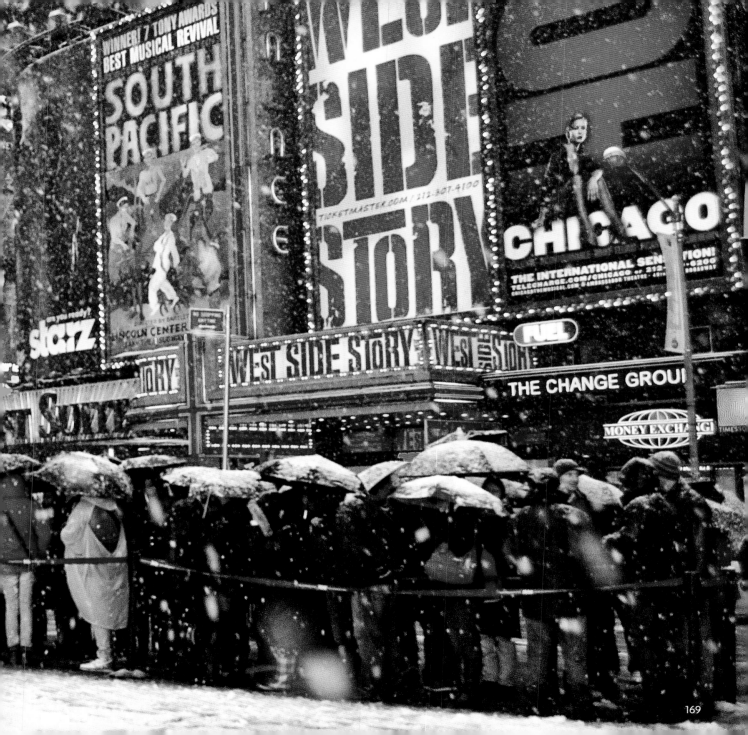

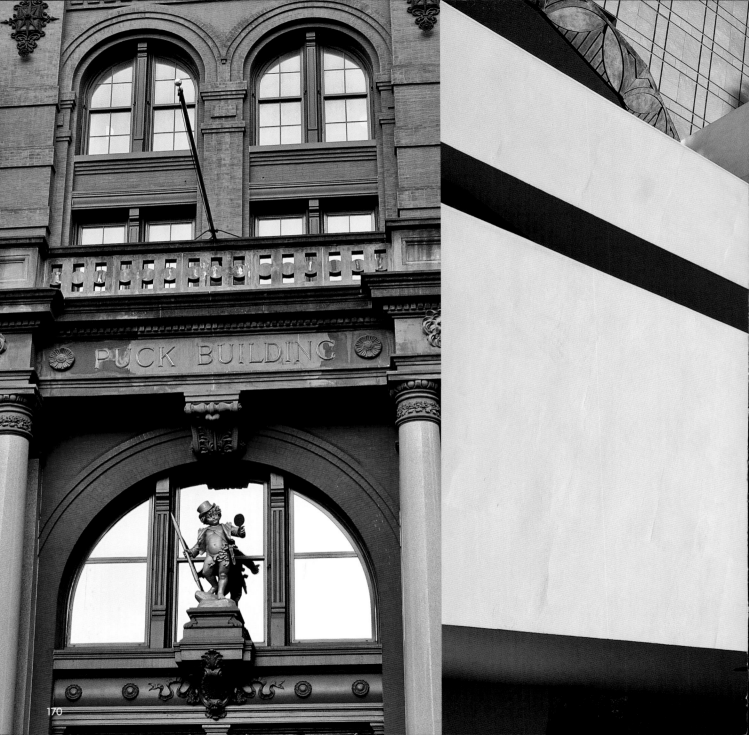

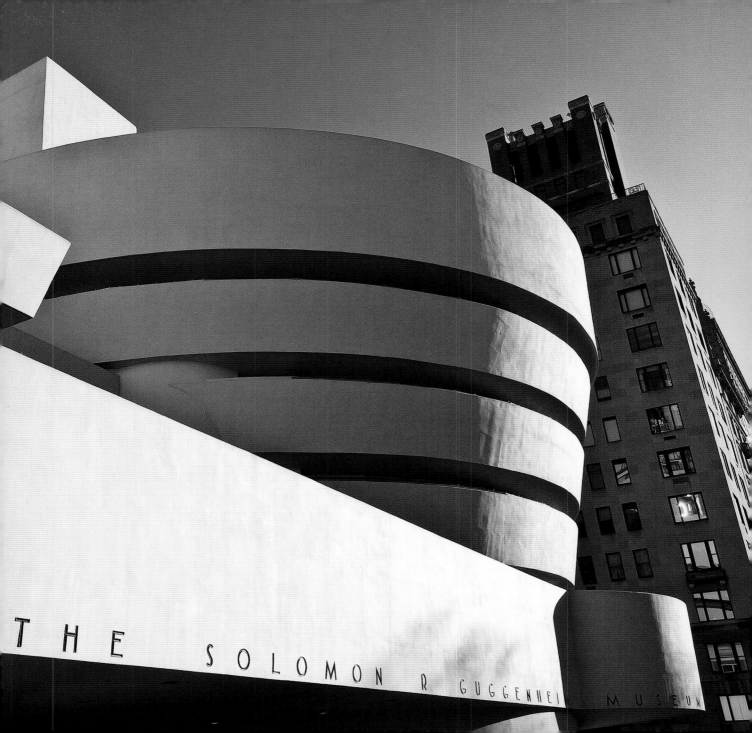

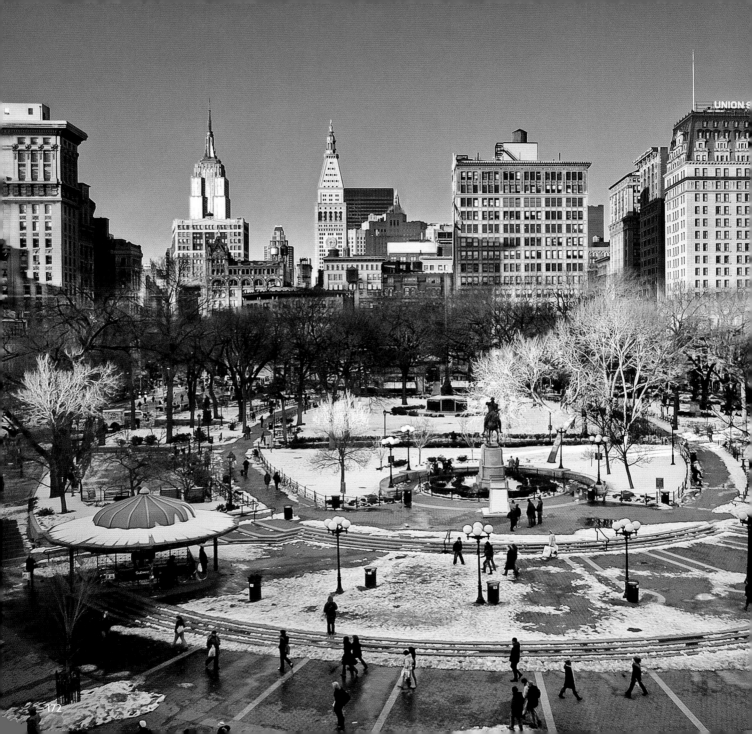

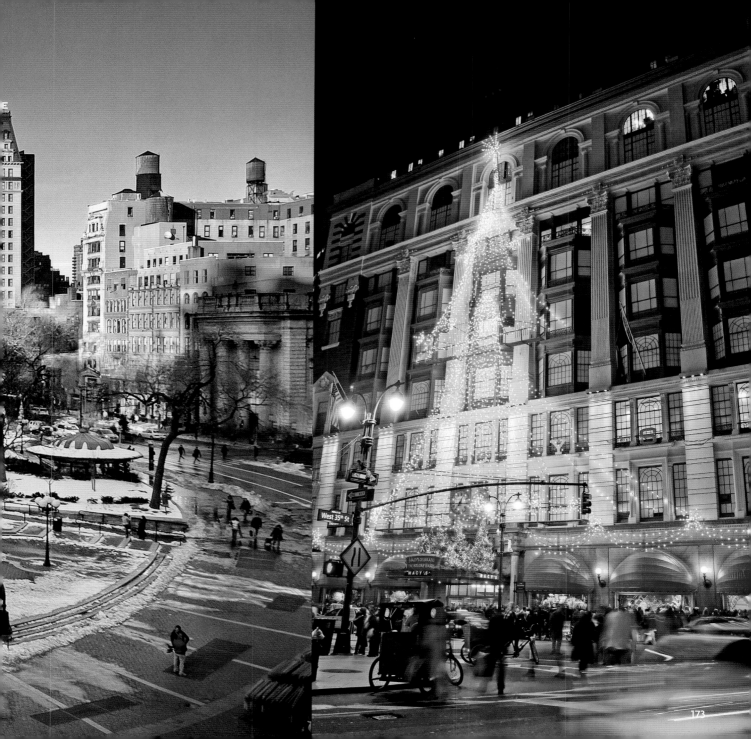

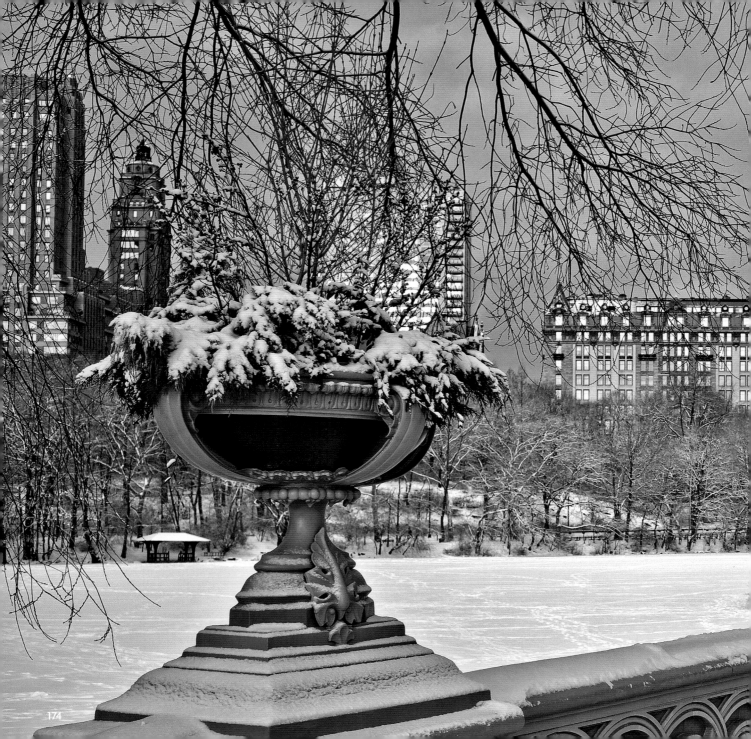

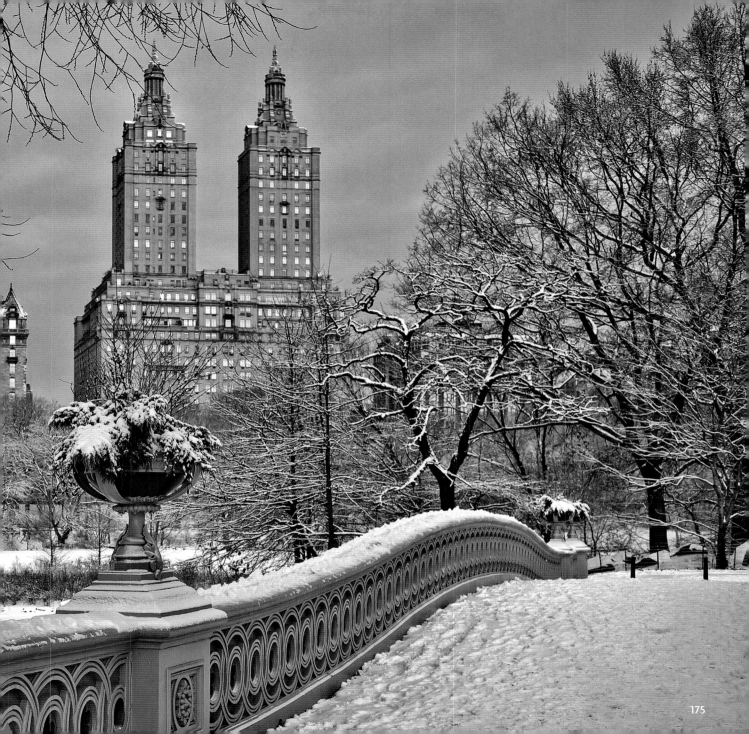

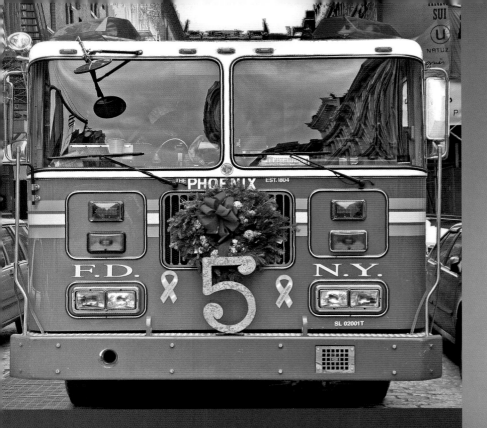

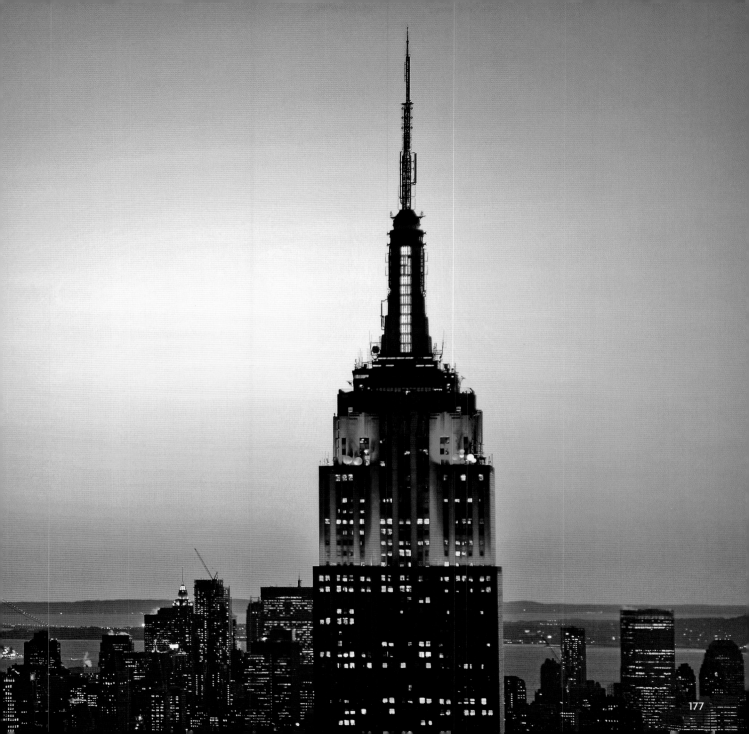

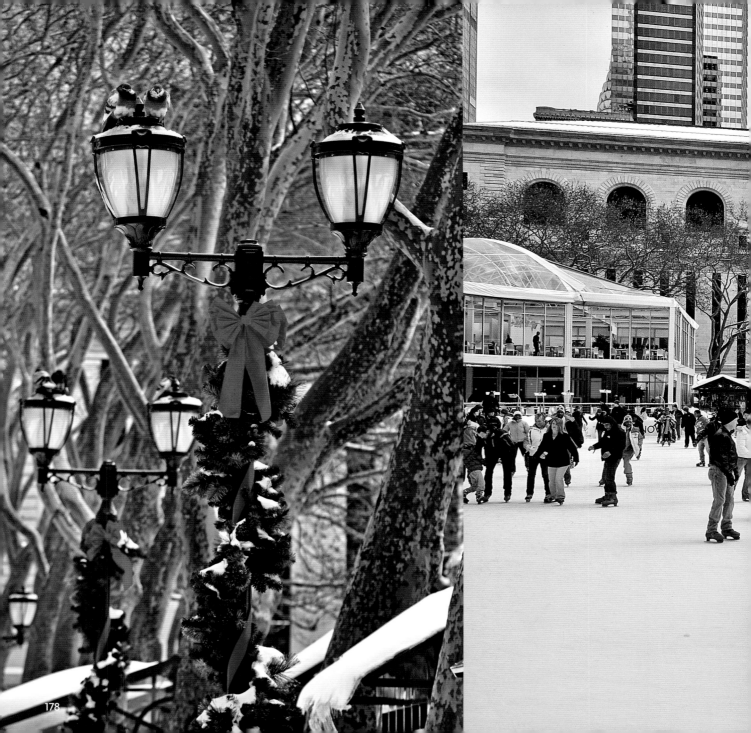

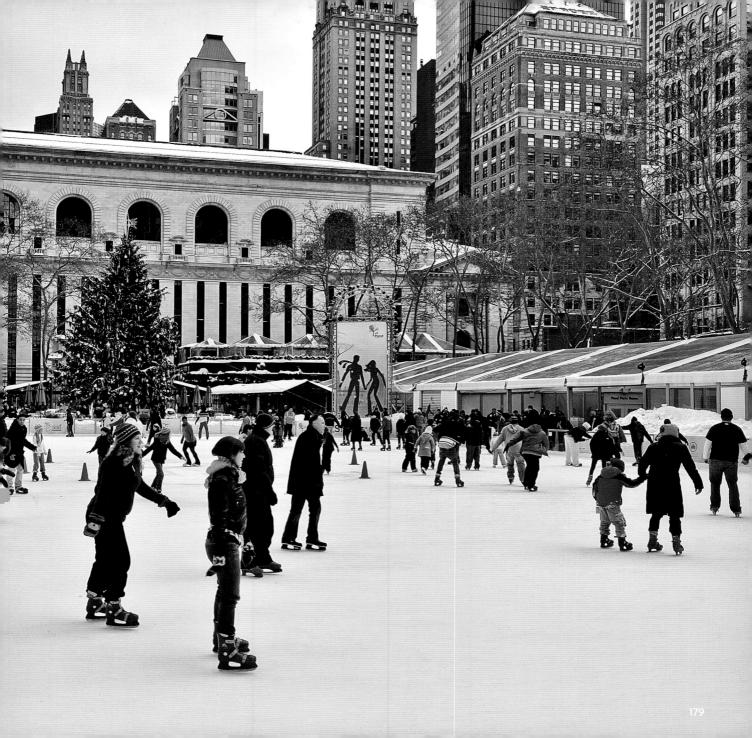

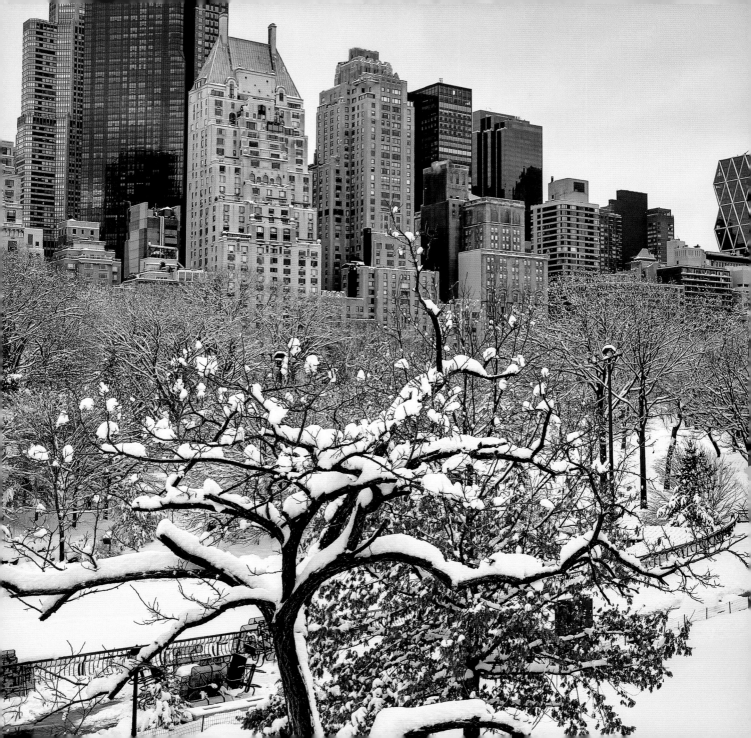

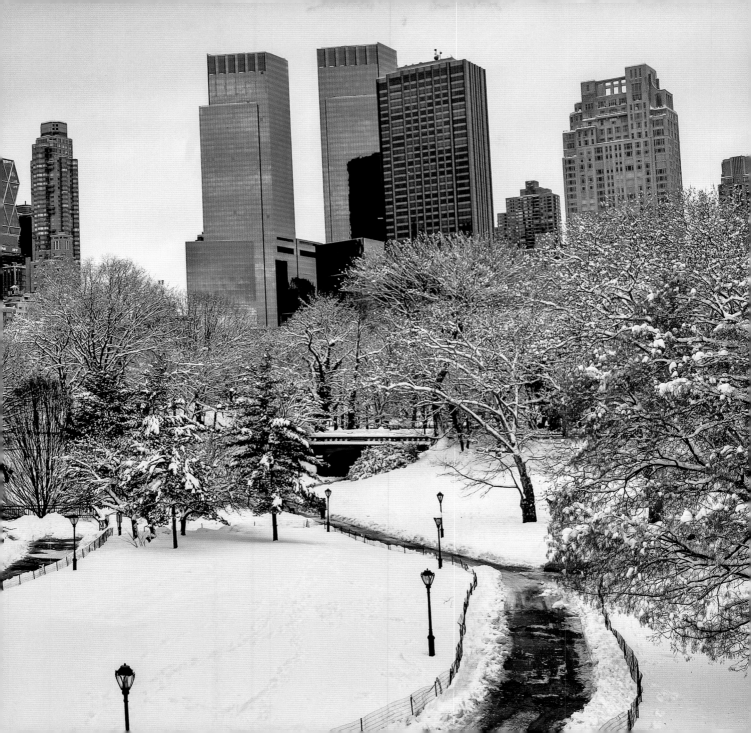

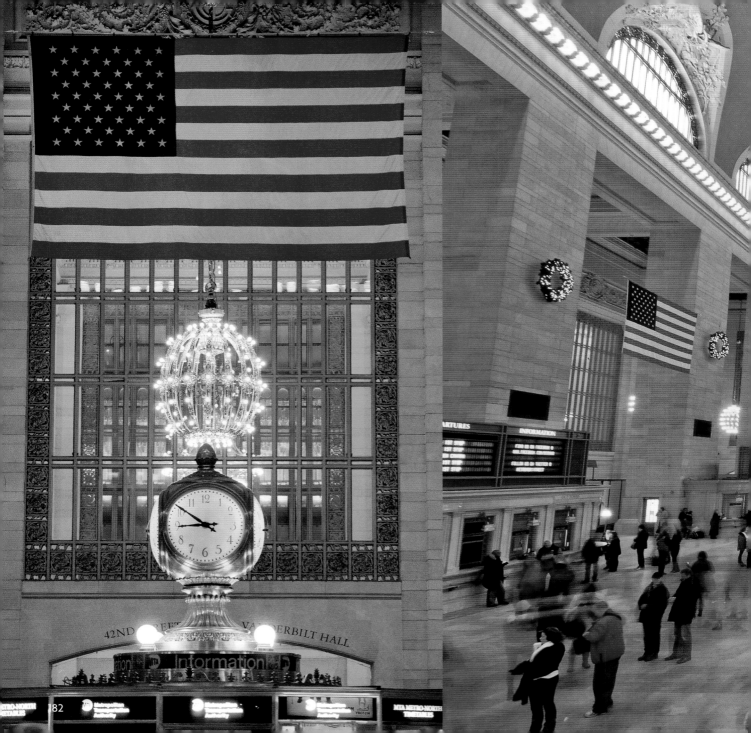

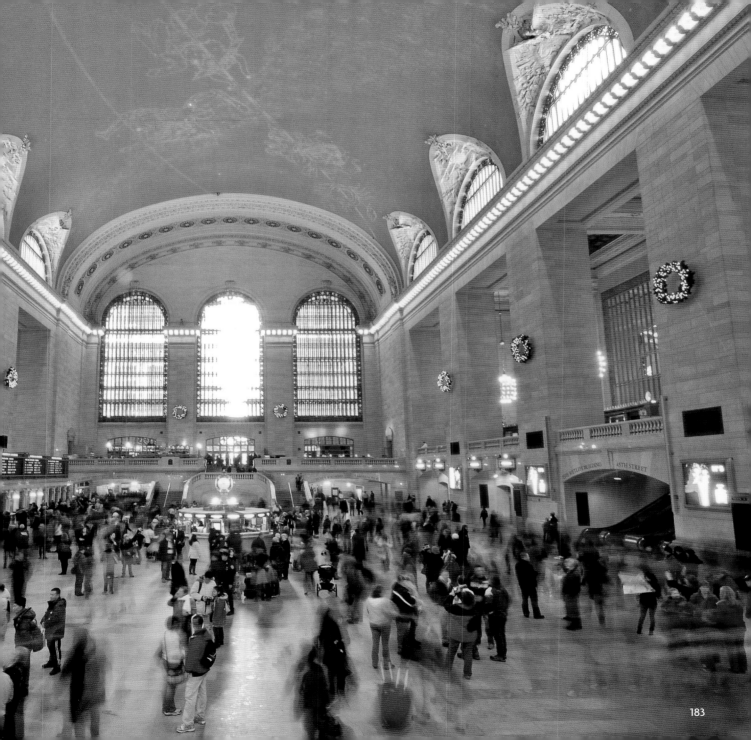

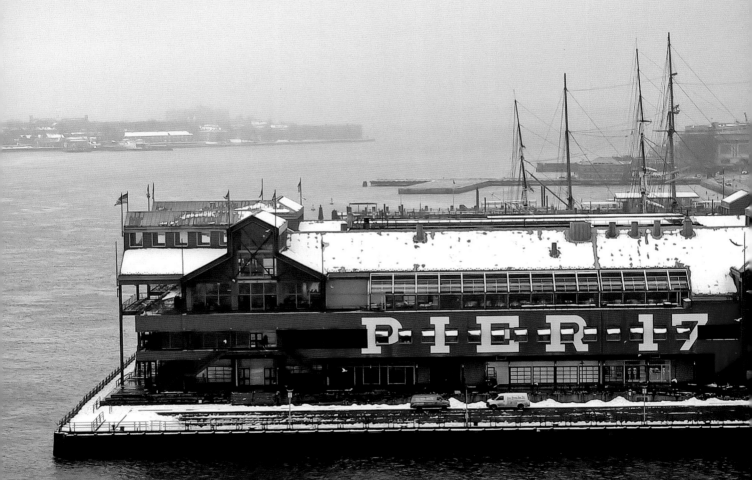

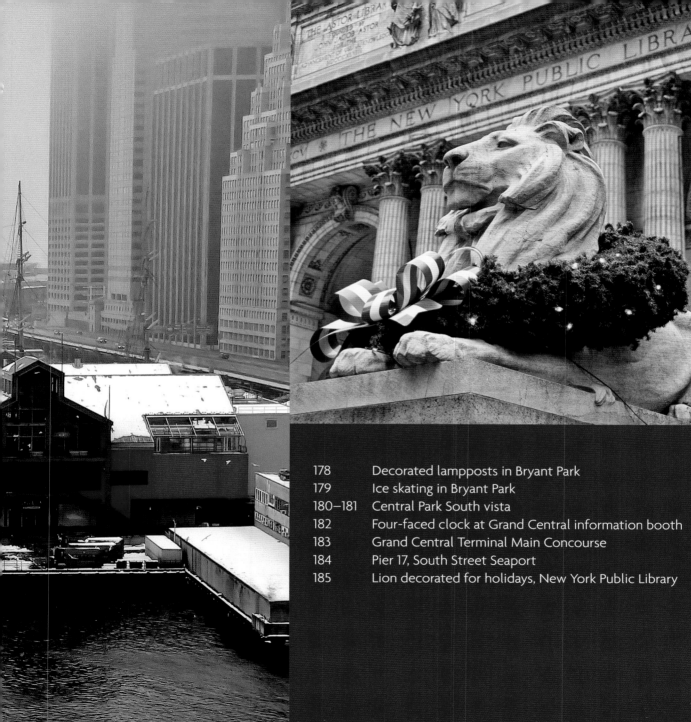

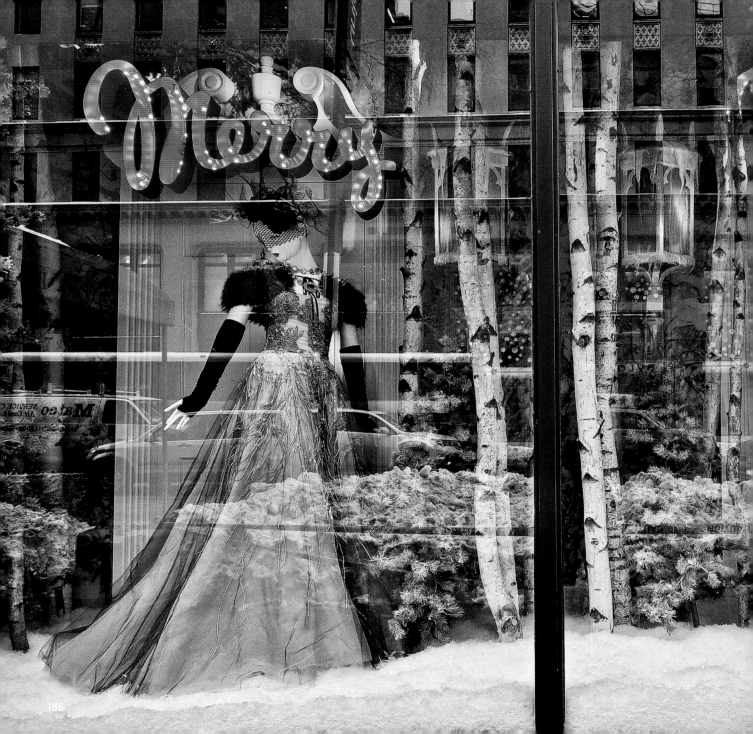

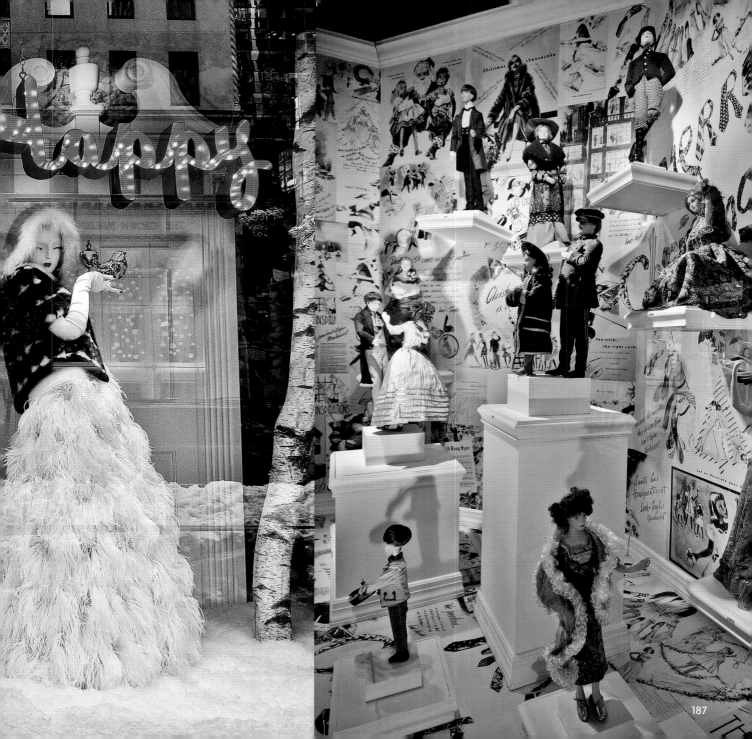

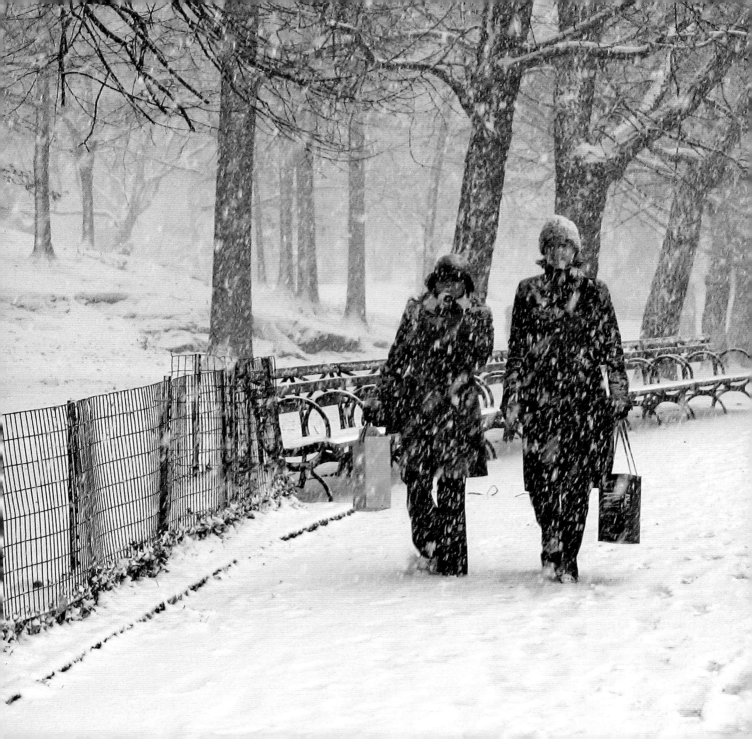

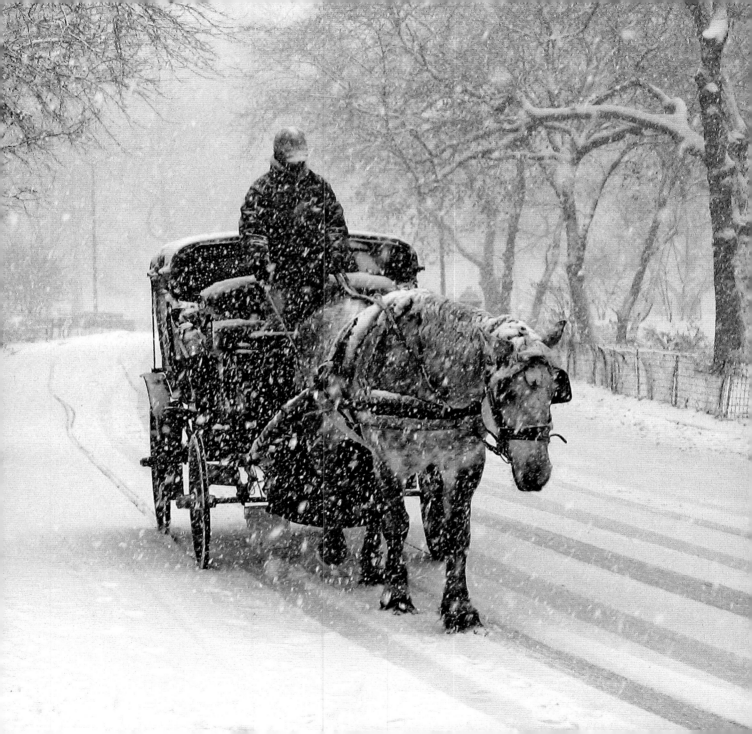

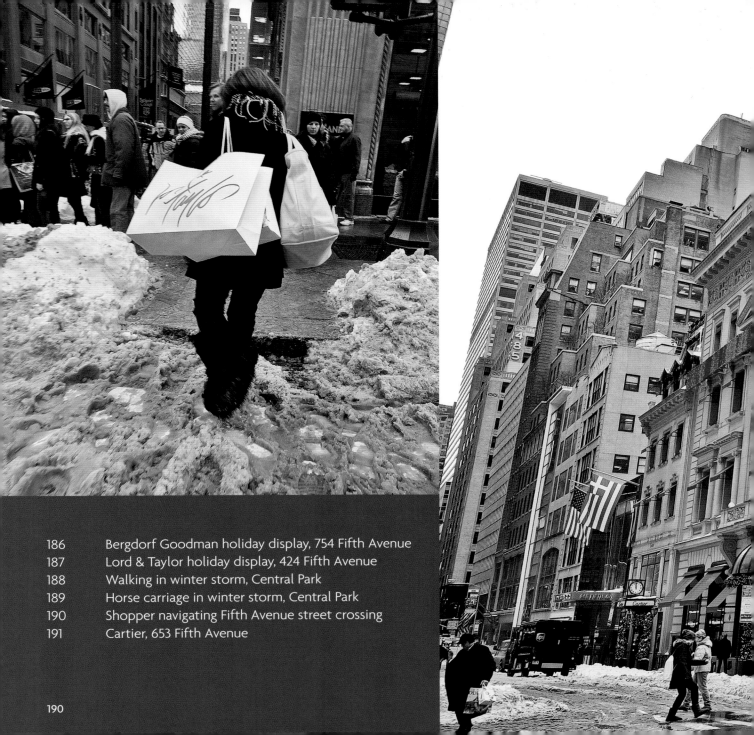

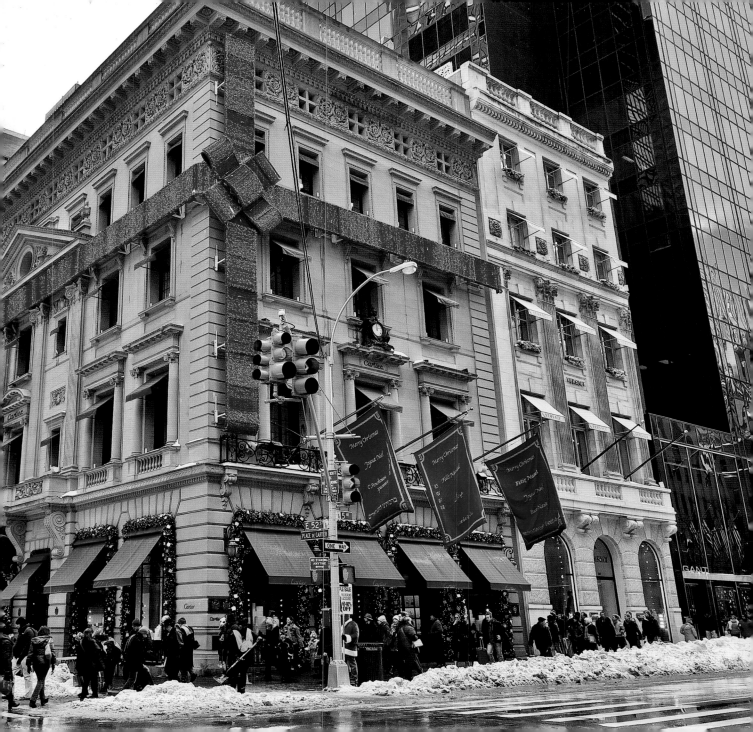

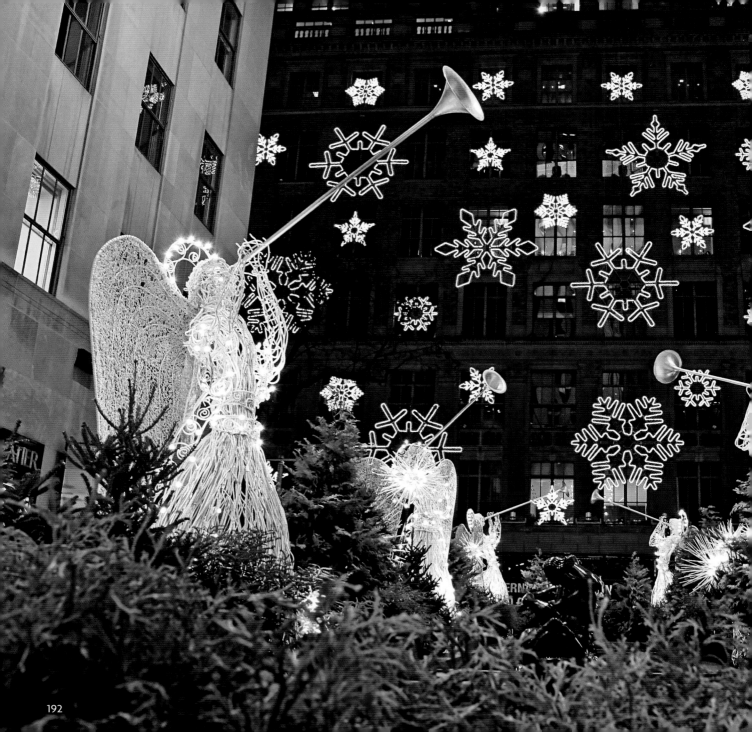

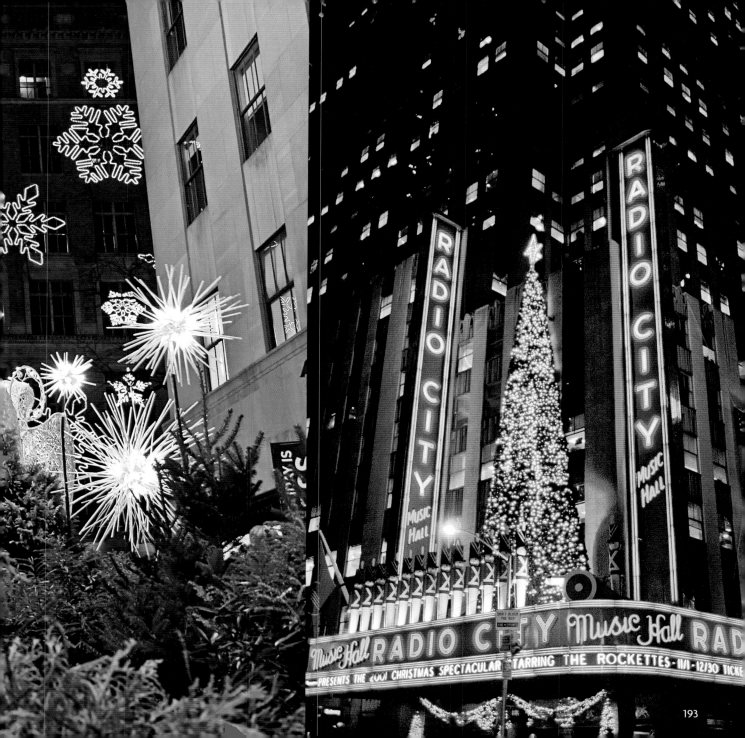

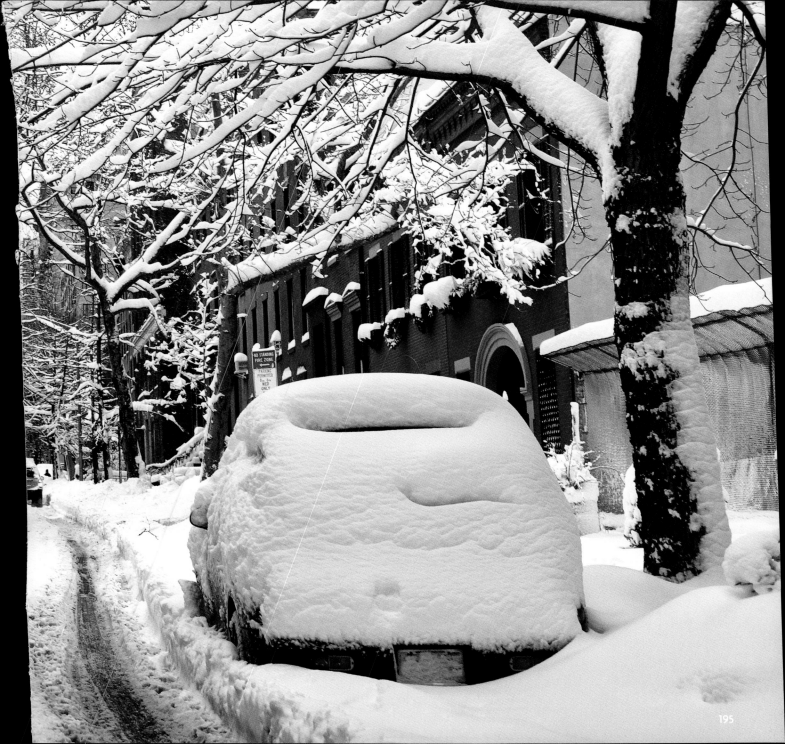

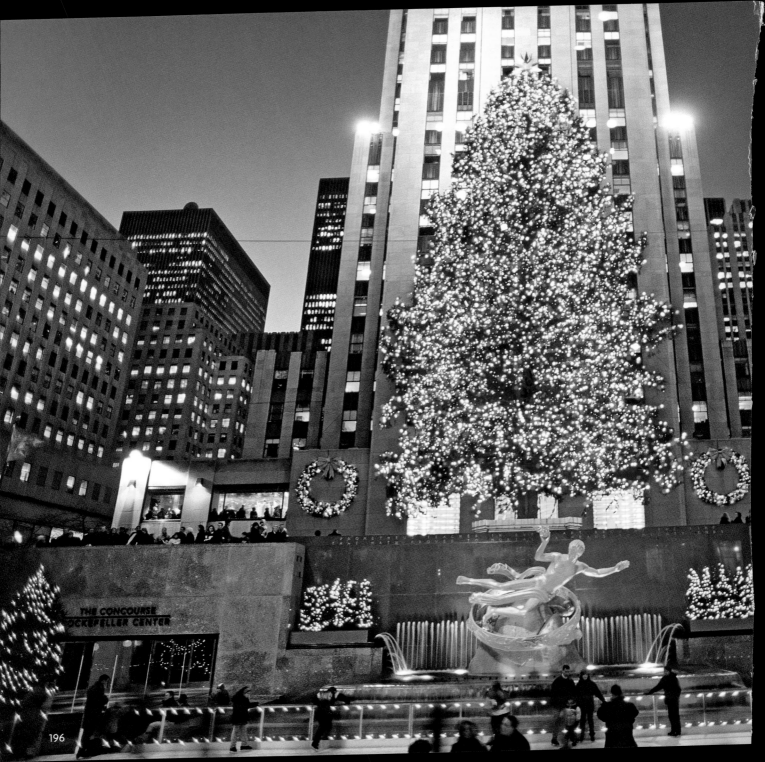

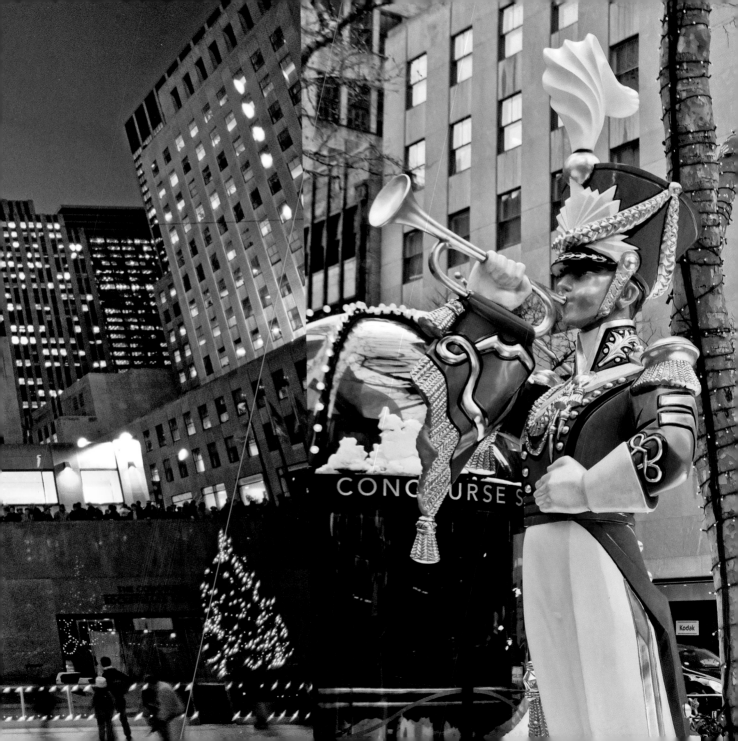

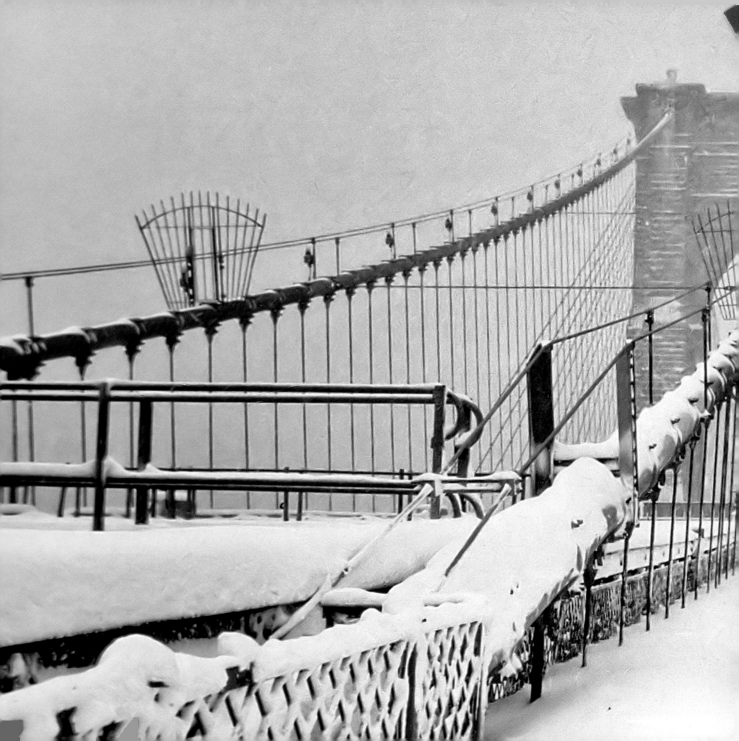

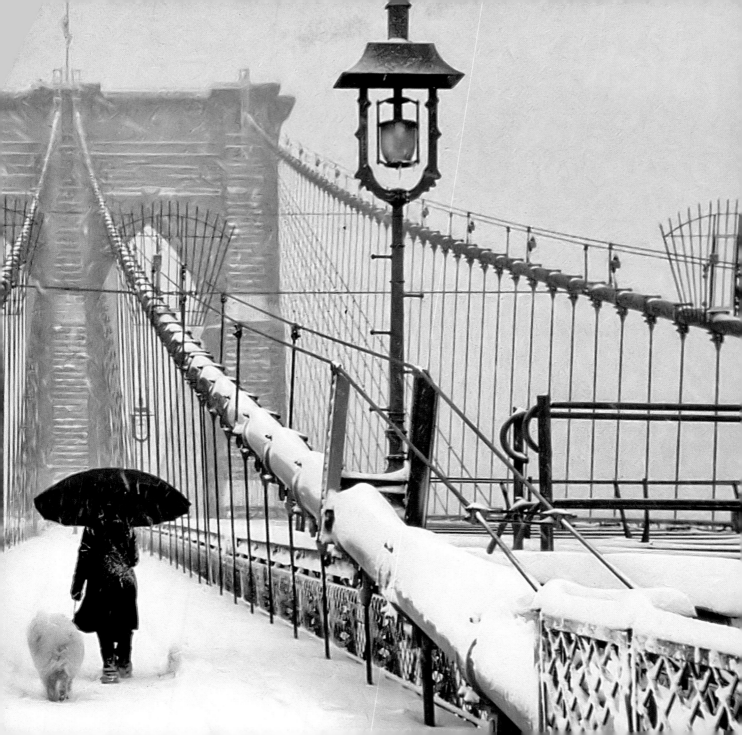

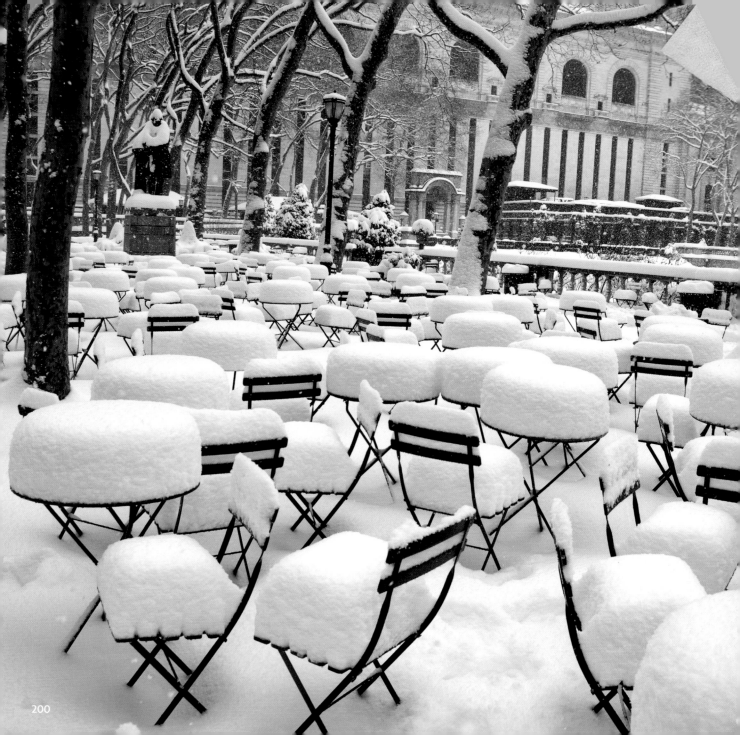

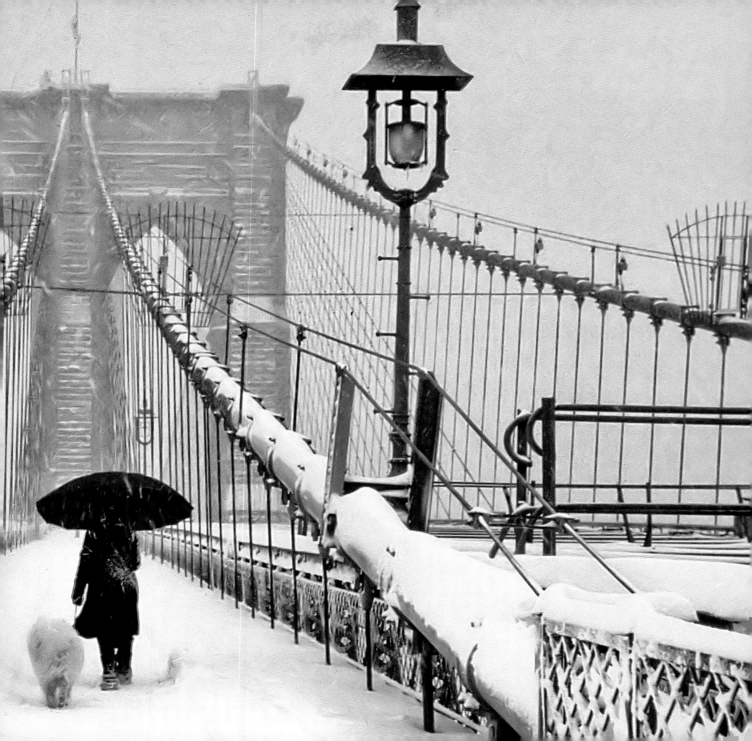

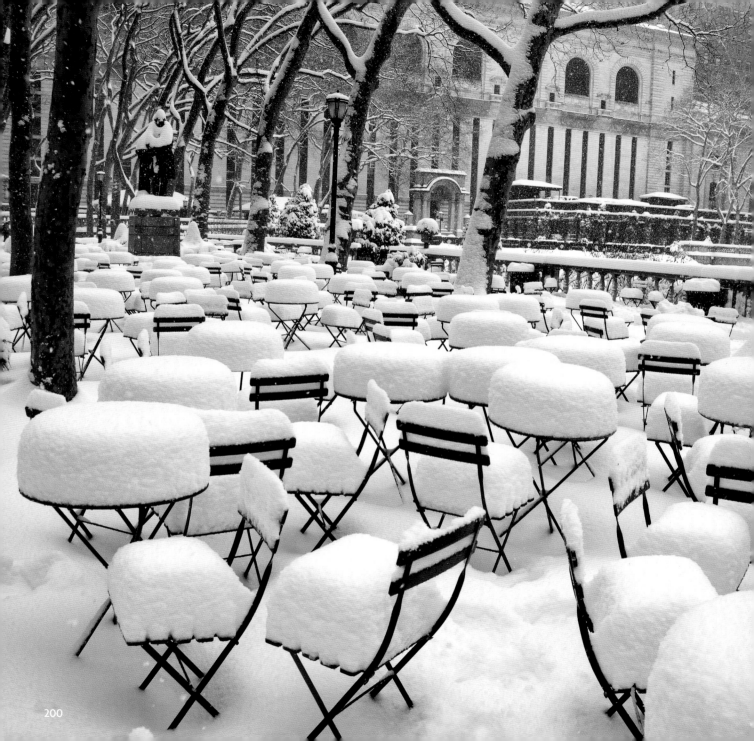

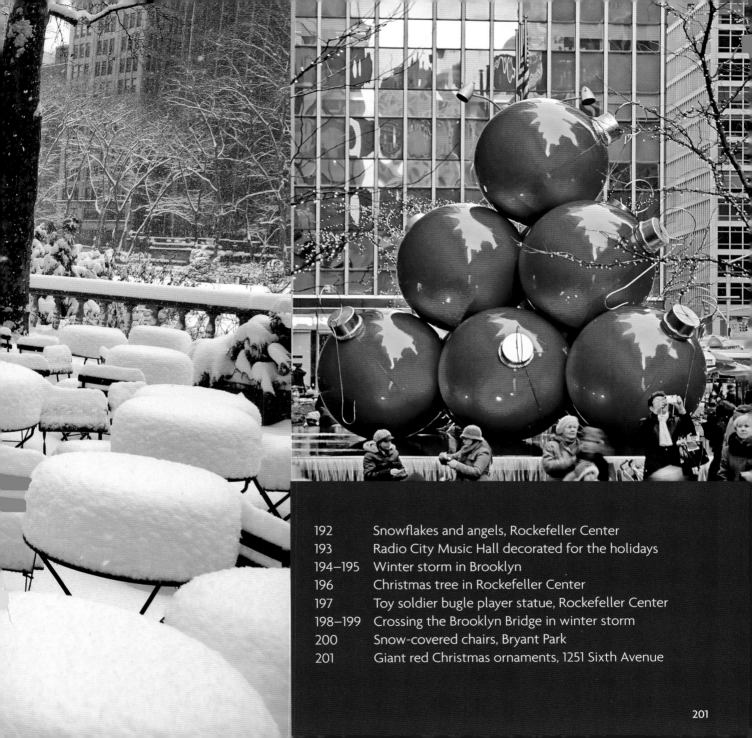

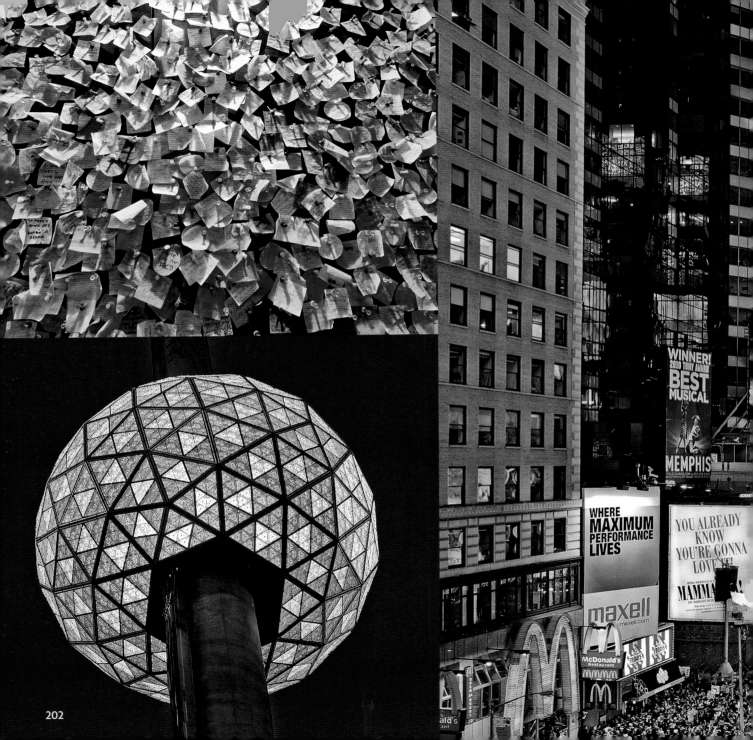

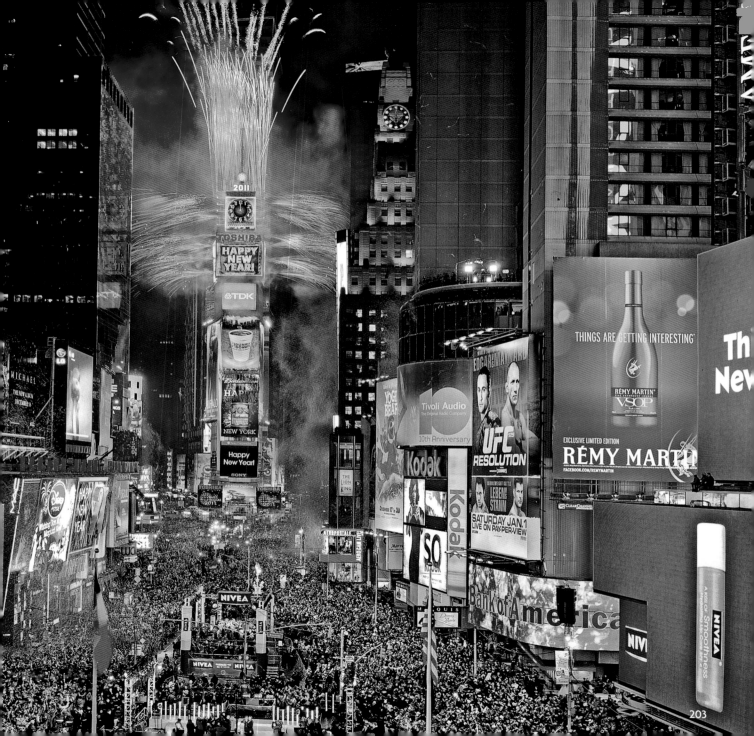

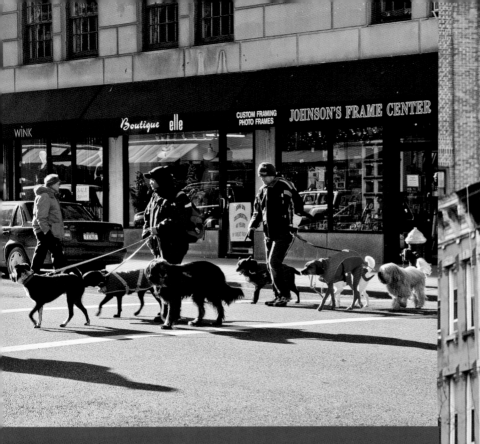

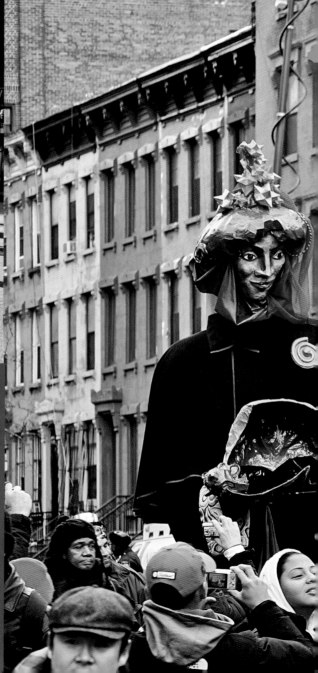

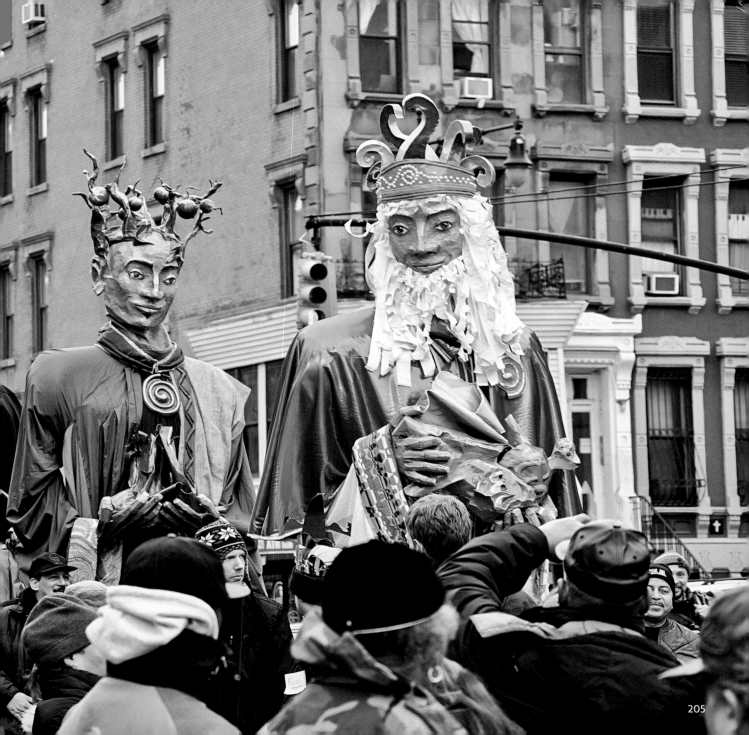

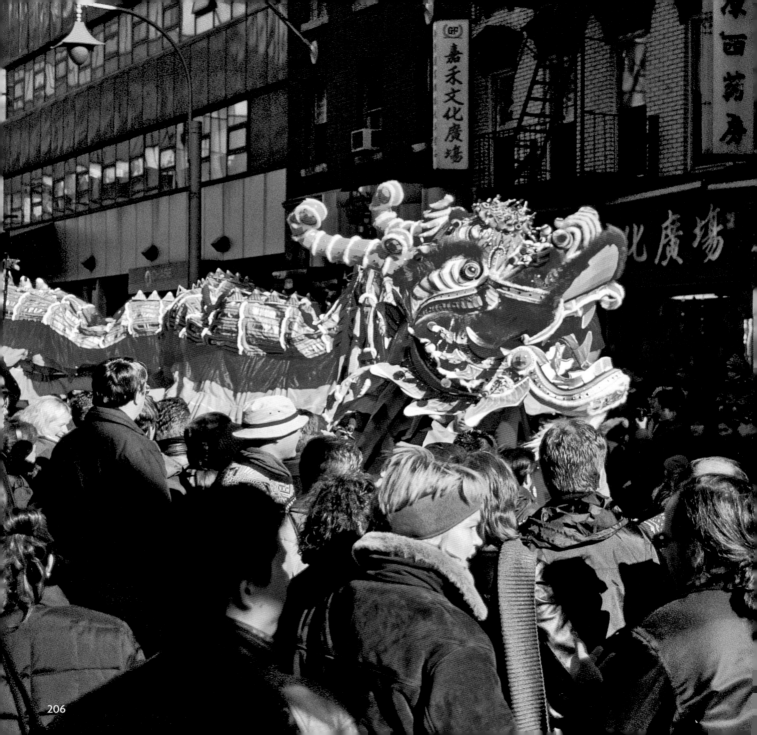

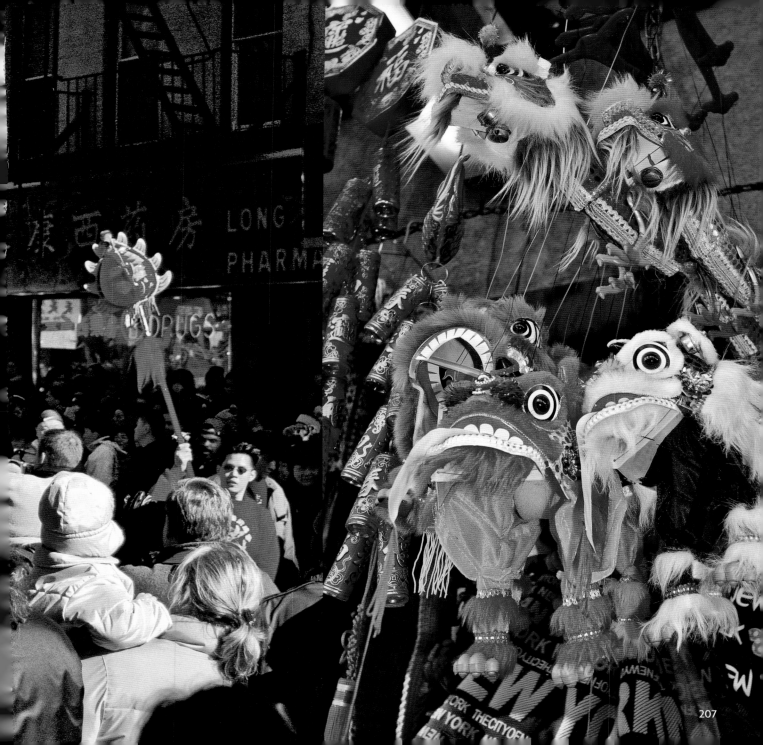

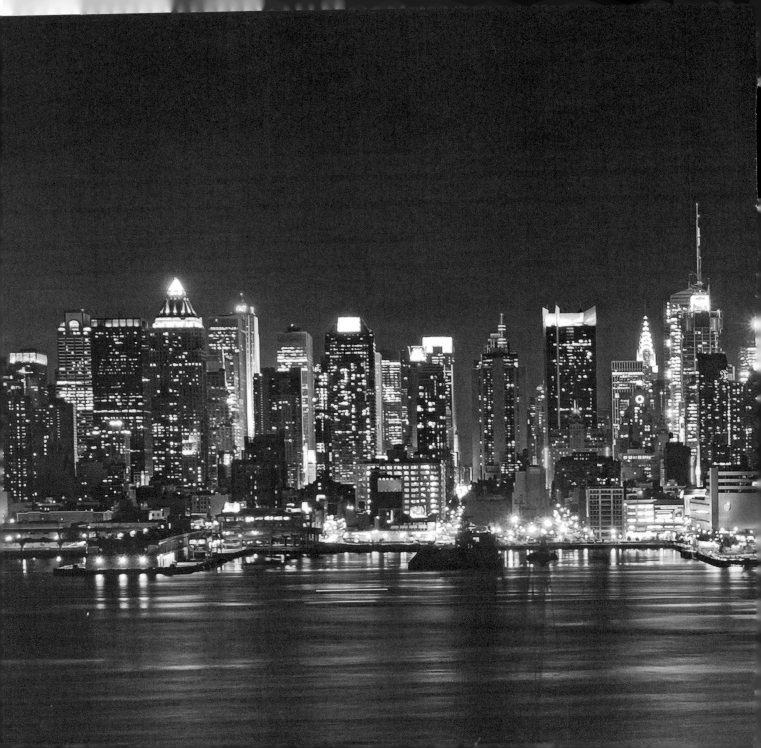